Data Protection for Photographers

Patrick H. Corrigan

Data Protection
for Photographers

A Guide to Storing and Protecting Your Valuable Digital Assets

rockynook

Patrick Corrigan (www.dpworkflow.com)

Editor: Joan Dixon
Project Editor: Maggie Yates
Copyeditor: Maggie Yates
Layout: Cora Banek
Cover Design: Helmut Kraus, www.exclam.de
Printer: Everbest Printing Co. Ltd through Four Colour Print Group, Louisville, Kentucky
Printed in China

ISBN 978-1-937538-22-4

1st Edition 2014
© 2014 by Patrick Corrigan

Rocky Nook Inc.
802 East Cota St., 3rd Floor
Santa Barbara, CA 93103

www.rockynook.com

Library of Congress Cataloging-in-Publication Data

Corrigan, Patrick H.
Data protection for photographers : a guide to storing and protecting your valuable digital assets / by
Patrick H. Corrigan.
 pages cm
ISBN 978-1-937538-22-4 (softcover : alk. paper)
1. Computer storage devices. 2. Photography--Digital techniques. 3. Image files--Security measures.
4. Data protection. I. Title.
TK7895.M4C67 2014
770.285'58--dc23
 2013038269

Distributed by O'Reilly Media
1005 Gravenstein Highway North
Sebastopol, CA 95472

TABLE OF CONTENTS

3 Storage Technologies 31

6 Backup and Archiving 93

INTRODUCTION

In my first book on data protection, *Backing Up NetWare LANs* (M&T Books, 1992), I said that the purpose of the book was to shed some light on a topic long shrouded in darkness, mystery, and mythology. Even though great strides in data storage and protection have been made in the last twenty years, many small office/home office (SOHO) computer users, including those of us involved in photography, still find effective data protection and storage to be a challenging endeavor. It is important to find a system that will accommodate the amount of data you need to store and archive; however, the number of data storage and protection options has increased dramatically in the last two decades, which adds to the confusion we encounter when trying to make decisions related to storing and protecting our images and other critical data.

This book is targeted toward small organizations and single practitioners—primarily those who do not have an in-house technical support staff. I will not be covering issues that principally concern larger organizations, such as server virtualization, data deduplication, or enterprise-class storage, backup, and archiving systems. My intent is to present information in the most simple and straightforward way possible, while still providing enough detail to allow you to make informed decisions related to data storage and protection. In some cases, I will make specific product recommendations; in other cases, I will use specific products merely as examples. Overall, you must make your own decisions based on your specific needs.

This book is about where and how to store your data, and how to manage your storage devices and systems. The Internet is filled with misinformation passed along so often that it gains credibility due only to its ubiquity. You will find statistics pulled out of thin air and statements of fact based only on the ramblings of a blogger who heard it from her cousin's brother-in-law. It is my goal to clear up some of this misinformation.

In this book, I will do my best to limit the use of technical jargon, but I can't completely eliminate it, because you will need to know some of the language of the field to better understand this subject. Bits, bytes, and megabytes are important, as are Mbits/sec and MBytes/sec. I will also do my best to be consistent, but some technical

For our purposes, data is electronic information, including, of course, your photographic images. Technically, the word data is the plural form of datum, but it has become common usage to treat it as a singular noun. In this book I will be referring to data as singular ("...data is...") as opposed to plural ("...data are...").

concepts are commonly referred to in multiple ways. For example, Megabytes per second can be referred to as MB/sec, MBps, or MBytes/sec. On the other hand, concepts that are unrelated are sometimes referred to in similar ways. For example, a megabit has a unit symbol Mb or Mbit, while a megabyte has a symbol MB or MByte.

Major Causes of Data Loss

A 2010 survey[1] by data recovery firm Kroll Ontrack stated that 40% of respondents believed human error was the leading cause of data loss. After more than thirty years in information technology, I agree with this assessment. Problems attributed to human error can include accidentally deleting or overwriting important data, failure to properly copy data from a source (such as a memory card) to a destination (such as a computer hard disk), and, of course, failure to properly protect data in case of loss. Hardware and system failures were also a leading cause of data loss. The survey found that viruses and natural disasters were low on the list. I would like to note that this was a survey of user opinion, and actual, verifiable statistical data is, for many reasons, not likely available. Other causes of data loss not mentioned in this survey include software-related data corruption, theft, and power-related issues.

A quick Internet search for "causes of data loss" returned several sites with statistics. Some even had very nice pie charts. They all seemed to disagree, however, and no sources for the statistical data were given.

Protection against these factors requires a comprehensive data protection strategy, not just a backup disk or cloud storage.

Data Storage Basics

I will be talking about several types of data storage. The first storage type is *image capture media*. This is the in-camera media where data is written as it is captured. In most cases, this refers to the flash memory cards used by your camera. It could also include videotapes and micro hard disks, but those media are not commonly used by

1 "Technology users believe human error is the leading cause of data loss," Kroll Ontrack, July 20th, 2010, http://www.krollontrack.com/company/news-releases/?getpressrelease=61462.

photographers and therefore will not be covered here. *Primary storage* refers to the primary location where you store images after they have been transferred from your camera. For many of us, this is an internal hard disk in a desktop or laptop computer, but it could also be an external hard disk or an external server or disk array (more about these topics later). *Backup* refers to the devices and systems used to store copies of data in case of disaster or data loss. These could include external or removable hard disks, external disk arrays or servers, optical discs (CD, DVD, or Blu-ray), magnetic tape, or online (cloud) storage. *Archiving* refers to the storage of data for long-term preservation. Archived data can include inactive data as well as copies of currently active data. Archive storage devices might be the same as those listed for backup. It is important to understand the role that each of these storage options play, and how to effectively manage them. In addition to these types of storage, I will also talk about flash memory cards, solid-state drives (SSDs), optical media (DVD, Blu-ray, etc.), digital tape, disk arrays, cloud storage, and more.

Data Transfer Rates

Data transfer rates are usually specified as the maximum rate for an interface, such as SATA. Sometimes they are specified as sustained rate, meaning a continuous rate over time, or a burst rate, which is the rate the interface can handle an occasional burst of data. It is almost guaranteed, however, that you will rarely, if ever, attain those rates in the real world. For one thing, there is always a certain amount of overhead involved in transferring data, including error correction and detection, metadata (data about the data), and, in the case of shared communications systems such as USB and Ethernet, routing information. For example, USB 2.0, which is rated at 480 Mb/sec (60 MB/sec), will transfer data between two hard disks at no more than 35-40 MB/sec.

Even if the interface can communicate at a particular speed, the devices using that interface may not be able to do so. For example, few SATA hard disks can transfer data at even half the rate of SATA 2 (300 MB/sec). A 7200 RPM SATA disk will provide a maximum data read speed of about 115 MB/sec and a maximum write speed of about 80-95 MB/sec.

The type of data matters as well. Large files typically transfer at a faster rate than small files, because there is less overhead in the transfer operation.

One difficulty a writer faces when presenting different types of interrelated information is determining the order of presentation. For example, discussing storage technologies before presenting their application gives the reader relatively dry technical

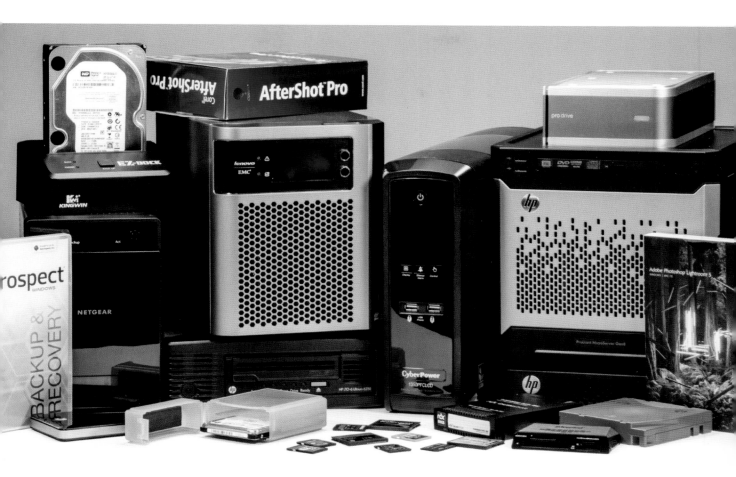

information without any context, but discussing primary storage before presenting the applicable storage technologies means that the information might seem disjointed. In order to present this material in an effective manner, I will sometimes need to reference other chapters and locations in the book, though I will do this as little as possible.

Also, keep in mind that storage technologies are changing rapidly. By the time this book is published, there will likely be newer, faster storage technologies on the market with greater capacities at a lower cost. Products described or profiled in this book may have newer versions with different capabilities, better performance, or other enhancements. Please use what you read here as a guide. I hope that the information presented can get you started in the right direction.

IMAGE CAPTURE MEDIA

The first place your images are stored is on the memory card (also called a *flash card*) in your camera. Many of the image corruption problems photographers experience occur at this point.

If you go online to almost any forum or discussion board where flash memory is discussed, you will invariably see messages such as, "My ABC brand memory card corrupted my data. I'm only going to buy XYZ brand from now on." The truth is, memory card failures are very rare, and data loss and corruption usually have other causes. We will discuss those causes, and ways to prevent or recover from them, later in this chapter.

What is Flash Media?

Flash is shorthand for *flash electronically erasable programmable read-only memory* (FlashEEPROM). Flash memory is non-volatile, solid-state storage that can be electronically programmed (written to) and erased. Non-volatile means that it retains data even when the power is off. Unlike earlier *electronically erasable programmable read-only memory* (EEPROM), which had to be completely erased before it could be reprogrammed, flash memory works like a hard disk: data can be written to or erased from a specific section of the memory without affecting the remaining data.

The most common types of flash memory for cameras are CompactFlash (CF) and Secure Digital (SD). A third type of flash, called Memory Stick, was created and promoted by Sony, but it has not been widely adopted. In addition, there are two relatively new offshoots of CF: XQD and CFast. There are other memory card formats, such as MultiMediaCard (MMC) and SmartMedia (SM), but these are no longer in common use.

How Flash Media Works

Flash media, such as memory cards used in cameras, USB flash drives, and flash solid-state disk drives (SSDs), is made up of two primary components: the flash memory chip itself and the memory controller chip. The type of memory that is predominantly used in these devices is of the NAND variety. NAND refers to a part of the internal architecture of the memory chip; this type of memory allows data to be written and retrieved in blocks. The controller is a microprocessor that makes the flash memory chip look like a hard disk to the computer (even though it's very different), and pro-

vides other essential management functions needed for error correction. Since flash memory wears out over time, the memory controller chip also minimizes the effects of that wear. Each bit of data is stored in a cell, the basic storage unit in flash memory. Each cell is organized into pages, which are usually 2 KB-4 KB in size, and each page is part of a block. Each block is typically 64 or 128 pages in size.

A bit is a binary digit, 0 or 1. Eight bits = one byte.
KB is shorthand for kilobyte, or 1024 bytes.

One function of the controller is to provide a *translation layer,* which makes the camera, computer, or other device use the memory card like a hard disk. This is very important, since the internal architecture of flash is very different from a hard disk. With a hard disk, you can both write and erase data a bit at a time. With flash, you can write data a page at a time, but you can only erase whole blocks. If you need to update or add data to a page, you must copy the data not being updated, merge it with the new data, then write it to a new page in a new block. You must also write any other written pages in that block to the new block, and then erase the original block. Erasing data from an existing block involves the same data-moving operation unless the whole block is being erased.

Each cell can only handle a finite number of program/erase cycles before it begins to wear out. This is called *memory wear*. To minimize this, the controller makes sure that all blocks are used evenly as data is written, erased, and written again. This function is called *wear leveling*.

Raw flash memory (memory without the controller) is prone to errors, so the controller must provide error detection and correction. After data is either written or erased, it is reread to verify its accuracy. If a single-bit error is discovered, *error correction codes* (ECC) will correct that error. When errors greater than a single bit occur, the controller will rewrite the data elsewhere and flag the entire block of cells as bad, preventing future writes to that block. Don't worry—the design of the flash card takes errors into account, so the whole package is very reliable.

"An error-correcting code is an algorithm for expressing a sequence of numbers such that any errors which are introduced can be detected and corrected (within certain limitations) based on the remaining numbers."

Eric W. Weisstein, "Error-Correcting Code." From MathWorld—A Wolfram Web Resource. mathworld.wolfram.com/Error-CorrectingCode.html.

What about memory wear? Most Flash memory cards are rated for 100,000 program/erase (write/erase) cycles, and some are rated at 1,000,000. When used properly, your memory card will become obsolete long before it wears out. For example, if you fill up a memory card (rated for 100,000 cycles) and then erase it twice a day, it

should last about 136 years (100,000/365.25/2 = 136.8925393566051). Since the electrical contacts are typically rated for 10,000 insertion cycles (about 13.6 years using the above formula), you might want to worry more about contact wear than memory wear—though it is still unlikely you will use a card twice a day for thirteen years.

Physically, most flash memory cards are pretty sturdy. Both CF and SD cards are designed to withstand a drop of at least three meters. Some manufacturers advertise additional durability, including being waterproof. I have accidentally put a number of flash cards and USB memory sticks through the laundry cycle and luckily, all have survived.

Who Makes Flash Memory?

There are currently four manufacturers of NAND flash memory chips: Hynix, Micron (Micron owns Lexar and Crucial), Samsung, and a joint venture between SanDisk and Toshiba. The main components of all flash media come from these manufacturers. There are numerous manufacturers of flash memory controllers. SanDisk manufactures its own controllers. It is also difficult to define what a manufacturer is, since some companies, like controller manufacturer Marvell, are fabless manufacturers, meaning they outsource the actual manufacturing process. There are many brands and manufacturers of flash memory 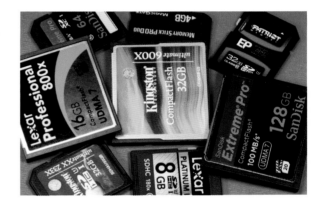 cards, and it is nearly impossible to determine which company actually manufactured a given memory card, since the industry tends to protect this information. There are also a number of *original equipment manufacturer* (OEM) suppliers who only supply complete products to other companies; even the major manufacturers sell, under their own labels, products made by other suppliers.

Regardless of where and by whom the actual cards are made, there are differences between vendors. SanDisk is the current market leader in the U.S., and Lexar is in second position. Other players in the market include Kingston, Patriot, Transcend, ADATA, PNY, Sony, Toshiba, and Samsung. SanDisk and Lexar are usually the first to market newer technologies, faster speeds, and higher capacities. Some vendors provide a full range of memory cards while others only supply SD cards. Certain vendors provide some level of manufacturing or assembly, while others only buy products from other manufacturers and put their labels on them. There will likely be differences in quality control and testing. The four vendors I spoke to directly for this book, SanDisk, Lexar, Kingston, and Patriot, all indicated that quality control and extensive testing were major advantages of their brands.

These are a few of the memory cards I have used over the years. I have never had a catastrophic memory card failure.

Causes of Memory Card Failure

I have personally used a wide variety of memory cards over the years and I have never experienced an actual card failure, although I know it does happen. Manufacturers don't publish failure statistics, but based on information from other sources, flash memory card failure seems to be rare. To get early-failure information, I talked to the sales- and return-desk staff at several retailers, and asked about memory card returns. Everyone I talked to said that card returns due to failure were extremely uncommon. When I asked if returns or problems were greater with any particular brand, the answer was universally "no." Most returns were due to the following:

- purchasing the wrong type of card (CF instead of SD, for example)
- purchasing a card that had the correct physical format, but used a file system that wasn't compatible with the user's device
- purchasing a card with a capacity greater than the user's device could handle
- purchasing a card that didn't provide the required level of performance
- other compatibility issues—though all memory cards are built to industry standards, there have been instances were a card from a certain manufacturer was not compatible with a particular device (this is extremely rare)

There are several common causes of failure:

- DOA (dead on arrival): this is extremely rare, especially with cards from reputable vendors, since most have excellent quality control and do extensive testing.
- Physical damage: memory cards are resilient, but not indestructible.
- The card is counterfeit.

Causes of Data Corruption

When someone experiences data corruption, the first thing they will blame is their memory card, but memory card failure is uncommon. Common causes of failure include the following:

- removing a memory card from the camera while data is still being written;
- removing a memory card from the card reader while files are still open;
- battery failure while data is being written;
- improper formatting;
- switching cards between different camera models without reformatting;
- problems during data transfer to computer, including camera battery failure; and
- extreme heat: avoid leaving your memory cards on your dashboard while the car is parked in the hot sun.

Counterfeit Memory Cards

Counterfeit memory cards have become a big business in the last several years. These cards have been distributed through a number of sources, including eBay and Amazon. In addition to obvious trademark and warranty issues, counterfeit cards usually provide lower performance and capacity than their labels indicate. Lower performance can affect your ability to shoot high-resolution video or high frame rate stills. The reduced capacity is even more insidious; the controller on a low-capacity card will be reprogrammed to report a higher capacity. Your camera will allow you to "fill" the card to its maximum reported capacity, resulting in lost or corrupted images. Even if a counterfeit card provides the listed performance and capacity, it is still likely to have been made with inferior components.

To avoid counterfeit cards, always buy from a trusted source. Also, check any suspect cards as soon as possible. If you report problems early enough you may have some recourse with the seller; for instance, Amazon has been reported to be very responsive to these issues. If you would like to test your cards for actual capacity, there is a free test utility here: heise.de/download/h2testw.html. The site is in German and the utility is Windows only. You can also find an open source alternative that runs on Mac OS, Linux, and Windows here: oss.digirati.com.br/f3.

Backward Compatibility

Cameras and other devices, such as card readers, that comply with newer versions of the CF and SD specifications will typically work with older cards. Newer cards, however, may not work with older devices for a number of reasons. The devices may be unable to address high-capacity cards or work with a newer file system.

Flash Memory Data Retention

How long will flash memory retain data without being powered up? Most manufacturer specification sheets do not quote a data retention period. I found two vendors of industrial SDHC cards that quoted ten years, and one photo website that quoted five years. Personally, I rarely keep data on my flash cards for more than a few weeks, but I recently pulled five- and six-year-old images from cards that I found sitting in a drawer. Even though flash memory is considered to be non-volatile, data stored in flash can still degrade over time. Solid-state drives (SSDs), like memory cards, are also flash media, but they are typically powered up frequently, which allows their controllers to monitor and manage error conditions, making them more suitable for long-term storage than memory cards.

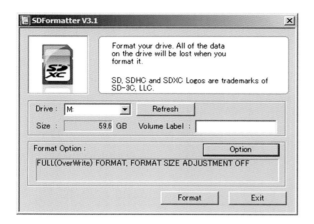

SD Formatter in Over-Write mode

Formatting Flash Memory Cards

In most cases it is best to format each memory card in the camera (or a camera of the same make and model) for which it will be used. This assures that the proper file system and directory structure required by that camera is established.

There may be some circumstances for which you want to use a specialized formatting tool. The SD Association has published a format utility for Windows and Mac OS: sdcard.org/downloads/formatter_4. This utility only works with SD cards. In addition to formatting, this utility can be used to overwrite existing data on a memory card to prevent it from being recovered. Use this function if you want to make sure deleted data is unrecoverable.

After you use this, however, you may still need to format the card in your camera to establish the proper file system and directory structure.

Best Practices for Flash Memory

Here are some steps you can take to extend the life of your flash memory and minimize data corruption:

- Do not remove a memory card from your camera while data is still being written. This is one of the most common causes of data corruption. It may take several seconds for your camera to write data from its memory buffer to the memory card. Many cameras have a red LED that indicates a write operation is in progress. Even if you turn off the camera before removing the card, make sure the write operation is complete.
- Do not run your batteries to exhaustion—they may run out of power during a write operation.
- Do not delete images in the camera. This can cause a problem called *write amplification*, a multiplying effect that causes data to be written and rewritten in different areas of the card. The increased number of writes can shorten the lifespan of the card. If it is done on a full card, which is the usual reason for deleting images, it can cause data corruption.
- Format each memory card in the camera. Do not format memory cards with your computer unless you are using formatting software designed specifically for that purpose, such as the SD Association's *SD Formatter* (sdcard.org/downloads/formatter_4). Even then, format the card in your camera to make sure the proper file system and directory structure is established.
- Do not use computer disk partitioning utilities, such as Windows *Fdisk* or MacOS's *Disk Utility*, to partition a memory card. At best, you will hurt perfor-

mance. At worst, you will corrupt data or damage the card. Flash memory cards are not hard disks—their controllers just make them seem like hard disks to your computer.

- Do not run defragmentation utilities on memory cards. Defragmentation adds to the number of program/erase cycles, effectively shortening the life of the card. There are certain cases where defragmentation can help, but this usually doesn't apply to cards used for capturing images in a camera.
- Make sure your card reader is designed to work with your memory cards. Older-generation readers may not always work properly with newer-generation cards.
- Make sure your card reader cable is in good condition. USB cable problems are rare, but they do occur.
- Make sure your computer supports the file system used by your memory card. Some higher-capacity memory cards, such as SDHX cards, use Microsoft's pro-prietary *exFAT* file system. Older versions of Windows and Macintosh operating systems, as well as most or all Linux distributions, cannot read this file system without first having additional drivers installed.
- Do not delete images from your memory cards until you have at least two copies of your images on different media (disk, tape, DVD, BluRay, etc.) and have veri-fied that the images are free of data corruption.
- After copying images to your computer, format the card (in your camera) instead of deleting the images to minimize write amplification.
- Make sure files are closed and it is safe to eject your card before removing it from your card reader.
- Buy memory cards from reputable vendors to avoid counterfeits. If the price of that eBay card seems too good to be true, it may be a counterfeit card.

What to Do If You Experience
Memory Card Damage, Data Loss, or Corruption

If you damage your memory card, experience data corruption, or accidentally delete images, follow these steps:

1. Do not attempt to write to or format the card. If it is an SD card, enable the lock tap to prevent data from being written.
2. If you have accidentally deleted files or formatted the card, do the following:
 - Try an image recovery tool. SanDisk and Lexar supply these with their pro-fessional-level memory cards, and many others are available at a relatively low cost (some are even free) on the web. Nearly all of these programs have a demo mode that will show you what they can recover. If one doesn't work, try another (see Image Recovery Software).

Some programs (despite being advertised as free) are only free for the demo version, or have limited functionality in free mode.

- Always recover to a drive or disk rather than the memory card you are recovering images from.

3. If you can verify that the data is corrupted on the memory card, try steps a and b, above. If not, do the following:
 - Verify that your card reader is compatible with your memory card. Older memory readers may not properly support newer, higher-capacity cards. The best case is that they just don't work. The worst case is that they seem to work, but deliver corrupted data. Try again with a newer card reader or copy directly from your camera.
 - Check your cable. If you have another compatible USB cable, swap it and try again.

4. If none of the above steps solve your problem, or the card is physically damaged, contact an image recovery expert (see Image Recovery Services).

Image Recovery Software

Image recovery software is available from a number of sources. Professional-grade memory cards from SanDisk and Lexar include recovery software, and there are numerous products available on the web. Most packages provide a demo version that will show you what can be recovered. If a particular product works for you, you can pay for a license or unlock code to actually restore your images. Since not all products produce the same results, you may need to try more than one. I have used SanDisk's RescuePro Deluxe, Lexar's Image Rescue 4 (lexar.com/products/lexar-image-rescue-4-software), and PhotoRescue (datarescue.com). All three programs recovered images, but there were differences between the products. To test these programs, I used a 512 MB SD card. I shot 15 RAW+JPEG images, and then reformatted the card. All three products recovered the files to the computer, not the original memory card.

RescuePro doesn't appear on SanDisk's website as a separate product. LC Technology supplies the software, and their PHOTORECOVERY software appears to be equivalent to RescuePro (lc-tech.com/pc/photorecovery).

I did not perform comprehensive testing while using these three products, nor did I test all available products. When selecting an image recovery product, you should perform research and testing. Since most of these products have a demo mode that will show you what they can recover before you buy the product, the research cost is primarily the time you will spend. The profiles below illustrate the results you might see from the various products.

SanDisk RescuePRO Deluxe

RescuePRO Deluxe recovered my Sony ARW RAW files with the correct extension. It recovered the full-sized JPG files and the smaller RAW thumbnails, also as JPG files. It did not maintain the original file names. RescuePRO Deluxe can create a sector-by-sector backup file to allow you to attempt data recovery at a later time. It also has a "wipe media" function that effectively makes data unrecoverable.

Lexar Image Rescue 4

Image Rescue 4 only restored eight of my 15 Sony RAW files, but it did restore them with the correct ARW extension. It also restored all the RAW thumbnails separately with an SRF extension, and restored all of the JPG files. Like RescuePro, Image Rescue can also create a sector-by-sector backup file ("Save as File" on the menu) and has an erase function that effectively makes data unrecoverable.

PhotoRescue

PhotoRescue comes in two versions: PhotoRescue 3 and PhotoRescue Expert. Both versions of PhotoRescue restored all 30 images (15 RAW and 15 JPG). One RAW and four JPG files were restored with their original file names, but the rest were restored with new file names. According to the developer, PhotoRescue will use the original file system information if it is still available, but use content-based recovery if not. Since the file names are not part of the content, new names must be assigned.

My versions of PhotoRescue initially did not include the specific signature information for my RAW files (Sony Alpha a77), so it used the Sony RAW extension, SRW. Within an hour of sending a new RAW file to the developer, I had a version of the software that properly recognized my files, and the RAW images recovered with that version had the correct extension. One advantage of working with a small software company is that it is often easy to talk directly to the developers and resolve problems quickly. By the time this text is published, this information will have been added to PhotoRescue.

If you select "Rebuild RAW pictures" in PhotoRescue 3's advanced mode, it will recover RAW files as full-sized TIFF files. During this process PhotoRescue renders the file internally and can sometimes save partial or corrupted files in a useable fashion. PhotoRescue 3 will recover the RAW thumbnails as JPEG files, but only if you prompt it to do so.

PhotoRescue 3 also has a sector-by-sector backup function ("Backup card" on the main screen), as well as an erase function (on the Tools menu). Unfortunately the erase function does not work with Windows Vista, 7, or 8.

A Note About Downloading Image Recovery Software

There are a couple of issues to be aware of when downloading image recovery software from the Internet. First, some software advertised as free really isn't. It may be demoware, which will show you what it can recover, but ask for payment before you can actually recover your images. Nearly all vendors of image recovery software use the demoware approach, but most are honest about it. Second, some one-stop download sites force you to install their own downloader. At least one high profile, formerly respected site now uses their downloader to install spyware and adware, which can be extremely difficult to remove. If the site requires you to install their downloader, use it to find the software you want, and go directly to the developer's website to download the product.

Image Recovery Services

If you have a card that is so damaged that you cannot read it, all may not be lost. There are services, such as Flashback Data (flashbackdata.com) and LC Technology International (datarecovery.lc-tech.com), that specialize in recovering data from flash memory cards. Even if the card is severely physically damaged, data recovery is often possible as long as the flash memory chip itself is intact. You should expect to pay in the hundreds of dollars for recovery from flash media.

There are numerous services advertising data recovery at a very low cost. Be careful—operating a data recovery lab is costly, and sometimes services that advertise low prices will only put in a minimum effort in order to maintain profitability, doing little more than you could do yourself with image recovery software.

Selecting the Right Memory Card

There are several things to consider when selecting memory cards:

- Is it the correct physical card for your camera? Most cameras will only accept a single type of card (CF, SD, Memory Stick, etc.), while some have dual slots for different types of media. Make sure the card fits the camera.
- Is it compatible with your camera? Some newer cards use file systems that older cameras may not support. Also, some older cameras may not be able to recognize newer, higher-capacity cards. Most newer cameras will work with older cards, but the performance and capacity of those cards might not be sufficient for your modes of shooting. For example, I have a 16 MB MultiMedia Card (the predecessor to SD) that I can use in my camera, but since I shoot RAW files that are about 24 MB each, that card doesn't do me much good.
- Does it have the required minimum sustained write speed? This is especially important for video and high frame rate burst mode shooting. Even with normal shooting, a low sustained write speed can cause delays.

- Is high read speed important to you? The read speed of the card, combined with the capabilities of your computer, card reader, and ingestion software, determine how quickly you can transfer data from your card to your computer. However, read speed has little to do with in-camera performance.

CompactFlash (CF)

The CompactFlash (CF) format was first specified in 1994, and first produced by SanDisk. The CompactFlash Association (compactflash.org) is responsible for maintaining the CF standards and specifications. It has been, and still remains, the preferred memory card format for photographers with professional-level cameras, although Secure Digital (SD) has made some inroads into this market. In addition, there are two more recent formats supported by the CompactFlash Association—XQD and Cfast.

CompactFlash (CF) memory cards

There are two types of CF cards—Type I and Type II. The primary difference is the thickness—Type I cards are 3.3mm thick, while Type II cards are 5mm thick. Type II was designed primarily to support Microdrives, which are 1" hard disks. Most cameras that use CompactFlash accept Type I cards, but some do not accept Type II. This should not be a major issue, since few, if any, Type II cards are currently being sold on the photographic market.

CF Capacities and Performance

CompactFlash cards are available with capacities of 4, 8, 16, 32, 64, 128, and 256 GB. Some vendors are still producing lower-capacity cards, but they have become somewhat rare. The current CF specification, CF 6, theoretically supports capacities up to 144 PB, so expect to see higher-capacity cards in the future.

PB = petabyte, or 1,000 gigabytes.

4-256 GB cards typically use the FAT32 file system. Although it might seem that a different file system, such as NTFS or exFAT, would make better use of disk space on higher-capacity cards, FAT32 is more suited to the internal architecture of the cards.

"X" Speed Ratings

CompactFlash vendors use an "x" rating to indicate read/write performance. This is based on the read speed of the original, first-generation audio CDs, which was 150 KB/sec. For example, 133x means that the read speed of the CF card is 133 times faster than the original 1x audio CD players, which means it has a read speed of approximately 20 MB/sec. The write speed is usually much lower than the read speed, often less than half, and is not indicated by the x speed rating. Also, there is no standardization of x specifications, so there can be considerable variation in performance between different cards

with the same x speed. The CF 6 specification supports transfer rates up to 167 MB/sec, with some vendors currently advertising rates up to 120 MB/sec. In December, 2012, Toshiba announced a new line of CF cards with read speeds of 160 MB/sec and write speeds of 150 MB/sec. These cards became available in spring, 2013.

One of the best resources for memory card performance information is Rob Galbraith's "CF/SD/XQD Performance Database" (robgalbraith.com). Unfortunately, due to a change in employment, Rob is no longer maintaining the site, so the last update was July, 18, 2012.

Read and Write Speed Ratings

Sometimes card speed in MB/sec is specified on the card or packaging. The fine print will tell you if this is the read speed or the write speed. Sometimes both read and write speeds are specified. A high write speed is important when shooting high-resolution video, and when shooting stills at a high frame rate, especially with a high-megapixel camera. High read speeds allow you to transfer files from your memory card to your computer faster, assuming your card reader and its connection are capable of higher speeds.

XQD memory card

XQD

XQD is an offshoot of the CF standard that was first announced in 2010 by SanDisk, Sony, and Nikon. While the CF card uses the ATA/IDE interface commonly used on PCs since 1986, XQD uses the PCI Express interface, the same high-speed interface used by PC expansion slots for high-speed video and other high-speed applications. It is expected to provide read and write speeds of up to 500 MB/sec. XQD is not backward compatible with CF.

AT Attachment (ATA), originally known as Integrated Drive Electronics (IDE), is also known as Parallel ATA (PATA).

At the time of this writing, Sony and Lexar are manufacturing XQD cards, and Nikon has one camera, the D4, that uses the format. Sony advertises up to 168 MB/sec and capacities up to 64 GB for the initial cards, while Lexar advertises a minimum guaranteed read transfer speed of 168 MB/sec, and 32 and 64 GB capacities. SanDisk, one of the original specifiers of XQD, has announced they will be supporting the competing CFast specification instead.

CFast

Cfast is another offshoot of the CF standard. The original CFast specification was first announced in 2008. CFast uses the Serial ATA (SATA) interface commonly used on PCs since 2003. The original CFast format is used in industrial applications, but has never been adopted by camera manufacturers.

CFast memory card

A new version, called CFast 2.0, was announced in late 2012. It uses the SATA 3 interface (announced in 2008) that is designed to provide a data transfer rate of up to 600 MB/sec. At the time of this writing, SanDisk is reportedly making small quantities of the card to provide to camera and other manufacturers, and it is rumored that Canon is planning to use the format in some of its professional-level cameras. As with XQD, CFast is not backward compatible with CF.

Secure Digital (SD)

The Secure Digital (SD) card format was jointly launched in 1999 by Matsushita (Panasonic), Toshiba, and SanDisk. It was based on the earlier MultiMedia Card (MMC) format, so MMC cards will usually work in devices designed for SD cards. SD card specifications are now maintained by an industry consortium called the *Secure Digital Association*. SD cards provide a higher maximum data transfer rate than MMCs, have a lock slider to prevent writing to the card, and have a built-in encryption function that was requested by music and media publishers to allow the use of *digital rights management* (DRM), a form of copy protection. To support DRM, each SD card has a portion (about 10%) of memory set aside for this purpose. This memory is not accessible to the user. SD and its variants are the most widely used flash memory cards on the market. There are currently three types of SD cards, each providing different maximum capacities. There are also three form factors (standard, mini, and micro), and five (sometimes overlapping) speed classes.

Secure Digital (SD) memory cards

SD Card Type

Each SD card type has a different minimum and maximum capacity, and uses a different file system.

SD Standard	Symbol	Capacities	File System(s)
SD	**S⊅**	Up to 2 GB	FAT 12, FAT 15
SDHC	**S⊅ HC**	4 to 32 GB	FAT 32
SDXC	**S⊅ XC**	64 GB to 2 TB	exFAT

MicroSD card

Comparison of SD and MicroSD cards

SD Card Form Factors

SD cards come in three form factors: full, miniSD, and MicroSD. Full-size cards are the most common form factor for digital cameras, while microSD cards are the most common form factor for smart phones. MiniSD cards have been used for smart phones in the past, but are currently used primarily for industrial applications. MicroSD and MiniSD cards can be used in devices that accept full-size SD cards using adapters.

Name	Dimensions	Weight
full	32 x 24 x 2.1mm	Approx. 2g
miniSD	20 x 21.5 x 1.4mm	Approx. 1g
microSD	11 x 15 x 1.0mm	Approx. 0.5g

SD Card Performance and Speed Classes

There are as many as four performance measurements that vendors specify on the card, packaging, or promotional material of a memory card. Of course, all performance and speed ratings assume that the devices using the cards, such as cameras and card readers, are capable of transferring data at that speed.

Read and Write Speed Ratings

Read and write speed ratings indicate the maximum performance levels for the card. Write speed is usually slower than read speed, sometimes significantly so. It is not uncommon to find the read speed displayed prominently on the packaging and the slower write speed written on the back of the package in the fine print. A high write speed is important when shooting stills at a high frame rate, especially with a high-megapixel camera. It is also important when shooting high-resolution video. High read speeds allow you to transfer files from your memory card to your computer faster, assuming your card reader and its connection are capable of higher speeds.

Speed Class	Symbol	Minimum Write Speed
2	Ⓔ	2 MB/sec
4	Ⓐ	4 MB/sec
6	Ⓖ	6 MB/sec
10	Ⓚ	10 MB/sec

Cards with a minimum write speed that is greater than 10 MB/sec are still considered to be Class 10.

Speed Class

The speed class is the minimum write speed, which can be critical when writing a steady data stream, such as video. Using a card without the required speed class can cause errors during video recording. The SD Association has defined four speed classes: 2, 4, 6, and 10. Each designation refers to the minimum write speed in megabytes per second.

UHS

In 2009, the SD Association defined another perfor-mance specification that only applies to SDHC and SDXC cards. Ultra High Speed (UHS) cards provide a higher data rate when used in devices that support UHS. UHS-I has a maximum data rate of 104 MB/sec. And UHS-II has a maximum data rate of 512 MB/sec. Actual data rates can vary widely. For example, I have UHS-I cards with the following read/write speeds:

- 27 MB/sec. read, 9 MB/sec. write
- 60 MB/sec. read, 35 MB/sec. write
- 50 MB/sec. read, 35 MB/sec. write
- 90 MB/sec. read, 50 MB/sec. write
- 95 MB/sec. read, 90 MB/sec. write

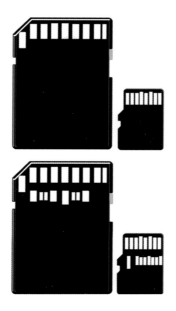

SDCard Pin Layout

The UHS designation is independent of the Class specification; for example, the first card in the above list is Class 6 while the rest are class 10.

At the time of this writing, UHS-II cards are beginning to appear on the market. In addition to higher maximum transfer rates, UHS-II cards have an additional row of connectors. They are backward compatible, but will perform at lower transfer rates when used with older devices.

UHS Class	Symbol	Maximum Data Rate
UHS-I	\mathbf{I}	104 MB/sec
UHS-II	\mathbf{II}	312 MB/sec

SD WiFi Cards

SD WiFi cards allow data to be transferred wirelessly from a camera to a computer or website. Eye-Fi was the SD WiFi pioneer, but other vendors have released SD WiFi cards as well. Although there are currently no CF WiFi cards, SD WiFi cards have been used successfully in some cameras using CF/SD adapters. In January, 2012, the SD Association announced a standard for SD WiFi cards (sdcard.org). Eye-Fi, itself a mem-ber of the SD Association, has contested the standard, intimating that it infringes on their intellectual property.

Eye-Fi 8 GB Pro X2
WiFi card

Eye-Fi

In 2007, Eye-Fi (www.eye.fi) released the first WiFi SD card. This 2 GB card (current cards have capacities from 4 GB to 16 GB) offered automatic uploads from a camera to a computer or online site. Since that time, the company has added various features to certain models of the card:

- Direct Mode: This allows direct transfer to a computer even if there is no WiFi router or hotspot.
- Endless Memory Mode: This mode automatically frees space on the card as images are uploaded so the user can continue to shoot without having to erase images or format the card.
- Geotagging: Eye-Fi's geotagging uses WiFi positioning to determine the camera's location and tag images with it. WiFi positioning utilizes a database of the locations of hundreds of millions of WiFi access points. Geotag-enabled Eye-Fi cards can use this information to write location information to an image's metadata.
- Support for multiple video formats and RAW data: The original card and some current cards only support JPEG files.
- Additional online and personal cloud features, sometimes available at additional cost.
- Support for mobile devices.

Eye-Fi cards automatically upload images as they are taken. They function in a manner similar to tethered shooting, allowing immediate transfer to applications, such as Lightroom. Eye-Fi cards do not connect to multiple devices simultaneously. Current cards are Class 6 or Class 10.

Transcend

Transcend (transcend-info.com) provides cards that allow you to view files and download them wirelessly from your camera to your computer, using a browser. Transcend also provides specific apps for Android and IOS devices. Transcend cards can connect to up to three devices simultaneously and automatically display photos immediately on Android and IOS devices, but they do not have an Eye-Fi-like auto upload feature. Transcend supplies a 16 GB and 32 GB card, both of which are class 10.

Toshiba and LZeal

Toshiba's FlashAir card (toshiba-components.com/FlashAir) and LZEAL's ez Share card (lzeal.com/en/products.asp) conform to the SD Association's standard for SD Wireless. Both have functionality similar to that of the Transcend cards. The current Toshiba product is an 8 GB class 6 card, while LZeal provides 4 GB, 8 GB, 16 GB, and 32 GB class 10 cards.

Memory Stick

Memory Stick is a flash memory format introduced by Sony in 1998. The original Memory Stick has since become a family of memory cards with limited backward compatibility. It has never been widely adopted outside of Sony products, and all current Sony cameras that accept Memory Stick variants also accept a second memory card format, such as SD. The only Memory Stick versions currently being produced are the Memory Stick PRO Duo and the Memory Stick PRO_HG Duo, with a maximum capacity of 32 GB.

Memory Stick PRO Duo

INTERFACES

In computing, *interface* refers to the protocols (rules of communication) and the hardware that connects components and allows interaction between them. There are many interfaces used in computers, but our discussion will concentrate on those that are used to connect cameras and storage devices to a computer. These include the computer's internal drive connectors and expansion slots, as well as the interfaces that connect to external devices such as networks, cameras, card readers, and storage devices. If this topic makes your eyes glaze over, skip ahead and use this chapter as a reference when necessary.

PCI and PCIe

PCI stands for *Peripheral Component Interconnect*. PCI is a connection for attaching various types of expansion cards to a computer's motherboard (also called a mainboard). PCIe, or *PCI Express*, is a higher-speed version of PCI. These expansion card slots, collectively known as the *expansion bus*, are used to add various types of devices to a computer, including video cards, networking cards, and others. The use of PCI for personal computers began in the early nineties, replacing earlier generation expansion buses. PCIe slots were added alongside PCI slots starting in 2003. Many current computers have eliminated the older PCI slots and only have those for PCIe since many of the devices that used the original PCI are either included on the motherboard, available for PCIe, or obsolete.

Bytes, Gigabytes, Terabytes
Data transfer rates and data storage space are measured in bits or bytes. A byte is composed of eight binary digits, or bits, either 0 or 1. A bit is the basic unit of computer calculation, and all values used and stored by digital computers are multiples of the bit. A byte is eight bits, and each of the 256 standard text characters is a byte in size. As you move beyond bytes to kilobytes, megabytes, gigabytes, and terabytes, the multiplier is 1024, not 1,000, so a kilobyte is 1024 bytes, a megabyte is 1024 kilobytes (1,048,576 bytes), etc. This is because computer architecture is designed for multiples of 2^{10}, or 1024.

You will see data transfer rates specified as Mb/sec and GB/sec, or MB/sec and GB/sec. The M is mega, and the G is giga. The lowercase b stands for bits, and the uppercase B stands for bytes.

A PCIe card can have one, two, four, eight, or 16 sets of connections, called *lanes*. Each lane has two pairs of connections: transmit and receive. Lanes can be used individually or in parallel to provide greater throughput. There have been three generations of PCIe. The major difference between each generation is the maximum transfer rate. Generation 1 supports up to 250 MB/sec per lane, generation 2 supports up to 500 MB/sec per lane, and generation 3 supports up to 1 GB/sec per lane. All versions are *backward compatible*—i.e., newer slots support older cards. Nearly all current desktop computers have generation 2 slots, and some have generation 3 as well. Generation 3 cards will work in generation 2 slots, but only at the lower data transfer rate.

The specification allows 32 lanes, but no current personal computer supports more than 16.

PCIe motherboard configurations vary, but it is common to see one or two 16-lane slots (16x) and two or more 1x slots. A 16x slot can accept 1x, 2x, 4x, 8x, or 16x cards.

There are some motherboards that include a second PCIe 3.0 16x slot that only runs at 4x speed.

Laptop Mini PCIe

Many laptops have an internal PCIe Mini Card slot. This slot provides a single PCIe lane and a USB connection. It is used for the laptop's wireless networking adapter, and there are few, if any, aftermarket Mini PCIe cards for other purposes.

ExpressCard

ExpressCard is a specification for an external connection for laptops that has a single PCIe (generation 1) lane and a single USB 2.0 connection. ExpressCard 2.0 was introduced in 2009, with support for PCIe generation 2 and USB 3.0. It is backward compatible with the original ExpressCard specification. At this time there are few ExpressCard 2.0 adapters on the market. ExpressCard adapters that add network, wireless network, USB 3.0, eSATA, and FireWire ports are available.

Bandwidth
In computing, bandwidth refers to the maximum data transfer rate in a communications channel, or the greatest amount of data that can be transferred in a given amount of time. This is a theoretical maximum that is rarely achieved, because the devices at both ends of the system must be able to send or receive data at that rate, which is seldom the case, especially over sustained periods of time. Also, every digital transmission includes a certain amount of overhead, or data required for reliability, error detection and correction, and other communications functions. In addition, some communications channels are designed for simultaneous communications between multiple devices or functions. Those devices must share the bandwidth, which reduces the bandwidth available for each communication.

SATA

SATA (*Serial ATA*) is currently the most common connection for hard disks and other storage devices. Multiple SATA ports are included in virtually every laptop and desktop computer.

SATA Versions

SATA is an update of an older technology, called ATA (*Advanced Technology Attachment*), originally called IDE (*Integrated Drive Electronics*). ATA/IDE had multiple parallel data paths, requiring a wide, cumbersome ribbon cable. SATA is serial and uses just two data pairs (transmit and receive), thus requiring a more manageable cable. There are other differences as well. ATA/IDE paired drives are in a master/slave relationship: if the primary drive fails, the secondary drive becomes inaccessible. SATA improved overall reliability by eliminating the master/slave approach. There have been three major versions of SATA:

- SATA 1.5 Gbit/s (SATA 1): Provides a maximum data transfer rate of 1.5 Gb/sec (this is the raw transfer rate); due to the encoding used for transmission reliability and error detection and correction, the actual maximum transfer rate is 1.2 Gb/sec, or 150 MB/sec
- SATA 3 Gbit/s (SATA 2): Provides a maximum data transfer rate of 3.0 Gb/sec (raw) or 300 MB/sec
- SATA 6 Gbit/s (SATA 3): Provides a maximum data transfer rate of 6.0 Gb/sec (raw) or 600 MB/sec

SATA 2 and 3 also have some additional performance and control features. SATA 2 has a hot-plug capability (the ability to plug and unplug devices while the system is powered up) and eSATA (external SATA). Most current desktop computers include ports for SATA 2 and 3.

Few SATA hard disks can provide sustained throughput beyond 300 MB/sec, the exception being those few disks that spin at 10,000 RPM or higher; however, many solid-state drives (SSDs) can take advantage of the SATA 6 Gbits/s data rate.

eSATA and eSATAp

eSATA, or external SATA, is designed for external connectivity, and features connectors that are physically more robust. eSATAp is an eSATA port combined with a USB 2.0 port. The USB port can provide power to an eSATA device. This port can be used as either eSATA or USB, and is commonly used in laptop computers.

Mini-SATA (mSATA)

Mini-SATA (mSATA), which has the same form factor and connection as the PCIe Mini card, is used exclusively for solid-state drives (SSDs). Originally designed for netbooks and laptops, it has been incorporated into desktop computer motherboards as well.

M.2

M.2 is an internal interface that combines SATA and PCIe. It is primarily for laptop and other portable computers. M.2 accommodates either two SATA 3 Gbit/s or 6 Gbit/s ports, or four PCIe lanes. M.2 was designed to support solid-state drives (SSDs) in small computers, but it can be used for WiFi and other technologies as well.

SAS

SAS refers to *Serial-attached SCSI*; SCSI stands for *Small Computer Systems Interface*. SAS is an interface employed by most high-end network servers. It is also used to attach high-performance disks and other devices to desktop computers. SAS host adapter cards are available for the PCIe bus, for use in desktop computers.

In some circumstances, SAS hard disks can provide greater reliability and better performance than SATA disks, but at a big increase in cost. Most SAS hard disks are designed for use in multi-disk servers and disk array environments, and can have decreased performance in a single-disk environment. Some storage devices, such as high-capacity tape drives and higher-end disk arrays, are only available with SAS interfaces. SAS has some similarities to SATA, and SATA devices can connect to SAS ports; however, SAS devices cannot connect to SATA ports.

Unlike SATA, SAS can support multiple devices per port though the use of external expanders, which act as SAS hubs. Expanders, which can be connected in a hierarchical fashion, allow a single SAS port to connect to multiple devices at once.

SAS Versions

There are three versions of SAS, two of which are in common use and one that is just emerging:

- 3 Gb/s SAS: Provides a maximum data transfer rate of 3 Gb/sec (raw) or 300 MB/sec
- 6 Gb/s SAS: Provides a maximum data transfer rate of 6.0 Gb/sec (raw) or 600 MB/sec
- 12 Gb/s SAS: Provides a maximum data transfer rate of 12 Gb/sec (raw) or 1.2 GB/sec

There are a large number of SAS devices that can take advantage of 6 GB/s SAS, including tape drives, high-performance hard disks, and SSDs. Although 12 Gb/s SAS is too new to be in widespread use, there are already SSDs available that can take advantage of its increased bandwidth.

SAS Host Adapters (HBAs)

Some higher-end servers have built-in SAS ports, but most systems require a SAS *host bus adapter* (HBA) to use SAS devices. The HBA typically uses a 4x, 8x, or 16x PCIe expansion slot, although there is at least one company producing a SAS adapter for the Thunderbolt interface. SAS HBAs include multiple ports, which can be internal, external, or a combination of both. For external connections, SAS HBAs combine four ports into a single cable connector. Internal connections can either use single-device connectors or four-port connectors, depending on the HBA.

Another type of SAS HBA is the SAS RAID controller (RAID will be discussed later in this chapter). A SAS RAID controller contains, in the card's firmware, the code necessary to implement RAID without requiring or relying on software running on the host computer's CPU. This hardware-based RAID usually provides better performance than software-based RAID. One or more ports on a SAS RAID controller can also be used to function as a standard SAS HBA.

Major vendors of SAS HBAs include Adaptec (adaptec.com), ATTO (attotech.com), and LSI (lsi.com). System vendors such as Dell, HP, and IBM typically sell versions of products from one or more of these vendors, renamed with their own designations. Such products are known in the industry as *original equipment manufacturer* (OEM) products.

SAS HBA Drivers

Drivers for HBAs from several vendors are included with current versions of Linux, Mac OS, Windows, and other operating systems. If the drivers are not included, you may be able to download them from the vendor's website. Drivers for OEM products are usually available from the system vendor, but in many cases the OEM-supplied drivers will work as well.

USB

Universal Serial Bus (USB) was designed to connect peripherals of all types to computers and other devices. USB is used to connect keyboards, mice, cameras, network connection devices, memory card readers, external hard disks, CD/DVD/Blu-Ray players, and more. USB can also supply power to attached devices.

USB uses a shared bus approach in a star topology. A star topology, also called a "hub-and-spoke" topology, is one in which multiple devices connect to a central unit. In the case of USB, that central unit is a USB controller in a computer. A host computer may have one or more USB controllers, and each controller may connect to multiple ports. In addition, up to four levels of hubs can be employed, which can vastly increase the number of devices that can be connected to each controller. All devices connected to a controller share the bandwidth of that controller.

There are three major versions of USB:

- USB 1.1: specified transfer rate of up to 12 Mb/sec. The USB 1.1 specification was released in 1998.
- USB 2.0: specified raw data transfer rate of 480 Mb/sec, with an effective maximum rate of 280 Mb/sec (35 MB/sec). This specification was released in 2000. Since that time there have been additions to the spec, including a battery charging specification and mini and micro connectors.
- USB 3.0: specified raw data transfer rate of 5 Gb/sec, with an effective maximum rate of 3.2 Gb/sec (400 MB/sec). USB 3.0 requires cables that are different from the cables for 1.1 and 2.0. Earlier cables have one pair for power and one for data. USB 1.1 and 2.0 operate in *half duplex* mode, meaning data can be transmitted in only one direction at a time. USB 3.0 cables have an additional data pair, allowing *full duplex* mode, meaning data can be transmitted in both directions simultaneously. The new cables have new connectors on the peripheral end, and USB 3.0 peripherals can only use USB 3.0 cables. The host end of the cable is compatible with USB 1.1 and 2.0 ports, allowing USB 3.0 devices to connect to USB 1.1 and 2.0 hosts, although those devices will operate at the lower 1.1 or 2.0 speeds. In addition, USB 3.0 host ports can accept USB 1.1 and 2.0 cables.

USB Power

A USB peripheral can be either self-powered (from its own power supply), or bus-powered (from the USB port). A USB 2.0 host port provides five volts at up to 500 mA of current, while a 3.0 host port provides up to 900 mA of current. USB power requirements are specified in *unit loads*. USB 2.0 provides five 100 mA unit loads, and USB 3.0 provides six 150 mA units. A bus-powered USB hub will only provide one unit load per port, while a self-powered hub can provide the maximum number of unit loads to any attached device.

USB Performance and Limitations

USB is a shared bus, which means bandwidth is shared by all devices connected to a particular controller. In other words, if you have a mouse, keyboard, external hard disk, and a card reader all connected to the same USB controller, they will affect each other's performance. Also, in addition to the external USB devices, there may be internal devices using USB ports. Some computers come with more than one USB controller, so judicious load-balancing between controllers can help alleviate performance issues. Unfortunately, it is not always easy to determine which USB ports share a controller.

IEEE 1394 (FireWire)

The IEEE 1394 High Speed Serial Bus is an interface that was developed by the Institute of Electrical and Electronics Engineers (IEEE) 1394 Working Group. The work on IEEE 1394 was initiated by Apple; they coined the name *FireWire*. It is used for connecting data storage devices, such as external hard disks and memory card readers, and other devices, such as digital video (DV) cameras, to computers.

There are two common versions: IEEE 1394a, which has a data transfer rate of 400 Mb/sec, and IEEE 1394b, which has a transfer rate of 800 Mb/sec. 1394b is backward compatible with 1394a. There are also 1600 Mb/sec and 3200 Mb/sec versions, but they have not been widely implemented.

Some Windows computers have 1394 ports, and add-in cards are available for computers with a PCI or PCIe expansion bus. Drivers are available for all major operating systems, including Mac OS, Windows, Linux, and FreeBSD.

Since 2000, most Macs have included IEEE 1394 ports: earlier systems provided 400 Mb/sec 1394a support, and later systems provided 800 Mb/sec 1394b support. In the last few years, Apple has dropped support for 1394 on some models, supporting USB 3.0 and Thunderbolt instead. With the success of USB 3.0 and Thunderbolt, support for IEEE 1394 in the personal computer market has dwindled, though it is still widely used for automotive and industrial applications.

Although IEEE 1394a has a slightly lower raw data transmission rate than USB 2.0, it tends to perform better in real-world applications. 1394b performs better still, but cannot compete with USB 3.0.

Thunderbolt

Thunderbolt is a high-speed interface that connects external devices to computers. With a raw data transfer rate of 10 Gb/sec, it is significantly faster than USB 3.0. Thunderbolt is a successor to Mini DisplayPort, a video connection widely used on Apple Macintosh computers. In addition to video support, Thunderbolt effectively extends the PCIe bus to external devices, and can be used for external hard disks and storage systems, memory card readers, and other data devices. Up to six devices can share a Thunderbolt connection, either as a daisy chain or using a hub. In addition to Thunderbolt devices, the interface also supports legacy DisplayPort monitors.

Thunderbolt was introduced on the MacBook Pro in 2011, and is included on most current Macintosh computers. Currently it is also included on a small number of Windows desktops and laptops, as well.

Thunderbolt 2

Thunderbolt 2 was announced in 2013, and should be in widespread adoption by 2014. Thunderbolt 2 doubles the speed of the original by multiplexing two standard Thunderbolt channels. Six Thunderbolt 2 ports are included on the cylindrical Mac Pro announced in 2013. The new Mac Pro should be shipping by the time this book is published.

Currently there are more than 80 Thunderbolt-enabled peripherals available, and that number is increasing rapidly. Devices include disks and storage systems, SAS adapters, external PCIe adapters, and high-end graphics devices. Although cables are fairly expensive ($30-60 each), more vendors are entering the market and prices are dropping. Since faster is always better in computing, I expect to see Thunderbolt eventually become as universal as USB is today.

Ethernet

All current local area network (LAN) connections, as well as most of the Internet, are based on Ethernet, which was first introduced in 1980. The original Ethernet had a data transfer rate of 10 Mb/sec, but most current connections operate at either 100 Mb/sec or 1 Gb/sec. A 10 Gb/sec version is also available. All versions are backward and forward compatible, but only communicate with each other at the speed of the slowest device. Technically, Ethernet only refers to a 10 Mb/sec version that existed prior to the 802.3 standard created in 1985, but the name stuck even though it is not an accurate name for current products. Current Ethernet operates primarily over twisted-pair copper cable and fiber optic cable, but can operate over other media as well. Ethernet is currently used to connect almost any type of data or communications device, including computers, printers, storage devices, and many more, to a computer.

Ethernet Performance

Because Ethernet is a shared technology, it has a significant amount of overhead. In addition to raw data, Ethernet must carry routing information and error correction and detection information. It must also handle multiple concurrent data streams. There are many factors that can affect Ethernet performance, so the actual throughput will be significantly less than the raw data rate.

WiFi

WiFi, technically 802.11, is a family of radio-based, wireless networking standards closely related to Ethernet. Like Ethernet, WiFi is currently used to connect almost any type of data or communications device to an Ethernet network and the Internet. Because WiFi uses radio broadcasting technology, and is generally less secure than Ethernet, it uses various data encryption schemes to protect data. One of the earliest encryption methods, WEP, is still commonly used, but is easy to break. A more recent encryption protocol, WPA2, is much more secure.

There are a number of different versions of 802.11 WiFi, with different raw data transfer rates. The two most common versions are 802.11g, with a maximum transfer rate of 54 Mb/sec, and 802.11n, with a maximum raw transfer rate of between 54 Mb/sec and 600 Mb/sec, depending on the specific hardware configurations used. These are aggregate rates: the total rate for all devices concurrently communicating with a particular wireless router or access point. There is a lot of overhead involved in a wireless network, so actual aggregate data rates are usually less than half of the raw rate. In 2013, 802.11ac devices began shipping. 802.11ac has a theoretical maximum throughput of 1.3 Gb/sec, using three data streams (typical access points can support up to eight data streams). Client devices support a single data stream at a theoretical maximum throughput of 433 Mb/sec. Actual throughput will be much lower.

STORAGE TECHNOLOGIES

Chapter **3**

In this chapter I'll talk about the technologies commonly used for data storage with desktop and laptop computers. This should give you a basic understanding of these technologies and help you make informed purchase decisions. If this chapter seems too technical, I suggest giving it at least a quick scan to become familiar with the terminology. You can always come back and use it as a reference.

Virtually all data storage for computers (and cameras as well) uses one of five technologies:

- flash memory
- magnetic hard disk
- solid-state disk (SSD)
- optical disc
- magnetic tape

A sixth technology, the magnetic floppy disk, is still available, but is no longer shipped with modern computers. Also, its capacity is so limited that it is virtually useless for storing today's photographic images.

Flash Memory

Flash memory is solid-state electronic memory that contains no moving parts. It is the basis of USB flash drives, camera memory cards, and solid-state drives (SSDs). For a detailed description of flash memory for image capture, see chapter 1.

The terms hard disk drive, hard disk, disk, *and* drive *are used almost interchangeably.*

Hard Disk Drives

A *hard disk drive* is an electromechanical device with one or more spinning magnetic platters, a servo-controlled read/write head, and electronic controller circuitry. Each disk is divided into multiple concentric *tracks*, which are in turn divided into equally sized *sectors*. Each track has the same number of sectors, so the tracks near the center of the disk are more densely packed than the tracks near the outer edge of the disk.

Data is written to the disk in equally-sized *blocks*. Block size depends on the specific disk format being used, but blocks are typically a multiple of 512 bytes in size. If a file size is less than or equal to a block, that file will be stored in its own block. If a file is larger than a single block, it will be written to multiple blocks.

A servomechanism, or servo, is an electronic device used for mechanical control. In a hard disk, the servo positions the read/write head.

Initially, files are written to the disk in sequential fashion, so all blocks that make up a file are contiguous. As the size of a file grows, like when you edit a word processing file, for example, there may not be enough contiguous disk space available to hold the new data, so it will have to be written to some other location on disk. This issue also occurs when you delete files from disk: the blocks used by those files are thrown back into the available block pool, but new files written to that space may be too large to be written contiguously. This causes what is known as *disk fragmentation*, where blocks of a file are written to non-contiguous locations. Each hard disk maintains a table that allows it to find all of the blocks that make up a file.

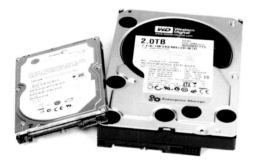

2.5" and 3.5" SATA hard disks

A hard disk is a *random-access device*. This means that when you request a file, the hard disk can retrieve it without reading each block of data in disk order. The disk's controller tells the servo where to position the read/write head in order to locate the blocks of data you've requested. When writing to the disk, the controller tells the servo where to position the read/write head to write the data to empty blocks. It will often take a number of revolutions and some repositioning of the read/write head to read or write an entire file. The rotation speed of the disk can affect performance. Hard disks sold for personal computers typically have a rotation speed of 5,400 or 7,200 RPM. 10,000 RPM disks are available, with a hefty increase in cost. 15,000 RPM disks are also available, but are mostly used in specialized high-performance systems.

Hard disks currently come in two form factors: 2.5" and 3.5". This measurement refers to the platter size, not the outside dimension of the disk drive. Most desktop computers use 3.5" disks, but can also accept 2.5" disks. Laptops use 2.5" disks.

Volatile and Non-volatile Memory
Computers use two types of memory—volatile and non-volatile. Your computer's working memory, known as random access memory (RAM), is volatile memory, meaning it only retains data while power is supplied. Hard disks, memory cards and magnetic tape are non-volatile, meaning they retain data even when power is unavailable.

Hard Disk Interfaces

There are two primary hard disk interfaces that concern us here—SATA and SAS. SATA is used by nearly all desktop, laptop, and other personal computers. As a hard disk interface, SAS is used for high-end servers and some high-performance workstations. It is used for tape drives and other specialized peripherals on desktop computers. SATA and SAS are the native interfaces of hard disks and are built into the drives themselves. Hard disks, especially external disks, can also be connected using other interfaces, such as USB, IEEE 1394, or Thunderbolt. In these cases the hard disk will be enclosed in a case that includes circuitry to convert the disk's native interface (usually SATA) to the connecting interface (for example, USB).

A third interface, Fibre Channel, is somewhat specialized and isn't pertinent to this discussion.

Classes of Hard Disks

There are two recognized classes of hard disk—*desktop* (sometimes called *consumer grade*) and *enterprise*. One of the primary differences between the two is the way the disks respond to error conditions. When disk errors occur, desktop disks will make many recovery attempts before timing out. Enterprise disks, on the other hand, will time out quickly, since they are designed to be used in multi-disk storage arrays, which do not tolerate unresponsive disks well. Some enterprise disks also have a greater degree of error detection and correction than desktop disks.

Enterprise disks sometimes have a faster rotational speed; 10,000 and 15,000 RPM enterprise disks are not uncommon. Enterprise disks provide more effective compensation for rotational vibration than desktop disks. They are claimed to be manufactured to higher standards and have higher reliability, but the few real-world studies available haven't shown a significant difference in failure rates between desktop and enterprise disks.

In addition to these recognized classes, one hard disk vendor, Western Digital (WD), provides multiple series of internal desktop hard disks, each promoting different levels of performance, reliability, and efficiency. WD also offers enterprise-class disks and, since their acquisition of Hitachi's disk business, HGST brand disks. Seagate, on the other hand, has a single series of internal desktop hard disks. Toshiba, currently the only other hard disk manufacturer, only lists four internal hard disks on their website. There have been about 200 hard disk manufacturers, but bankruptcy, consolidation, and acquisition has shrunk the field dramatically.

Hard Disk Performance Factors

There are many factors that affect the performance of a hard disk. The disk's rotational speed and the maximum transfer rate of the interface (SATA 3 Gbit/s vs. SATA 6 Gbit/s, for example) are both factors, but only disks with a high rotation speed (10,000-15,000 RPM) can exceed the limits of SATA 3 Gbit/s. Also, virtually all hard disks include memory to buffer and cache certain types of disk writes. The effect of this on performance varies with the type of data being accessed.

Another factor that can affect disk performance is file fragmentation. Some file systems and operating systems are affected by fragmentation more than others. Running periodic or background defragmentation can help Windows performance, especially on disks using the older FAT file system. Windows computers using the NTFS file system (NTFS is the predominant file system for Windows) and Macs are less susceptible, but fragmentation can take its toll over time as data is deleted and written, and the disks fill up.

High-end SAS and SATA host adapters sometimes include RAM for buffering; data in held in this memory until it can be written to the disk. This can greatly improve disk performance in some circumstances. There is also the possibility of this cached data being lost in the event of a power outage, so many high-end host adapters include battery backup for the buffer memory.

Other factors can affect disk performance, including the performance of the computer's other components. A slow CPU or too little RAM, for example, will slow nearly all operations. Likewise, a slow memory card reader can prevent data from being written to disk at maximum speed.

Disk Formatting

Disk formatting is preparing a hard disk for a specific file system, such as Apple's HFS or Microsoft's NTFS. Most external hard disks are pre-formatted with the Windows NTFS format. Both Mac and current Linux versions can read and write to an NTFS-formatted disk, but reformatting to a format that is native to the operating system is a good idea. For example, NTFS cannot properly track all of the metadata that Mac OS X associates with files. Reformatting can be done with utilities supplied by the computer's operating system. One word of caution—reformatting will delete all the existing data on the disk.

Hard Disk Life

Like other electrical and mechanical devices, hard disks will eventually fail. Most manufacturers claim a life of about five years for a hard disk, but this is only an estimate. I have one network server that has been running continuously for more than ten years with the same hard disk. I have also seen disks fail within a year or two. Disk vendors tend to keep actual failure rate information confidential, if they track it at all.

Shelf Life of Inactive Hard Disks

The figures quoted for hard disk longevity typically refer to the life of a hard disk in an active system that is powered on continually or on a regular basis. I have seen no published figures, from hard disk manufacturers or independent sources, for the life of data stored on hard disks that are not powered on regularly. I have also seen no evidence that there is a greater chance of data loss for non-powered vs. powered hard disks under normal storage conditions. However, several factors can affect the shelf life of such disks, including:

- lubricant evaporation
- lubricant polymerization
- decay of the recorded data (signal fade)
- corrosion or degradation of the electronic components

Any of these factors could affect stored disks, but there seems to be no way to predict if or when. Temperature, humidity, storage conditions, and manufacturing defects in particular batches of disks could all be factors.

One blog post claimed that signals on an unused disk can fade to the point of being unreadable in a year or two. This report was anecdotal, at best. Without sources, I question the validity of these claims, especially if a disk has been stored in normal temperature and humidity conditions. In my personal experience, this has never been a major issue. After an exhaustive Internet search, I found no actual evidence that disks that are powered on regularly retain data better than those that aren't, or vice versa; however, the general consensus of opinion seems to be that powered-on disks retain data better than disks that sit on the shelf.

Solid-State Disks (SSDs)

Solid-state disks (SSDs) use flash memory technology, but are usually supplied in a 2.5" form factor with a SATA disk interface. In desktop and laptop computers they are sometimes used to replace slower hard disks. They can also be used in conjunction with hard disks as high-speed cache, using special software algorithms that allow the most-used data to be retrieved from an SSD instead of a hard disk. Like other flash memory devices, SSDs have a limited number of program/erase (write/erase) cycles, and depending on usage, can have a limited lifespan. SSDs can be significantly faster than spinning hard disks when reading data. When writing data, especially if existing data is being erased or overwritten, an SSD may not provide a great increase in performance compared to a hard disk, and in some cases my even be slower.

2.5" SATA SSD

SSDs are also supplied as PCIe expansion cards. At the time of this writing, SSDs with 12 Gb/sec SAS interfaces were beginning to hit the market.

The cost of SSDs is significantly higher than the cost of the equivalent hard disk storage space, especially for SSDs greater than 500 GB capacity, which can cost over ten times as much. Because SSDs have no moving parts, they are almost impervious to damage from shock, which makes them ideal for environments where equipment is prone to damage from dropping.

Solid-State Hybrid Disks

A *solid-state hybrid disk* (SSHD) combines a hard disk and an SSD in a single disk package. An SSHD moves frequently used data to the SSD portion of the disk for faster access. SSHDs should excel in environments where the same data must be accessed multiple times, but offer little benefit with newly accessed data. For example, an SSHD should significantly decrease the amount of time it takes to open a program like Photoshop, but will probably be of little or no help in opening images for editing.

Disk Arrays and RAID

A *disk array* is a collection of disks that function as a cohesive system. In an array, multiple disks can be used to:

- appear as a single, larger disk;
- provide disk redundancy and fail-over; and
- provide improved performance.

LenovoEMC px4-300d 4-disk external RAID array (front cover removed)

A disk array can be as small as two disks or as large as hundreds of disks. Disk arrays can be internal to a computer or reside in one or more external enclosures. Modern disk arrays can include hard disks and SSDs in various configurations to improve performance.

The most common approach to disk arrays goes by the acronym RAID, which originally stood for *redundant array of inexpensive disks* and soon morphed into *redundant array of independent disks*. With RAID, data can be distributed across disks in a number of distinctive ways to accomplish specific goals. The different methods of data distribution are defined as *RAID levels*. Different levels provide different degrees of redundancy, capacity, and performance.

Multiple disks can also be configured as JBOD, or *Just a Bunch Of Disks*. In other words, each disk can function independently.

Hardware-, Software-, and Firmware-based RAID

There are three primary ways to implement RAID: hardware-based, software-based, and firmware-based.

Hardware-based RAID

Hardware-based RAID uses a dedicated RAID controller that has its own CPU to handle RAID processing. This generally provides the best performance because a dedicated CPU takes the load off the host computer's CPU. Dedicating RAID controllers can also provide write caching, which makes write operations, from the host computer's point-of-view, faster. In a power outage the data in the write cache can be lost, so many RAID controllers offer optional battery backup for their cache memory. Hardware-based RAID is also transparent to the computer's operating system; no special RAID software is required; however, a driver for the RAID controller may need to be installed.

Software-based RAID

Software-based RAID uses the host computer's CPU for RAID processing. It's usually a function included as part of the operating system. Versions of OS X, Windows, Linux, and FreeBSD include RAID support. Software-based RAID can have some effect on computer performance, but is negligible in most cases. RAID 0 and 1 typically have the least impact, while higher RAID levels have greater impact.

Firmware-based RAID

Firmware-based RAID, also sometimes called *fake RAID*, is software-based RAID implemented through the computer's motherboard or an add-in expansion card. The RAID configuration is stored in non-volatile RAM on the motherboard or add-in card so the system can boot from the RAID volume. Firmware-based RAID is usually easy to set up if you have the correct driver software for your operating system. Since it is effectively software-based RAID, it has similar performance characteristics.

RAID Levels

Not all RAID levels are used or applicable to systems commonly used by photographers. The following outlines the RAID levels you might encounter when buying data storage systems.

RAID 0

RAID 0 has the highest performance and least protection of all RAID levels. It requires a minimum of two devices and writes the data in a synchronized manner across all the disks, making them appear as a single physical unit. The process of writing data across multiple disks is referred to as disk- or drive-spanning, and the method of writing that data is called data striping.

 Data striping writes all data sequentially across all disks, a block at a time, using a method called block interleaving. Block size is determined by the operating system, but it usually ranges from 2 KB to 64 KB. Depending on the design of the disk controllers or dedicated RAID controllers, these sequential writes can overlap, which can

improve performance. When used by itself, RAID 0 can provide increased performance and large single-volume sizes, but it does not provide fault tolerance. If a disk fails, the entire subsystem fails, which generally results in a complete loss of data.

RAID 1

RAID 1, also known as disk mirroring, requires matched pairs of disks that are mirror images of each other. With RAID 1, data is written to two identical (or nearly identical) pairs of disks. If one disk fails, the system can continue to operate off the mirrored disk. Unless two disk controllers, or a dedicated RAID controller, are used, this configuration can impose a performance penalty when compared to a single-disk configuration, since the data must be written to each disk sequentially.

RAID 5

RAID 5 requires a minimum of three matched disks. RAID 5, like RAID 0, provides data striping across all disks. Unlike RAID 0, RAID 5 writes parity data across the disks, as well. Parity is a method used for error detection and correction. If a single disk fails, the data on that disk can be recovered using the parity data on the remaining disks. This technique allows independent disk reads and writes, and allows a dedicated RAID controller to perform multiple concurrent I/O (input/output) operations. The performance of RAID 5 can sometimes match or exceed that of single disk systems when a dedicated RAID controller is used. RAID 5 also provides the highest level of data integrity of all standard RAID implementations, since both data and parity information is striped. Keep in mind, however, that rebuilding a RAID 5 disk array exacts a severe performance penalty on the system and can take many hours to complete.

RAID 6

RAID 6 is similar to RAID 5, but it doubles the amount of parity data written across the disks. This allows RAID 6 to recover from the failure of two disks instead of just one. Due to the double parity approach, RAID 6 disk writes are slower than those performed by RAID 5.

RAID 10

RAID 10 is, effectively, a combination of RAID levels 0 and 1. Like RAID 0, data is striped across a multiple disk array, and those primary disks are mirrored to an identical set of secondary disks. Performance of a RAID 10 array can vary greatly, depending on its implementation.

Hot Swap, Hot Spare, and Automatic Rebuild

Hot-swap, hot-spare, and automatic rebuild are functions that can simplify the recovery process if a disk fails in a RAID array.

Hot swap is a function that allows you to remove a failed disk from a disk subsystem without having to power the system down. Some RAID systems support this and some do not. In systems that support hot-swap, the hard disk carriers are designed for quick and easy disk access and toolless disk replacement.

With *hot spare* capability, spare disks are preinstalled in the disk subsystem and lie dormant until needed. A system with hot spare capability may or may not employ automatic rebuild. If it does, the system automatically swaps the failed disk with the spare disk and the rebuild begins immediately. If not, the rebuild will have to be initiated manually. In either case, at some point after a hot spare disk takes over for a failed disk, you will need to replace the failed disk with a new hot spare.

Automatic rebuild refers to the ability of the system to rebuild the array automatically once a failed disk is replaced.

RAID Issues

While RAID can solve some capacity and reliability problems, it also creates some problems of its own.

Rebuild Time: A failed RAID array can take hours, even days, to rebuild. Performance is impacted during this process.

Multiple Disk Failures: Most RAID systems are designed to protect against the failure of a single disk. Unfortunately, evidence suggests that multiple disk failures in a RAID array within 1-10 hours is 2-4 times more likely than standard statistical distribution would indicate.

Disk Errors During Rebuild: An *unrecoverable read error* (URE) on a single disk means that a file could not be recovered. This same error on a disk in a recovering RAID array, however, could prevent completion of the rebuild. As the capacity of disks and the size of RAID arrays increase, so does the potential for this error to occur.

Write Cache Issues: To improve performance, many dedicated RAID controllers cache disk writes in memory on the controller. The controller will then report to the host system that the data has been written to the disk, even if it is still waiting in cache memory. A system crash or power failure can prompt the cached data to be deleted before it is written, causing data corruption. If you use a caching RAID controller, make sure it employs battery backup for the cache memory.

Desktop Disk Recovery Algorithms: Desktop-class SATA disks are designed to make Herculean efforts to recover from a disk error, and will often retry disk reads and writes multiple times before reporting the error to the host system. Even if the disk recovers, the process may take too long for the RAID controller, which will report the disk as failed. This is one of the reasons that enterprise-class disks are recommended for RAID arrays.

Operator Error: It seems obvious, but when removing a failed disk, it is very important to make sure you are removing the correct one. When one disk has failed, removing the wrong one will likely kill the entire array.

Standard and Non-Standard RAID

In addition to the RAID levels standardized by *Storage Network Industry Association* (SNIA), there are a number of non-standard RAID implementations. Some of these are proprietary, like Drobo's *BeyondRAID* (see chapter 5), and some are part of open source projects such as the Linux operating system and the Apache Hadoop file system. Being non-standard is not necessarily a problem, since there is little standardization between various RAID implementations other than the correspondence to particular RAID levels. There is little or no standardization between RAID controllers from different vendors, so it is unlikely that you will be able to use an existing array with a different controller without completely reinitializing the system and restoring the data from backup. For all practical purposes, assume your RAID implementation is proprietary, and if you need to move your hard disks to a new system, assume you will need to rebuild your RAID array from scratch and restore your data from backup.

Disk arrays fail for a variety of reasons. Be prepared and make sure a disk array does not store the only copy of your data.

Optical Disc

Optical Discs include Compact Disc (CD), DVD (which originally stood for Digital Videodisk), and Blu-ray Disc (BD). Photographers have used optical discs for many years as a backup medium. In fact, in *The DAM Book*, author Peter Krogh suggests creating a directory structure using folders (called *buckets*). They are limited in size to that of the optical media you use, so each bucket could easily be backed up to a single optical disc.

The DAM Book is a great introduction to the topic of digital asset management for photographers. Peter Krogh, O'Reilly Publishing (oreilly.com).

Standard-size (120mm) CDs have a maximum capacity of 650-870 MB. Standard-size, single-layer DVDs hold about 4.7 GB of data, while double-layer DVDs hold about 8.5 GB. There are mini (80mm) versions of both, but they are primarily used for software distribution. Rewritable versions of both are slower to write to than the write-once versions, and significantly more expensive.

There are four primary formats for BD—single-layer, double-layer, and BDXL 3-layer and 4-layer. The capacities are 25 GB, 50 GB, 100 GB, and 128 GB respectively. The BDXL specification is relatively new and not yet in widespread use. There are also rewritable versions and mini versions of single-layer and double-layer BD.

Optical Media Shelf Life

There is a wide range of claims related to optical media longevity. I have seen reports of CDs and DVDs becoming unreadable after three or four years, while some vendors claim a shelf life of 50-200 years for recorded CD-R, 30-100 years for DVD-R, and 30-200 years for BD-R and BD-RE. These estimates are based on accelerated aging tests, which may or may not reflect real-world conditions. Environmental and storage factors play a major role in optical media longevity, as does the quality of the disc itself. Discs with a gold reflective layer are considered the best choice for archival storage.

Unrecorded double-layer DVD+R

Labeling Optical Media

The best way to label optical media is to use a special CD/DVD marking pen. Labeling should only be done on non-data areas of the disc, which basically means the area around the center hub. Solvent-based pens such as Sanford Sharpies should be avoided, as should adhesive labels. Laser-based labeling systems such as HP's LightScribe, which requires special LightScribe media, are claimed to not affect longevity. One popular labeling option is direct inkjet printing on CDs and DVDs with a special printable surface, but there is little information available concerning the longevity of this media.

The National Institute of Standards and Technology (NIST) has published "CD and DVD Archiving Quick Reference Guide for Care and Handling" (itl.nist.gov/iad/894.05/docs/disccare.html), which gives a good overview of the proper handling of optical media. The U.S. National Archives and Records Administration has published "Frequently Asked Questions (FAQs) about Optical Storage Media: Storing Temporary Records on CDs and DVDs" (archives.gov/records-mgmt/initiatives/temp-opmedia-faq.html). Designed to help with records management in Federal agencies, the information is applicable to all optical discs.

Handling Optical Media

Optical discs are easily damaged. Sliding an optical disc across a desktop can create scratches that will make it unreadable. They can also be damaged by moisture and humidity, so they must be handled with care. Here are a few tips to maintain the longevity of optical discs:

- Avoid touching or scratching the recorded surface of the disc. Handle by the edges and center only.
- Store discs upright in a protective sleeve or case.
- Store discs in a clean, cool, dry environment.

If you need to clean a disc, use a clean, soft cotton cloth. Wipe from the center to the outer edge. If further cleaning is needed, use alcohol (isopropyl or methanol) or a commercial CD/DVD cleaning solution.

Removing Scratches from Optical Media

Any attempt to remove scratches should be considered an absolute last resort before discarding the disc. Using scratch removal techniques on a good disc could damage it and make it unreadable.

A quick search of the Internet will return many methods of scratch removal, including the uses of petroleum jelly, banana peel, peanut butter, mayonnaise, hair gel, and hair spray. These methods fill the scratches with foreign material. These approaches may work, at least temporarily, but they do not actually remove the scratches.

To remove the scratches, you need some kind of abrasive compound. Using a coarse abrasive will likely destroy the disc. Two abrasives that have been known to work are toothpaste and metal polish. Of the two, metal polish is the coarsest, so you might want to try toothpaste first. Apply the abrasive with a soft cotton cloth, rubbing from the center to the outer edge. Make sure you remove any remaining abrasive by carefully washing the disc.

Digital Magnetic Tape

In the early days of computing, magnetic tape was the primary storage medium for data. With the advent of spinning magnetic hard disks, it became the primary medium for backing up and archiving data.

Over the years, tape has experienced a number of problems, and has been named the culprit when supposedly backed up data could not be restored. Tape is also perceived as being slow, which is not necessarily the case.

Digital magnetic tape (from this point on I will refer to it as "tape") is a linear media. This means that unlike hard disks, which are random access devices, data must be written to and read from tape sequentially. Also unlike a spinning hard disk, which spins continually, tape must stop and start if data is not being received at the tape drive's speed. This stop/start phenomenon is called *shoeshining*, since like a shoe-shine rag, the tape must go back and forth across the read/write head. As you can see, sometimes the problem with tape is not that it's too slow, but that it's too fast, and must continually stop and restart when it's not been fed at full speed.

A computer's power-saving schemes can tell a disk to go to sleep after a certain period of inactivity, but generally the disk constantly spins, even if data is not being written or read.

Traditionally, there have been other problems with tape. Many of the low-cost cartridge tape drives targeted toward smaller businesses were not reliable. Much of the available tape backup software was poorly written and difficult to use, with particularly arcane restore procedures. Tape drive read/write heads also require periodic

cleaning to prevent debris buildup. Because tape requires different software and procedures for its use, it becomes an easy scapegoat when poor backup procedures result in data loss. All these factors have contributed to tape's reputation of being unreliable.

An additional problem is that there have been multiple competing physical and logical formats for tape. Most vendors of backup software supported the various physical formats, but also used their own proprietary logical formats and file systems, creating a high degree of vendor lock-in. In other words, if you backed up your data with vendor A's software, you couldn't restore it with vendor B's software. This is still somewhat true today, even with non-tape backup approaches, but at least there are options that don't lock you in to a particular software vendor.

In recent years, the cost of hard disk storage has dropped significantly, and hard disks have supplanted or replaced tape for backup in many organizations, especially in the SOHO market. However, as data storage requirements have exploded, the market for digital tape has increased, especially in the enterprise, or large organization, market. Even for small organizations with lots of data, tape is again becoming a viable medium for backup and archiving. In spite of its past reputation, modern-day digital tape is vastly improved when compared to its ancestors. If you have a large library of images you are seriously concerned about protecting, tape may be a good option to consider.

Linear Tape Open (LTO)

The most common tape technology in current use (and the one that should be of most interest to photographers) is Linear Tape Open (LTO). LTO, also called *Ultrium*, is a tape format created by the LTO Consortium (lto.org), which directs LTO development and licensing. LTO is a cartridge tape technology that was developed as an open standard, with licensing and certification available to manufacturers of tape drives and media. LTO drives are supplied by at least four companies, and media is supplied by at least ten. This means you are not locked in to a single vendor for drives or media.

LTO tape drives are available as internal drives that fit standard 5 1/4" drive bays, external desktop drives, and rack-mount drives for standard 19" equipment racks. Tape changers and tape libraries are also available.

Since its initial release in 2000, there have been six generations of LTO technology, each generation with increased speed and capacity.

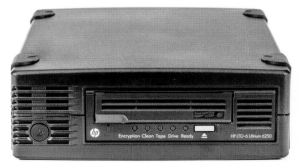

LTO-6 external tape drive

LTO Generation	Year of Release	Capacity Native/ Compressed	Data Transfer Rate Native/Compressed
LTO-1	2000	100/200 GB	20/40 MB/sec
LTO-2	2003	200/400 GB	40/80 MB/sec
LTO-3	2005	400/800 GB	80/160 MB/sec
LTO-4	2007	800/1600 GB	120/240 MB/sec
LTO-5	2010	1.5/3 TB	140/280 MB/sec
LTO-6	2012	2.5/6.25 TB	160/320 MB/sec

LTO tape cartridge

LTO tape drives have built-in compression, which is why there are two specifications for capacity in the above chart. Compressed capacity and compressed data rate are the averages that can be expected with common types of data found in business environments. Since many image formats do not lend themselves to additional compression, these specifications may be of minimal importance to photographers. The good news is that an LTO drive will not try to compress files that have already been efficiently compressed. Both compression and decompression are automatic, so when files are retrieved from tape they are automatically restored to their original size and format.

The compressed data rate is variable based on the compressibility of the data. Also, not all drives from all manufacturers meet these transfer rates.

LTO Reliability

LTO has proven to be very reliable. Based on accelerated life testing, LTO tape has an expected archive shelf life of up to thirty years. Hard disk manufacturers typically do not specify a shelf life for non-spinning hard disks, but 3-5 years is a good estimate. Error rates are another measure of reliability. Based on published figures, LTO incorporates error detection and correction, and has an average bit error rate of 1 bit in 10^{-17} bits without error detection/correction, and an estimated undetected bit error rate of 1 bit in 10^{-27} bits. This means the bit error rate prior to error detection/correction is about 1 bit error in 100 Petabytes.

Desktop SATA hard disks, the type most commonly used for backup because of their cost, have a sector error rate of 1 sector in 10^{-15} bits, which is one bad sector (typically 4096 bytes) in 1 petabyte. The bottom line is that LTO tape is far more reliable for long-term data storage than disk.

Prudence and changes in technology call for migrating archived data to new media at least every 7-10 years.

Life Expectancy of LTO Tapes in Regular Use

Every read/write pass on a tape reduces its life expectancy. Although a tape that has been written and read a few times has a thirty-year life expectancy, using a tape over a period of days, months, or years reduces its expected life span. The following table provides estimates of life expectancy for tapes that are used once a week and once a month.

Expected Usage Life of LTO Media (Courtesy of Imation, Inc.)									
Tape Series	Raw (uncompressed) Capacity	Total Data Tracks Written on Tape	Data Tracks Written Each Pass	Total EOL End-to-end Passes	Number of Passes to Write Full Capacity	Number of Full Capacity Reads/Writes (EOL)	Years of Life Assuming 1 Full-capacity Write per Month	Years of Life Assuming 1 Full-capacity Write per Week	Total GB Processed over Full Tape Life (uncompressed)
LTO-1	100GB	384	8	9,600	48	200	17	4	20,000
LTO-2	200GB	512	8	16,000	64	250	21	5	50,000
LTO-3	400GB	704	16	16,000	44	364	30	7	145,455
LTO-4	800GB	896	16	11,200	56	200	17	4	160,000
LTO-5	1500GB	1,280	16	16,000	80	200	17	4	300,000
LTO-6	2500GB	2,176	16	27,200	136	200	17	4	500,000

These estimates apply to Imation brand media, but characteristics of LTO tapes from other manufacturers should be similar. This chart is only a guideline and may change dramatically based on the user's daily practices for the care and handling of the media, maintaining the proper use/storage environments, drive maintenance and a number of other factors.

Backward Compatibility

An LTO tape drive can read tapes from its own generation and two prior generations, and can write to tapes from its own generation and one prior generation. For example, an LTO-6 tape drive can read LTO-4, LTO-5, and LTO-6 tapes, and can write to LTO-5 and LTO-6 tapes.

LTO Tape Drive Interface and Drivers

LTO-5 and LTO-6 drives have 6 Gb/s SAS interfaces. Most earlier generation drives are supplied with a 3 Gb/s SAS interface, an Ultra 160 SCSI interface, or an Ultra 320 SCSI interface. PCIe host adapters are available for all four interfaces, and drivers are available for all major operating systems. One brand of SAS host adapter, the High-

Point RocketRAID, reportedly only supports hard disks and does not support LTO tape drives. SAS host adapters from LSI, Adaptec, ATTO, HP, and IBM do support LTO. Other SAS host adapters likely do as well, but check before purchasing.

Although LTO drives are not available with Thunderbolt interfaces, there are options. ATTO (attotech.com) makes ThunderLink, a Thunderbolt to SAS adapter, which allows the connection of an LTO drive to a computer with a Thunderbolt interface. An option for Thunderbolt connectivity to SAS or SCSI is the mLink from mLogic (mlogic.com). mLink is a generic Thunderbolt to PCIe adapter that accepts a single PCIe expansion card. It can be used with a PCIe SAS host adapter.

SCSI is a parallel interface and is the predecessor to SAS.

Linear Tape File System (LTFS)

Traditionally, a major problem with tape has been the need for specialized backup software. This creates a degree of vendor lock-in that is uncomfortable to many people. It also means an added degree of complexity when you are writing data to or retrieving data from tape.

To increase the openness of LTO, the LTO Consortium created the Linear Tape File System (LTFS). LTFS makes an LTO tape drive compatible with the computer like any other storage devices (e.g., a hard disk, DVD, or memory card). This allows the use of any software, including backup software that is not tape-aware, to read from and write to an LTO tape. LTFS requires the installation of supporting software, which is available for current versions of Mac OS, Windows, and Linux. LTFS is supported on LTO-5 and LTO-6 drives and tapes only.

It is important to remember that even though LTFS makes a tape drive appear as a disk drive, it is not the same. A disk is random access; a tape is linear. When a file is "deleted" from an LTFS tape, it is merely removed from the file listing and the space is not freed. All subsequent writes are appended to the end of the existing data on the tape. Even with LTFS, tape should be used strictly as a backup and archive medium.

LTO Performance

Remember the issue of shoeshining described earlier in this section? LTO tape drives provide speed matching, which slows down the tape drive to accommodate slower data streams. The minimum speed varies from product to product, but is typically one-third to one-half of the maximum data transfer rate. There are two approaches to speed matching: *continuously-variable* and *stepped*. HP developed the continuously-variable approach, which is called *Data Rate Matching*. IBM drives use the stepped approach, which adjusts the speed over a 14-step range. IBM calls their approach *Digital Speed Matching* (DSM).

Other LTO vendors use one or the other of these technologies, and have their own trade names for speed matching. Both approaches accomplish similar results, but the variable-speed approach seems more elegant. The drives also have a memory buffer, which can smooth out the transfer rate of data streams that are not delivered at a consistent speed.

Instead of the constant stop/start of older tape technologies (when the data stream was too slow), an LTO drive does not start writing to tape until the buffer is about half full. At that point, the drive will begin writing, and adjust its speed based on the status of the buffer to make sure data is constantly streaming to tape. This minimizes, but doesn't totally eliminate, the stop/start, since some systems cannot provide a data stream that is fast enough to keep data in the buffer. This combination of speed matching and buffering improves performance and reduces wear and tear on both the drive and tapes. These two features have helped minimize the types of performance issues experienced with older tape technologies. If your computer can deliver data at a rate within the range managed by the tape drive's speed matching, then performance should be very good. If not, it should still be adequate.

I'm Feeding My Tape Drive at High Speed—Why Do I Still Hear Clicks, Stops and Starts?
LTO, like most digital tape, writes data in a serial serpentine fashion. This means that data is written in multiple narrow tracks on the tape. When the end of the tape is reached, the tape drive must stop, position the read/write heads for the new tracks, and then start the tape in the opposite direction.

LTO Tape Drive Maintenance

The only routine maintenance that should be required with an LTO drive is periodically using a cleaning tape cartridge. This process is greatly simplified when compared to earlier tape drive technologies. The indicator lights on the tape drive will automatically illuminate when cleaning is required. In fact, cleaning at other times is not recommended unless the drive is experiencing read or write errors. Each cleaning cartridge is good for a specific number of cleanings. When you use the cartridge, it automatically stops at the correct point on the tape for the next cleaning to begin and then ejects itself.

The cleaning cartridge doesn't indicate the number of remaining uses, so you should mark one of the usage check boxes on the label each time you use the cartridge. However, if you don't do this, the tape drive's LEDs will indicate when a cleaning cartridge is exhausted.

Tape Changers, Autoloaders, and Libraries

Changer, *autoloader*, and *library* are three names used for devices that hold multiple tapes and load them on demand. The size and capacity can range from devices that hold as few as six tapes to systems that manage thousands of tapes. At the simplest level, these devices can be used to sequentially load multiple tapes when a backup job is too big for a single tape. At a more complex level, they can manage large tape archives by retrieving the correct tape when a stored file is requested.

Tape changers are overkill for most photographers who back up and archive to tape, but for some they can be very helpful. Most changers are complex and expensive, but reasonably cost-effective changers are available from several manufacturers, including Overland Storage (overlandstorage.com), Tandberg Data (tandbergdata.com), and Quantum (quantum.com). Using a changer requires backup software with changer support, which could be an additional cost.

Tape Servers and Appliances

Many video production companies use dedicated LTO tape servers or appliances for archiving and managing digital video assets. All of the products I have looked at use the LTFS file system, which helps limit vendor lock-in. These systems are beyond the needs of most photographers, but for those who are moving into the video arena, this type of system may be in your future. If you are curious, companies that provide products at the lower end of the market include XenData (xendata.com), For-A (for-a.com), and Cache-A (cache-a.com).

Which Is Faster—Disk or Tape?

I wanted to test the belief that backing up to tape is inherently slower than backing up to disk. Specifically, I wanted to test the ability of an LTO tape drive to back up data from a relatively low-speed data stream, such as a 7200 RPM SATA disk, since this is the most common type of hard disk used in desktop computers and SOHO storage systems.

I set up two series of tests. For both tests I copied or backed up a 329 GB data set of mostly uncompressible photographic images from a 7200 RPM SATA II hard disk. I turned compression off on the tape drive in both test series. The data was copied or backed up to another 7200 RPM SATA drive and to an HP StoreEver 6250 model EH970A LTO-6 tape drive. The SATA II drives were connected to SATA III ports on the host computer's motherboard. The tape drive was attached to a 3 Gbs SAS host adapter, and compression was disabled. The maximum data rate of a 7200 RPM SATA drive is about 130-140 MB per minute, well below the maximum throughput of the 3 Gbs SAS adapter and the 3 Gbs SATA II drives.

For the first test series, I used LTFS and copied the data set using the Windows command-line utility Robocopy. I first copied the data between the two 7200 RPM SATA

disks, then from a SATA disk to the HP LTO-6 drive. On the tape test, there was audible start/stop, primarily when a large number of small files (under 1 MB) were being copied. The start/stop indicated the few times when the data stream could not keep the tape drive's buffer full. These events were rare, however, and the tape drive mostly hummed along, changing its speed to accommodate variations in the data stream. Of course, there was also the normal stop/start at the end of the tape, when the drive repositioned the read/write heads to a new set of tracks and then reversed the tape's direction.

For the second test series, I used the tape drive in native (no LTFS) mode and backed up the same data set using Retrospect 8.1. I disabled Retrospect's verification, compression, and system file backup in order to keep conditions as similar as possible to the first test series. I performed the same disk-to-disk and disk-to-tape tests.

Copy/Backup Method	Disk-to-Disk	Disk-to-Tape
Robocopy and LTFS file copy	44.347 MB/sec	56.541 MB/sec
Retrospect backup (native tape mode)	40.458 MB/sec	82.518 MB/sec

In both tests, disk-to-tape was significantly faster than disk-to-disk. Of course, these results only apply to this particular data set. The type and size of files, use of compression, and other factors would give different results. The results do show, however, that LTO holds its own in backup speed when compared to 7200 RPM hard disks.

Online (Cloud) Storage

In one sense, online, or *cloud*, storage is a very simple thing—you store your data on the Internet. Beyond that, it gets complex. There are a plethora of services selling cloud storage and cloud backup, and each one is different. What they have in common is that they will store data on servers for a price; sometimes, for small amounts of data, storage is free. Some services charge upload and download fees, storage fees, and data access fees. Some offer flat pricing: a certain amount of storage for a fixed monthly fee; some offer unlimited storage for a fixed monthly fee.

Cloud is not a new term. It started with the first packet-switched networks in the 1970s. The term refers to a network that handles routing functions internally, which is what the Internet does. The end points, such as your computer and a server somewhere on the network, only need to know each other's address information to communicate. Devices in the network handle all the routing in a transparent fashion. Your computer doesn't need to know the internal workings of this nebulous network, or cloud.

Offering unlimited storage may seem like a money-losing proposition, but it's really a matter of statistics and playing the odds. The user bets they will store massive amounts of data, and the provider, like a gambling casino, bets against it. On average, again like a casino, the house (service provider) wins. Some services that offer unlimited storage will throttle bandwidth if you store more data than they like. In other words, they are not saying you can't store a massive amount of data, but they make it difficult. Some services that advertise high performance will do the opposite—they will use all available bandwidth for their service, making it difficult or impossible to access anything else on the Internet while data is being transferred to their site. This will limit the amount of data you store, because you'll only want to transfer data at off hours when you aren't doing anything else online. Also, some providers will only transfer data from your internal hard disk, and charge extra for transfers from external disks, NAS and SAN devices, and servers.

Cloud storage providers often use data compression and deduplication to optimize storage usage. Deduplication is the process of locating redundant data, including whole files or parts of files, and then referencing only a single instance of that data by using pointers to that one instance. Both compression and deduplication processes can affect performance, depending on how they are implemented. Some providers deduplicate across data from multiple clients. For example, if you store a downloaded video that is also stored by other users, only one copy will be kept on disk, and pointers will be set so all customers who stored that video will access the same copy. Sophisticated software is required to do this effectively and securely.

Some services provide redundant storage and some do not. Some of those that provide redundant storage will store data in two or more different geographic locations, while others will only store it on different servers or disk systems in the same location. Some services will allow you, for a price, to send a hard disk with your data to "seed" your cloud storage, and some will not. Some will, again for a price, return your data to you on a hard disk and some will not. Some photo sites will allow you ownership of the metadata (captions, titles, layout) so you can easily transfer your photos to another site and some will not.

It has been said that the devil is in the details. This is definitely true with cloud storage. You need to read the fine print. Read the Service Level Agreement, if the provider publishes one. In most cases it will tell you that the provider will do their best to preserve your data, but if it gets lost, or there is unauthorized access, the responsibility is yours, not theirs.

You should also consider the possibility that your cloud service will abruptly change its terms or even shut its virtual doors, locking your data behind them. For example, on March 1, 2013, European cloud service provider RapidShare eliminated its unlim-

ited data plan[1], and gave its customers a three-week notice. Customers had the option to cancel the service or pay for much more expensive per GB plans. On January 19, 2012, the U.S. Department of Justice shut down the online storage site Megaupload.com[2], seizing its domain names and denying users access to their data. Over the last few years there have been numerous shutdowns of cloud storage sites. When the online site Digital Railroad shut down in 2008[3], customers received a 24-hour notice. Photographer Ryan Pyle lost over 7,000 images.

It's a good idea to keep your expectations in check when it comes to cloud storage. Do your homework—read the fine print. Online reviews are often suspect, but read them before you buy. Look for reviews from both professional reviewers and users that point out the negatives as well as the positives. Many services are free for a limited amount of data or provide a trial period. Take advantage of those services to see if one of them might work for you. Also, look at the provider's service and support policies. Most are online or email only. Find out how quickly you can expect a response and how you resolve problems. Finally, never make cloud storage your only storage.

1 "RapidShare scraps unlimited storage with short notice," Cnet, March 18th, 2013, http://news.cnet.com/8301-1023_3-57574924-93/rapidshare-scraps-unlimited-storage-with-short-notice.

2 "Feds Shut Down Megaupload: Warning Sign for the Cloud Storage Model?" KapitallWire, January 24th, 2012, http://wire.kapitall.com/investment-idea/feds-shut-down-megaupload-warning-sign-for-the-cloud-storage-model.

3 "What happens to the data when an online storage site closes?" Macworld, May 15th, 2009, http://www.macworld.com/article/1140636/whathappens.html.

IMAGE INGESTION
AND ORGANIZATION

When I first started with digital photography, it seemed much easier than working with film. Put the memory card in the camera, shoot pictures, copy the images to the computer, then view or print. What could be easier?

Then I realized that digital isn't really easier, it's just different. Instead of a film-changing bag, you have image-transfer software. Instead of a darkroom, you have digital image-editing software. Instead of negative and slide preservers, file folders, and a file cabinet, you have images stored on memory cards or other forms of digital storage.

For many years, I had a large collection of images with arcane names provided by the camera. What I have now is an organized library of images in a logical naming structure with customized metadata and keywords for efficient location and identification. This chapter is about preparing your own organized library, which entails the following series of processes:

1. **Choose an image-management program**. An image-management program is software designed specifically for managing a library of images. It allows you to organize and locate images using metadata (including camera and exposure information), keywords, a rating system, and more. Several types of image-management programs are described in this chapter.

2. **Create an organizational structure**. A well-thought-out directory structure (folder hierarchy) and file-naming scheme will save you many hours in the long run.

3. **Move images from camera to disk.**

4. **Rename images.** You don't have to do this, but it will make locating and retrieving images easier.

I use the terms directory *and* folder *interchangeably.* Directory *is the term many of us who started in the pre-GUI days of computing are most comfortable with. The term* folder *didn't come into common usage until the computer started putting pictures of them on the screen.*

5. **Convert to DNG.** Many photographers convert their RAW images to Adobe's Digital Negative (DNG) format.
6. **Apply metadata.** In addition to camera-generated metadata, you might want to add keywords and copyright information to some images as part of the ingestion process.
7. **Import images into an image-management program.** You need to do this if you use a catalog-based program such as Apple Aperture or Adobe Lightroom, or a digital asset management (DAM) program.
8. **Verify images.** This includes visual verification and, if necessary, software verification.
9. **Initial backup of images.**

Metadata

Metadata is data about data. In this case, it is data about an image that is attached to that image. Camera-generated metadata can include information about the camera, exposure, location (geotagging), and more. Additional metadata can be added to the image itself or to an external file.

Exif: Some metadata, called Exif (Exchangeable image file format) data, is created when you press the shutter. Besides camera, lens, exposure, and GPS location information, Exif includes standardized fields, as well as vendor-specific data, known as Makernote data. While the standardized Exif fields are well documented, Makernote fields are not, so the specifications usually have to be reverse-engineered to allow software to read or write Makernote data in an organized fashion.

IPTC: IPTC (International Press Telecommunications Council) is a set of metadata schema developed primarily for professional photographers. Originally a subset of the IIM (Information Interchange Model), the IPTC schema is designed to identify, describe, and manage images. It provides copyright information, as well as information about the photographer and the content of the image.

XMP: XMP (Extensible Metadata Platform), which incorporates much of the IPTC schema, was developed by Adobe in 2001. In 2005, the IPTC organization published the IPTC Core Schema for XMP. XMP is now an open source standard. It includes keywords, copyright data, non-destructive editing information, and more.

Keywords: Keywords are descriptive terms that can be added to XMP metadata to aid in searching for and managing images. Image-management programs such as Apple's Aperture and Adobe's Lightroom support the use of hierarchical keyword lists, which simplifies the task of applying consistent keywords to images.

Where Metadata is Stored

Exif and IPTC data are stored as part of the image file. Most standardized image formats, such as JPEG and TIFF, store XMP data as part of the image file, as well. For RAW formats other than DNG, XMP data is stored in a separate sidecar file. RAW files converted to DNG store XMP data in the DNG file itself.

Cataloging programs, such as Lightroom, provide the option to write the data to the sidecar file, but typically store XMP data in their catalog, instead.

Metadata Issues

There are several issues with metadata that are currently being addressed by the various standards organizations, including:

- Exif, IPTC, and XMP data are all typically included in photographic images. There is some overlap; the mapping between these types of metadata is not well defined, and can cause confusion. For example, software that writes copyright information to XMP might not write that information to IPTC, and vice-versa.
- Camera vendors are not consistent about how they write data to Makernote fields, making it difficult for software to consistently report that data.
- Devices other than cameras can create images, and the various metadata schemas need to be expanded to include those devices.

Reading and Writing Metadata

Many photo-editing and -management applications allow you to edit subsets of metadata. Third-party programs, such as Phil Harvey's free ExifTool (http://www.sno.phy. queensu.ca/~phil/exiftool), and Bogdan Hrastnik's companion ExifToolGUI for Windows (http://freeweb.siol.net/hrastni3/foto/exif/exiftoolgui.htm) will allow you to view and edit a much wider range of metadata. ExifTool GUI is available for Mac and Linux, as well.

Protecting Your Images

Unfortunately, many photo and social media sites strip metadata when you upload images. Some will retain the data on the originally uploaded file, but will strip it from derivatives. Facebook strips all metadata, and Google+ retains it. Photobucket retains it in uploaded files, but not "Save As" files. You can find the results of one test of media sites here: http://www.embeddedmetadata.org/social-media-test-results.php

To protect your images, it's important to have your upload sites retain your metadata. As an added precaution, you might want to watermark uploaded images with a copyright notice. There are some circumstances, however, where you might want to remove certain metadata from uploaded images. This includes specific identification or location information for images of people, especially minors. Removing this type of metadata is an identity-protection precaution.

Creating an Effective Directory Structure and Naming Scheme

Although your image-management software and the metadata attached to your images are your most important tools for management, a well-designed directory structure (or hierarchy) and image and folder naming scheme for your library helps, as well. You might have multiple directory hierarchies—perhaps one for your *managed library*, one for derivative images, and one for videos. I'm going to define a *managed library* as the set of images that are under the control of your cataloging or image-management software.

Rules for File and Directory Naming

There are some general rules that should be followed for file and directory naming. Directory and file names should be limited to the characters A-Z, a-z, 0-9, underscore (_), period (.), and hyphen (-). This aids in portability between different operating systems. Periods should not be used as the first or last character of the name, and should be reserved as a separator between the file name and the standard three-character extension for the file type (.tif, .jpg, .dng, etc.). Periods should not be used in directory names. Most current operating systems accept file names of up to 255 characters. The latest specification for the standardized ISO 9660 file system (with Joliet extensions) for CD ROMs allows file names of up to 64 characters, plus a three-character extension. Deep directory hierarchies can also be problematic when writing to CD ROMs.

A comprehensive document on naming recommendations can be found here: controlledvocabulary.com/imagedatabases/filename_limits.html. Controlled vocabulary provides a pre-populated hierarchical keyword list for popular image management programs.

Operating systems all handle case in file and directory names differently. For example, current Windows and OS X versions can write file names using uppercase and lowercase letters, but case is ignored when listing or searching for files. With Linux, uppercase and lowercase versions of the same letter are read as different characters. Windows and OS X would see XyZ.jpg, xyz.JPG, and xYZ.jPg as the same file, but Linux would see these as three different file names. For portability across file systems, make sure you keep file names unique regardless of case sensitivity.

Even though OS X is not case sensitive, some of the command-line utilities that are included are case sensitive due to their Unix roots.

Directory Structure and Naming

Your directory structure(s) should give you an idea of what images are where. It should also be designed to expand over time, and to be logically partitioned if necessary. Like a file cabinet and file folders, a directory structure only gives you one-dimensional organization, but you get to choose what that one dimension is; chronological by date, for example, or alphabetical by subject. Use the system that is best for you.

Here is my structure:

It is very simple: the catalog name, the year, and the project folder named with the date and the project. If a project spans multiple days I either create multiple folders or name the folders like this:

The first folder spans multiple days in a month, while the second spans multiple days in two months. Since I am not a full-time professional, this works for me:

If I were creating thousands of images every month I might do something like this: In order to sort by date, the folder name consists of the four digit year, two digit month, and two digit day. The month folders start with the two digit number of the month followed by the month name.

The Bucket System

In *The DAM Book*, Peter Krogh recommends setting up a folder structure for image files in such a way that each folder at one level of the hierarchy can fit on one piece of archive media. This is a good approach, but Peter's system, which he proposed several years ago, was targeted toward CDs, DVDs, or Blu-ray discs. Unfortunately, in the last few years, newer, higher-resolution cameras have increased image file sizes dramatically, and the capacity of flash memory cards has increased as well. For example, I currently use 32 GB and 64 GB memory cards, and 256 GB cards are available. Single- and dual-layer Blu-ray discs hold 25 GB and 50 GB, respectively, and I have a difficult time justifying archiving my images to media with less capacity than my memory cards. BDXL discs can hold 100 GB, but at $40 per disc, they are not particularly cost-effective. The bucket system isn't obsolete; it just needs to be adjusted. If the bucket system is attractive to you, I would suggest creating buckets that can fit on a single removable hard disk or magnetic tape.

Image Naming

Your file-naming scheme should not only make sense to you, but if you share or sell photos, it should make sense to the recipients of the images, as well. When you get digital images from multiple sources, it's nice to know at a glance who took the photos, as well as the general subject matter and the date they were taken. I avoid spaces in image names because they confuse some command-line batch processing utilities; I use underscores between words and dashes between date elements.

Here is my naming scheme:

Corrigan_Book_cover_2013-08-15_0001.dng

The name is comprised of my last name, the project name, the image creation date, and the sequence number. For derivative files, I might add other information. For example, if I export a .jpg file that is 1920 x 1080 pixels, I add "-1920" to the file name, like this:

Corrigan_Book_cover_2013-08-15_0001-1920.jpg

Which Files Go Where?

Determining how to handle specific file types may depend on your image-management software. For example, if your software can manage both still and video formats, you may want to keep both in the same directory structure. Otherwise, you might want to separate them. What about derivative and exported files? Where should they be kept? Do you need to keep all of your images in your active, managed library? Should you create multiple libraries or catalogs?

Let's define some terms:

- *Primary image files* are, for all practical purposes, your originals. These are the files that will be managed by your image-management software.
- *Derivative files* are edited or modified versions of your primary files. For example, if you edit a RAW file in Photoshop and save it as a TIFF file, you have created a derivative. From this file you might create other versions, such as JPEG files for web publishing.
- *Exported files* are files that have been saved in a final form for publishing, web publishing, or other purposes. These files will not be edited again. If you need a different version, you will create it using a primary or derivative file.

There are other file types as well. Some photographers convert their original RAW files to Adobe's Digital Negative (DNG) format (more about DNG later). They may or may not keep the original RAW files. A photographer may also have scans of negatives, prints, or images taken by others.

How you decide to handle all of these file types will affect your directory structures. Here is what I do:

I use Adobe Photoshop Lightroom to manage my primary and derivative images. This includes my DNG files (I convert my RAW files to DNG), original JPEG files from my older cameras and my phone camera, and specialized images, such as panoramas, from my current camera. It also includes derivative TIFF files that have been edited in Photoshop or other editing applications, scanned photos (usually saved as TIFF files), and video files from both my DSLR and my phone.

When I export photos for other purposes, I keep those in a parallel directory structure. When these images are exported, they are effectively read-only files; if I need to create modified versions, I will go back to the source image managed by Lightroom. These might be JPEGs for web publishing, the TIFF files sent to my publisher for this book, images for clients, or personal images for friends and family.

Even though I convert my RAW files to DNG format, I keep the originals as well. During the ingestion process, I utilize the same naming scheme for my primary DNG files that I used in my parallel directory structure. They are eventually migrated off to archive tapes.

*USB 3.0
Multi-card reader*

Image Ingestion

At first glance, the process of image ingestion seems pretty simple: connect your camera to your computer or put your memory card in the card reader, load the software provided by your camera manufacturer (it may even auto-load), and copy the images to your computer. For new photographers uploading JPEGs from a point-and-shoot camera and viewing them with Picasa or editing them with Photoshop

Elements, this is an effective process. For professionals and serious amateurs working with thousands of RAW files, this process quickly creates chaos within an organized library. An effective ingestion process has to assist in the short-term and long-term maintenance and management of the image library. An effective image ingestion involves this process:

1. Download the images from the camera.
2. Rename the images based on your naming criteria.
3. Apply metadata, such as copyright information.
4. Convert the images to DNG (optional).
5. Create an initial image backup.
6. Import the images into the management application or viewer/browser.
7. Visually verify the images.
8. When the images are imported and verified, and when backup copies have been made, you can delete them off the memory card. Some import utilities offer to delete images off the memory card as part of the import process. *Never do this*! Errors can occur during this process. Keep the images on the card until you are absolutely sure you no longer need them.

The relative simplicity or complexity of the process depends on your equipment, software, and procedures.

Ingestion Hardware

NETGEAR WNCE2001 universal WiFi adapter (photo courtesy of NETGEAR, Inc.)

The most common methods for transferring images to a computer are direct camera connections via USB, and transfers using a card reader. Ethernet and WiFi are also transfer options. There are two modes of transfer—batch and on-demand.

USB 3.0, either through direct connection to the camera or via a card reader, has the highest transfer rate. Since few cameras (the Nikon D4 being one exception) have USB 3.0 connections, a USB 3.0 card reader is usually your best option for high-speed data transfer. USB 2.0 works just fine, but it can't keep up with the transfer rates of newer, high-speed memory cards.

Several newer cameras, such as the Nikon D4 and the Canon 1D X, have Ethernet connections. The Nikon has a 100 Mbit/sec connection and the Canon has a gigabit connection. With Ethernet, these cameras function as FTP (file transfer protocol) and web servers, allowing image transfer, camera control, and more. The advantage of Ethernet is that the camera becomes a network device, and can be accessed and managed by any computer with access and the appropriate software. Both Canon and Nikon supply WiFi adapers for these cameras, but the price is prohibitive (about $600 each). Some photographers have successfully used the NETGEAR WNCE2001 universal WiFi adapter, which sells for less than $50.

WiFi is now common on higher-end point-and-shoot cameras, and is beginning to make an appearance on DSLRs and interchangeable lens mirrorless cameras. At the time of this writing, the Canon EOS 70D includes WiFi, as do some of the Sony NEX models, Panasonic Lumix models, and the Sony a7 models. Wifi can be added to almost any camera with an SD WiFi adapter, but not with the same level of functionality as the Canon or Nikon Ethernet connections. The Eye-Fi adapters function in on-demand mode, transferring images to a computer as they are taken. Cards from Transcend, Toshiba, and LZeal function as web servers and allow downloading from the card using a web browser. SD WiFi cards can be used in cameras that use CF cards by using an SD-CF adapter.

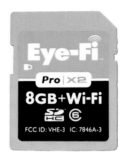

Eye-Fi WiFi SD card

Transferring in batch mode is the most common way to move images from a camera or memory card to a computer, but many studio shooters use on-demand mode. I would call this tethering, but that implies a cable connection to the computer. With WiFi the cable is no longer needed. Tethering or on-demand is used by a lot of studio shooters, since they can immediately transfer their images to the computer without touching the camera. They even have the option of immediate, automatic import into programs such as Lightroom. It is a tremendous time-saver to be able to immediately view your pictures on a large monitor. Since my Sony Alpha a77 does not have tethering, I use the Eye-Fi card to give me this on-demand capability.

NFC

Near field communication (NFC) allows devices to communicate with each other when they are in close proximity or physically touching. NFC is especially useful for transferring images from a camera to a portable device such as a smartphone or tablet. NFC is available on a number of point-and-shoot cameras and on some mirrorless interchangeable lens cameras, such as the Sony NEX-5T and Alpha 7 series, and the Samsung NX300.

Ingestion Software

Choices for ingestion software include your operating system's file copy utilities (Mac Finder, Windows Explorer, etc.), camera-vendor-supplied utilities, image-management software, and third-party utilities. The type or types of software you use for the ingestion process depends on your workflow.

OS File Management and Copy Utilities

These utilities include the Mac Finder. They have the advantage of always being there. They are good for moving images from a memory card or camera to a location on a disk, but little more in terms of the ingestion process.

Camera-Vendor-Supplied Utilities

Camera-vendor-supplied utilities, such as Nikon's ViewNX or Sony's PlayMemories Home, are designed to work with a specific brand of camera and its files. They will typically open automatically when a memory card is inserted into an attached card reader. In addition to copying images from a memory card or camera to disk, some can perform basic editing functions as well.

Image Management Programs

Programs such as Apple's Aperture, Adobe's Lightroom, and Corel's Aftershot Pro are designed to manage your image library. They can provide most tasks that are part of ingestion, but they don't always perform those tasks in a manner that is convenient to your workflow. They also may not perform specific pieces of the ingestion process. Lightroom, for example, will create a second copy of the files that you import. If you then convert to DNG, the second copy will be in the original RAW format. Some photographers want that second copy to be DNG as well, so they might use a third-party utility, such as Marc Rochkind's Ingestamatic, instead of Lightroom, to ingest images.

Third-party Utilities

There are many third-party utilities that can help with image-ingestion. Ingestamatic is designed specifically for image ingestion. There are also general-purpose image tools, such as FastStone Image Viewer, that can be useful for tasks like renaming images or adjusting time stamps before the files are imported into your library.

Figure a

A Sample Ingestion Workflow with Lightroom

This sample ingestion workflow accomplishes the following:

- downloads the images from the camera;
- renames the images based on my naming criteria;
- applies common metadata—in this case, copyright information;
- imports the images into Lightroom;
- converts the images to DNG (the DNG import function automatically verifies the integrity of the images);
- creates an initial backup by saving the image files to a second drive, where they are renamed, but in their original ARW RAW format. (I have never had to use these files. I do it as a precaution. These files are eventually moved from primary storage to archive.)

When the process is complete, I visually verify the images. I also create backups of the DNG files before I delete the images from the memory card.

The process:

1. In Lightroom Library mode, click on the Import button on the lower left corner of the screen (figure a).

2. In the Source window, select the card reader or camera (figure b).

Figure b

3. At the top center of the screen, select Copy as DNG. Select the images to be imported. All photos are selected by default (figure c).

Figure c

4. On the File Handling menu on the right, check Make a Second Copy To: and enter a location for the second copy. It will have the same file-name as the imported DNG, but it will be in original RAW format (figure d).

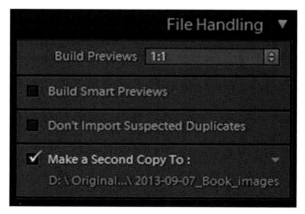

Figure d

Figure e

Figure f

5. Under the File Renaming tab, check Rename Files. Click the up/down arrows to the right of Template. If you have already created custom templates, you might want to select one to modify to add the project name. Click the up/down arrows again and select Edit (figure e).

6. Using a combination of text and the variables provided, edit the image names. The example above the edit window shows the result (figure f).

7. Under Apply During Import, click the up/down arrows to the right of Metadata and select or create your default metadata template (figure g).

Figure g

8. My copyright metadata template (figure h).

Figure h

9. Click the Import button on the lower right to begin the import (figure i).

Figure i

10. You can view the status of the import process in the upper left corner of the screen (figure j).

Figure j

On-demand Import

On-demand import transfers photos directly from your camera to your computer immediately after the photos are taken. On-demand can be done via direct cable connection, connection to an Ethernet network, or via WiFi, either with a WiFi-enabled SD card such as the Eye-Fi cards, or an Ethernet-WiFi adapter connected to an Ethernet-enabled or Wifi-enabled camera.

Depending on the software employed, you can use on-demand to import images directly into your image-management software. For example, Lightroom has direct support for a number of cameras. If you are using an unsupported camera, you can set up auto-import and a *watched folder*. Your on-demand system copies the images from the camera to the watched folder, and Lightroom imports them as they arrive. There are limitations to on-demand capture; Lightroom, for example, does not allow conversion to DNG for tethered shooting or auto-import.

Image-management software with tethering support includes Apple Aperture, Adobe Lightroom, and PhaseOne Capture One Pro.

DNG

Most professional and serious amateur photographers shoot RAW images; RAW images can display the maximum dynamic range that a camera is capable of capturing. Of course, RAW images require processing before they are usable, so some, particularly sports and news photographers, shoot JPEG. Since RAW is the direct output from a camera's sensor, almost every camera manufacturer has a different RAW image format, and in many cases each sensor has a different format.

I usually shoot RAW. When I travel, I shoot RAW+JPEG so I can email images or post them online.

This presents several problems:

- Every photo-editing or management application has to provide support for the many (over 200) RAW formats.
- RAW formats are proprietary. There is no guarantee of long-term support, especially when camera manufacturers go out of business. This has already happened. Kodak, once the 800-pound gorilla of photography, has already dropped support for some older formats.
- Adding metadata to a RAW file requires an XMP file. If the two get separated, your metadata will be lost.

An extreme example of abandoned image formats is the NASA Lunar Orbiter analog images from 1966 and 1967, when the images were stored on tape. Each tape drive was six feet tall, three feet wide, and weighed 600 pounds. Tapes took about an hour to run on the tape drive, and held one high-resolution image and one medium-resolution image. See this Wikipedia article about recovering those images: http://en.wikipedia.org/wiki/Lunar_Orbiter_Image_Recovery_Project.

To help alleviate these issues, Adobe created the Digital Negative (DNG) in 2004. DNG is an open-specification RAW image format that was developed for image preservation, to support multiple image formats for software developers, and to provide a common RAW format for camera manufacturers.

Advantages of DNG include:
- a common, openly-documented format for RAW images;
- an embedded preview that can reflect all adjustments made by non-destructive (parametric) editors;
- an embedded checksum for verification of image integrity;
- the ability to incorporate additional metadata without using sidecar (XMP) files;
- DNG files are typically 10-15% smaller than the original RAW files;
- the original RAW file can be embedded in the DNG for later extraction (although this will increase DNG file size);
- DNG has been adopted by Casio, Hasselblad, Leica, Pentax, Ricoh, and Samsung as the native RAW format for many of their camera models; and
- Adobe DNG converters, including the free, stand-alone DNG converter and the embedded converters in Lightroom and Adobe Camera RAW, perform image validation upon conversion.

Two disadvantages of DNG are:
- once the images are converted, they can no longer be opened or modified with the camera manufacturer's software; and
- some image-management and editing software only supports DNG for cameras that use it natively, not images converted to DNG from other RAW formats.

Image Management

There are two major approaches to image-management software: browser-based and catalog-based.

Catalog-based systems maintain a database of information about the images, including metadata. They may or may not apply metadata changes to the images or XMP files. Browser-based systems do not maintain a database, so all data has to be written to the images or XMP files.

Saving Metadata to XMP
Lightroom always saves metadata and editing parameters to the catalog, and it gives you the option to save this information to an XMP sidecar file or directly to a DNG image. This can be done automatically or manually. Even though it slows things down a bit, I use the setting "Edit/Catalog Settings/Automatically write changes to XMP." That way, even if I have a problem with the catalog, my settings are associated with the file itself.

The advantage of browser-based programs is that they can be very fast when working with only a few hundred or a few thousand images, because there is no import time. The advantage of catalog-based systems is that they can manage libraries of many thousands of images, and once the images are imported, locating images by any criteria (including metadata and keywords) is very fast. Apple's Aperture, Adobe's Lightroom, Phase One's Capture One Pro, Corel's AfterShot Pro, and the open-source DigiKam are all catalog-based systems. Camera Bits' Photo Mechanic is a browser program.

Some image-management programs include image-editing functions and some do not. Some use *parametric image editing (PIE)*, which means the original image is never modified—the editing process writes parameters to the database. Some programs give you the option of writing the parameters to either an XMP sidecar file, or if the file is a DNG, the parameters can be written to the DNG file itself. Aperture, Lightroom Capture One Pro, and AfterShot Pro are all parametric editors. These are sometimes referred to as *unified workflow tools* or *cataloging PIEware*. DigiKam provides non-destructive editing by only saving changes to a copy of an image, not the original. Photo Mechanic does not include an editing function. None of these programs provide the editing power of Photoshop or the open source editor, GIMP, so they all provide the ability to export images to external editors.

Aperture can read XMP files, but it does not write to them. Aperture does have the option of writing IPTC metadata directly to the RAW file itself, a practice that goes against the principal of non-destructive editing.

Multi-user Image Management

Most image-management programs are designed for only a single user to work with a catalog or set of images at a time. The programs that are designed for multi-user access are, for the most part, general-purpose *digital asset management* (DAM) programs designed to manage more than photographic images. Many of these programs are complex and expensive. Daminion and Extensis Portfolio Server Studio are two DAM programs that should be within the financial means of many small studios with multiple users. Neither of these programs have the editing capabilities of the unified workflow tools discussed previously, so they need to be used with external editing programs.

Choosing Image-Management Software

In many ways, the image-management software you choose determines your workflow. Programs like Aperture and Lightroom have dramatically changed the workflow process for most photographers; they give photographers a level of control over their images that wasn't previously available. They've also created a certain amount of ven-

dor lock-in, because once you've invested time and images in one system, it's difficult to switch to another. I suggest that before you make a decision on image-management software you do your own research. Most vendors have time-limited demos that can help you in the decision process. However, like test-driving an automobile, you likely will not find out all you need to know in a short period of time. For one thing, it is unlikely you will import thousands of images during the demo period, and you will probably not get a chance to try all the program's features. Still, the demo can give you a feel for what to expect.

Not every photographer works the same way. Cataloging PIEware works well for many of us, but not all. If you need to ingest and rate hundreds or thousands of images quickly, then a browser like Photo Mechanic might be right for you; however, you still may need a program like Lightroom for long-term image management. If you have more than one person needing access to your image library at the same time, you should look at a multiuser DAM system. Of course, you will still need editing software.

One more thing to consider: the entire ingestion/management/editing process will likely require more than one type of software, and sometimes your workflow will vary depending on the type of job you're doing. I use a different process when I'm batch-ingesting images than I do with on-demand ingestion. Consistency is good, but flexibility is important, too.

Moving from One Image-Management System to Another

What's involved in moving from one product to another? Moving from no management system to a program like Aperture or Lightroom isn't all that difficult, but moving from one program to another is a more complex process. For example, if your Aperture images are *managed*, meaning they are stored in the Aperture library file itself, you will first need to move them to the file system. Adjustments made in Aperture are not readable by Lightroom and vice-versa; to keep those adjustments, you'll need to export images as TIFF or JPEG, or keep a copy of Aperture on hand. Fortunately, most metadata and keywording are covered by industry standards and do transfer between programs. Before you switch systems, do some testing to determine the process required, the time involved, and the problems you'll have to deal with after the switch.

Working with Catalogs

The advantage of catalog-based image management is that you have all the information about your images in one place. The disadvantage is that this place can get large and unwieldy. The decision to work with a single catalog or multiple catalogs depends on many factors, including your software, the size of your library, and your method of working.

Here are some reasons to use multiple catalogs:

- Your single catalog has become slow due to size.
- You are moving part of your catalog off of live storage and onto archive media.
- You have special project catalogs, and you will never need to find images across catalogs.
- You have multiple users working on different projects, so you create special project catalogs so they can be accessed concurrently without moving to a multi-user DAM system.

I have two catalogs: a main catalog that has nearly all of my images, and a secondary catalog that contains images strictly of personal interest. When I move to a new version of Lightroom, I initially create a separate catalog for the new version so I can try out new features. When I'm reasonably sure the major bugs have been worked out (usually by the .2 release) I migrate my old catalog and merge my new one into it.

Software

Following are brief descriptions of software used for image ingestion and image management.

Ingestion Tools

Ingestamatic

Ingestamatic (basepath.com/site/detail-Ingestamatic.php) is an image ingestion tool for Mac OS and Windows that allows you to

- preview and select photos to ingest;
- batch rename the photos;
- back up images to one or two locations;
- add metadata and keywords;
- add location information manually or from a GPS tracking log;
- convert files to DNG; and
- launch a photo processing application, such as Photoshop or Lightroom, when the ingestion process is complete.

Ingestamatic makes extensive use of macros (variables) for both naming images and applying metadata. It also allows you to verify images using the Adobe DNG converter without actually converting the images to DNG.

FastStone Image Viewer

FastStone Image Viewer (faststone.org) is a general-purpose image-viewing utility for Windows that is useful for a number of tasks. It can perform basic editing functions, such as cropping, exposure and color adjustment, resizing, red-eye removal, spotting, and more. It can apply borders and watermarks, and it can batch-rename files. It can

also batch-change both file and EXIF time stamps, either with a specific date and time or with an offset. The latter is especially useful for travelers who neglect to adjust their cameras for different time zones. FastStone Image View is free for personal use, although the developers request donations. Licenses for commercial use are available.

XnViewMP

XnViewMP (xnview.com) is a general-purpose image-viewing utility for Windows, Mac OS, and Linux. It has similar capabilities to FastStone Image Viewer. It has extensive language support. It is free for personal use, although the developers request donations. Licenses for commercial use are available.

Browser

Photo Mechanic

Photo Mechanic (camerabits.com) is targeted toward photographers who must ingest and evaluate a large number of images quickly and efficiently. It can even ingest images from multiple cards simultaneously. The user can add star ratings and color codes with a single keystroke. The user can set up a list of common *tags*, or metadata, and apply the list to some or all of the photos. Photo Mechanic can embed metadata in certain RAW files and use XMP files for others. It also works with video files.

Photo Mechanic's greatest asset is speed. It doesn't have editing capability, but it does allow cropping and rotation of images. It can also FTP images from within the program. Photo Mechanic is perfect for photojournalists and anyone else who needs to process images quickly.

Here is a video tutorial by Dan Carr on integrating Photo Mechanic and Lightroom: youtube.com/watch?v=iO07PIIiRHM

Catalog-based Image Managers

Apple Aperture

Aperture (apple.com/aperture) was first released in 2005. It was the first cataloging PIEware program in widespread use. It provides an image-management database, non-destructive parametric editing, and organization of images by metadata, keywords, and faces (Aperture has face detection and recognition). It supports geotagging and includes export functions for several online photo sites, including Apple's iCloud, Facebook, Flickr, and SmugMug. Aperture supports most RAW formats as well as other common image formats, including JPEG, TIFF, PSD, and common audio and video formats. It has tethering and multiple display support. One of Aperture's unique features is the LightTable, which allows the user to lay out images in a free-form fashion. Another unique aspect of Aperture is that it provides the option of storing images in the file system or in the database itself. Aperture only runs on Mac OS, and is tied closely to the operating system; this allows you to browse the library from within any Mac app.

Adobe Lightroom

Lightroom (adobe.com/Lightroom) is the most widely used cataloging PIEware application on the market. It is available for Mac OS and Windows, and Adobe has done an excellent job of maintaining consistency between the two platforms. Like Aperture, it has an image-management database, parametric editing, and the ability to organize images by metadata, keywords, and more. It supports geotagging, tethering, and multiple display, and has extensive editing and image-manipulation functions. It provides DNG conversion on import, noise reduction, lens correction, automatic perspective correction, and soft proofing. Lightroom can import common video formats, but unlike Aperture, it can't import audio files.

Corel AfterShot Pro

AfterShot Pro (corel.com/corel/product/index.jsp?pid=prod4670071) was known as Bibble before Corel acquired it. It is available for Linux, Mac OS, and Windows. It has many of the same editing and organizing features that are found in other cataloging PIEware applications, including an extensive lens-correction database. Although it works with most RAW formats (Bibble was known for its excellent RAW conversions), it does not support files that have been converted to DNG, even though it supports DNG files from cameras that produce them natively. There are two additional shortcomings: it offers no support for video files and no red-eye correction, although a third-party red-eye plugin is available.

Although AfterShot Pro is catalog-based, it does provide the option of working with images that have not been imported into the catalog. This is handy for working with a few images quickly.

PhaseOne Capture One Pro

Capture One Pro (phaseone.com/en/Imaging-Software/Capture-One-Pro-7.aspx) started out as a support program targeted toward medium-format digital cameras. It provided excellent RAW support, tethering, studio light control, parametric editing, and other features attractive to professional medium-format photographers. What Capture One didn't have was a catalog. That has changed since PhaseOne acquired Expression Media, a highly regarded image-management program, from Microsoft. PhaseOne renamed it Media Pro, which was the product name before Microsoft acquired the product from iView. Recently Phase One integrated Media Pro into Capture One Pro 7, and created a full-service cataloging PIEware application. Like other such programs, Capture One has support for a wide range of RAW formats. It has full tethering support for 35mm-class DSLRs as well as medium-format cameras. The biggest criticism of Capture One is that it is resource-intensive; optimum performance requires a newer 64-bit computer with a fast processor and lots of RAM.

DigiKam

DigiKam (digikam.org) is an open source image-management program that started out as a Linux application. It now runs on Mac OS, FreeBSD, and Windows. DigiKam allows you to view, manage and edit images, apply keywords and metadata, convert RAW files, and more. Since it is open source, it's written by volunteer programmers, and is a little clunky around the edges. However, it's still a very useable application, and it's available at no cost. One of the major differences between DigiKam and programs like Aperture and Lightroom is the way the programs handle non-destructive editing. Aperture and Lightroom use parametric editing and never change the actual image file. DigiKam, on the other hand, creates a separate copy of the image to edit.

Multi-user Digital Asset Management (DAM) Programs

Daminion Server

Daminion Server (daminion.net) is a multi-user photo-management program designed for small groups. It is currently a Windows-only client-server program. The server can be nearly any computer running Windows XP or later (my test server is a six- or seven-year-old low-end XP system), but performance may suffer on a low-power machine. The Daminion client software and server software can run on the same machine. The program uses the powerful open source PostgreSQL enterprise-class relational database system, so it should be able to support very large image libraries. Daminion works with a wide range of file types, including most RAW file formats, video formats, audio formats, vector image formats, and the PDF document format. The program does a good job of handling metadata, keywords, and ratings; it even provides color ratings that are consistent with Lightroom. One nice feature of Daminion is the "check-out/check-in" feature. This makes sure no one else attempts to edit a photo that is being edited by someone else.

Extensis Portfolio Server Studio

Extensis Portfolio Server (extensis.com/portfolio-server-11) is a multi-user DAM for many types of digital assets. Studio is the lowest-cost version and it supports three concurrent users. Portfolio Server supports nearly all graphics, video and audio formats, and numerous document formats. It allows the adding and editing of metadata and keywords, the opening of files by external applications for editing, and provides file conversion for many file types. The broad file type support makes Portfolio Server a general-purpose DAM and not just a photo-management application.

PRIMARY DATA STORAGE

Primary data storage is the location (or locations) where you keep the active, working copies of your files, including photographic images, word processing files, accounting data, etc. In computer science terminology, the phrase *primary data storage* refers to a computer's RAM and ROM, not disk storage. However, for the purpose of this book, I will use Primary data storage as a term that refers to the location (or locations) were you keep the active, working copies of your files, including photographic images, word processing files, accounting files, etc. For most people, their computer's single internal hard disk is

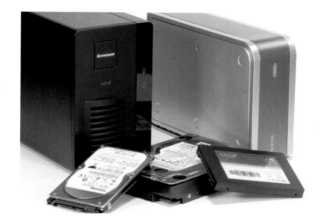

the most common location for active data. However, this is not the only, nor necessarily the best location for active data, especially for photographers, who tend to amass many gigabytes of images.

Internal Hard Disks

Most desktop and laptop computers include at least one internal hard disk. At the time of this writing, new computers are typically supplied with disks of 500 MB to 2 TB in capacity, and larger disks are easily available and relatively inexpensive. However, depending on the age of your computer, a hard disk larger than 2 TB may require special driver software, which is supplied by the disk manufacturer.

When is a Gigabyte Not a Gigabyte?
There is a discrepancy between size calculation for RAM (random access memory, the internal working memory in your computer) and storage. The multiplier for RAM is 1024, so a kilobyte is 1024 bytes; a megabyte is 1024 kilobytes (1,048,576 bytes); etc. This is because computer architecture is designed for multiples of 210, or 1024. Years ago, hard disk manufacturers decided to use multiples of 1000 instead of 1024, so in the alternate universe of storage devices (hard disks, flash memory cards, etc.) a megabyte, gigabyte, or terabyte is smaller then the equivalent value for RAM. In addition, space on hard disks is used for formatting, so the actual available storage space will be even less. For example, my notebook computer's 500 GB disk drive displays a capacity of 484,272,168 bytes.

Laptops use 2.5″ disks, which are available with capacities up to 1 TB. 2.5″ disks are available with capacities of up to 2 TB, but these disks are too thick (15mm vs. 9.5mm) to fit most laptop drive bays. Usually tablet computers use flash memory instead of a disk for storage, providing limited storage space for images and other data. Desktop computers use 3.5″ disks, which are available with capacities up to 4 GB. Desktop computers can use 2.5″ disks, but these cost more and require an adapter to mount in a 3.5″ drive bay. Some laptop computers will accept a second hard disk, and nearly all desktop computers will accept one or more additional disks. (This may not be true of all-in-one computers, which house the CPU in the monitor case.)

The computer's internal disk is a good choice for storage if you have a small library of images, especially if you're shooting JPEG files, and if you're the only person accessing those files. Of course, as you add images to your library, and as you migrate to newer, higher-megapixel cameras, your image sizes will increase. If you're a JPEG shooter, you might eventually find yourself moving to RAW files, which will also increase your storage requirements. This internal disk is shared by the computer's operating system, programs, and various support files; as your image library grows, you will most likely run out of disk space. You should consider your options before you get to that point.

Multiple Internal Disks

Most desktop and some laptop computers allow you to add additional internal hard disks. Additional disks can always be configured as separate, stand-alone disks. Some systems allow you to build RAID arrays with internal disks without the use of a separate RAID controller; with this on-board RAID approach, the RAID processing is handled by the computer's CPU, which will affect performance. For better performance, a dedicated SAS or SATA RAID controller with internal disk connections can be installed in a PCIe slot.

External Hard Disks

External hard disks come in many varieties with many different connection options. The one thing they have in common is that they consist of a hard disk inside an enclosure that includes circuitry to convert the disk's native interface, usually SATA, to the connecting interface, such as USB. The disk can be either 2.5″ or 3.5″. The 2.5″ units are sold as portable disks and are designed to obtain power through the computer interface connection, while the 3.5″ units are usually sold as desktop systems and include their own power supply, since the power requirements of the larger drives might be beyond what the computer interface could supply. The most common interface for external disks is USB, with USB 3.0 rapidly overtaking USB 2.0 in popularity. Disks with Firewire 400, Firewire 800, and eSATA interfaces are also available.

External disks have the advantage (or disadvantage, in some cases) of being easily disconnected and moved to another computer. This means that it is easy to acciden-

tally disconnect the disk at the wrong time, possibly causing data corruption. External disks are often less expensive than internal disks, partly because they are sold by big-box retailers like Costco.

External Disk Arrays

External disk arrays are available from numerous vendors in a variety of capacities and configurations, from two-disk units that support RAID 0 or 1 to large, rack-mounted arrays with hundreds of disks. Arrays that are practical for most photographers will hold 2-12 disks, with raw capacities up to 48 TB. Prices range from several hundred to several thousand dollars.

External hard drives come in many shapes and sizes

SANs and NASes

There are two major classes of external arrays: the poorly defined *Storage Area Network* (SAN) device and the *Network-Attached Storage* (NAS) device. The term *SAN* refers to the network that connects computers and storage devices, but through common misuse it has come to refer to the storage device itself. Some external arrays provide both functions and can be used as either a SAN or a NAS device. Depending on the vendor, SAN and NAS devices can be supplied with or without disks. Buying a diskless unit and adding your own disks saves money, but can add to complexity if warranty or support issues arise. If you do add your own disks, make sure they are on the system vendor's supported-disk list. All or most SAN and NAS devices designed for small offices are based on the open source Linux operating system. One difference between these devices and Linux computers is that the operating system in the SAN or NAS device is stored in flash memory and not on the devices' hard disks. Also, unlike a general-purpose computer, unless you are into serious system surgery, you are pretty much stuck with the operating system and updates supplied by the vendor.

SAN

A SAN storage device is called a *block-addressable device*, because it appears to your computer as just another disk drive, and the computer writes to hard disks in blocks of data. Typically with home and small office systems, only one computer connects to a SAN device at a time. In larger enterprise systems, one or more SAN storage devices can connect to multiple network servers and provide a high degree of redundancy and fail-over in case a particular server or storage device fails.

SANs designed for homes or small businesses typically use an Ethernet connection and a communications protocol called *iSCSI*, although some SAN devices can also con-

nect through USB 3.0. Thunderbolt-enabled SANs are also available. iSCSI carries the SCSI disk interface protocol over Ethernet. The SAN is called an iSCSI *target*; iSCSI *initiator* software is loaded on the host computer, and uses an Ethernet connection as a SCSI host adapter. Although iSCSI could share the same Ethernet connection used for LAN and Internet connectivity, a separate, dedicated network connection in the host computer is sometimes used for better performance and security. Most small office SANs include one or two 1 Gb/sec Ethernet interfaces, and some have an internal expansion slot to allow the addition of a 10 Gb/sec Ethernet card. Performance can sometimes be improved considerably by using a 10 Gb/sec Ethernet card in the host computer.

NAS

A NAS device is a *file-addressable device*; as far as your computer is concerned, the NAS appears as another computer to which you (or your computer) can log in and share files. The protocols for communicating between a NAS and a computer depend on the computer's operating system. Windows systems use SMB/CIFS (Server Message Block/Common Internet File System), Macintosh systems use AFP (Apple Filing Protocol), and Linux and Unix systems use NFS (Network File System). Users or computers log into the NAS device as they would another computer on the network.

Like most small office SAN devices, NAS devices for small offices typically have one or two 1 Gb/sec Ethernet connections, while some have an internal expansion slot to allow the addition of a 10 Gb/sec Ethernet card.

Some NAS devices include built-in facilities to back up your computer's hard disks, media sharing functions for music and video, and remote connection facilities, allowing you to remotely transfer files to and from the NAS. In addition, some NAS devices provide specific support for Time Machine, Apple's native backup utility.

Some vendors provide applications that run on their NAS devices, turning them into limited-function, general-purpose servers. Some even provide software development kits and encourage third-party development as well. These are, after all, Linux-based systems, and their functionality is only limited by CPU power, RAM, connectivity, and expansion capability.

File Servers

A network file server is similar to a NAS device in that a user or computer can log in and transfer files. A file server, however, has more processing power and expansion capability than a NAS device; its operating system is stored on a hard disk or SSD instead of the small flash memory module used in a typical small NAS device. It will usually sup-

Technically, a server is a function, not a thing. Using a technique called virtualization, *multiple servers can run on a single computer. Virtualization is beyond the scope of this book, so we will refer to a server as a dedicated machine instead of a function.*

port multi-core CPUs or multiple CPUs. It will likely have multiple expansion slots, support for a greater amount of RAM, and support for server-based applications. Some NAS devices support server-based applications as well, but on a more limited basis. File servers can be purpose-built systems from vendors such as HP and Dell, or they can be general purpose computers used as servers. Purpose-built systems will often provide for lights-out remote management, which allows nearly all management and upgrade functions, including BIOS access and firmware upgrades, to be performed remotely. Purpose-built servers often ship with dedicated RAID controllers and multiple Ethernet ports. Server storage can be internal disks and disk arrays, or external disk arrays, including SAN devices, connected via SAS, iSCSI, Thunderbolt, and other interfaces.

Network file servers, like desktop and laptop computers, can run a variety of operating systems. Server versions of Windows, Mac OS X, and Linux are the most common. All three will support Windows, Mac OS X, and Linux clients, although cross-platform support sometimes requires expert assistance.

One important difference between a file server and a small-office NAS device is that the NAS device is more or less turnkey—a few simple setup procedures through a management GUI and you are ready to go. Setting up a file server requires much more work and technical expertise.

Planning For Growth

Not too long ago, my 10 MP camera created RAW images about 10 MB in size. My current 24 MP camera creates RAW images about 25 MB in size. By upgrading my camera body, I increased my future image storage requirements by 250%, assuming I average the same number of shots per year. (However, the average number of shots I've taken per year has also increased, compounding the issue.) Camera sensor resolutions are growing, so you can be pretty sure your next camera will create larger images than your current camera.

Another consideration is the use of Photoshop; when I edit with this program, the size of the resulting TIFF files averages 80 MB. Also, many still photographers are now shooting HD video, eating up yet more disk space. The point is that if you keep taking photographs and videos, you will need a lot more storage space. There are a few important things you may want to consider:

- Add storage before it is needed. Don't wait and make a panicked decision when you're critically low on disk space.
- Plan for future storage. For example, if you are buying a multi-disk array for active storage, see if that system supports future expansion, either by adding additional disks, replacing smaller disks with larger disks, or other means. Some arrays support *thin provisioning*, which allows you to create volumes that are logically larger than current disk capacity so that you can add additional storage without having to rebuild the array.

- Plan for migration to larger storage. If you know that you are going to replace a storage system, have a migration plan in place before you do so.

Primary Storage Strategies

Effective storage strategies will vary depending on a number of factors, including:

- the size of your image library (expect growth over the next several years);
- the type(s) of computers used;
- requirements for access by multiple people or from multiple computers;
- cost considerations; and
- the level of available technical expertise.

All of these issues should be considered when making storage decisions. The size of your library and expected growth will dictate current and future capacity requirements. The types of computers being used (Mac, Windows, etc.) must also be considered because it is possible that some storage devices, especially SAN and NAS devices, might not be able to communicate with your computer(s). If multiple people need to access data, that might mean that you need a shared storage system like a NAS or a file server. Cost is obviously a factor and your storage solution(s) must be affordable. Lastly, do you have the technical expertise, or is it available to you, to support the systems that you implement? Every additional device added to your data-processing/image-processing environment adds to its complexity, and makes troubleshooting and problem resolution more difficult. If you rely on someone other than yourself for technical support and problem resolution, it might be a good idea to include them in your decision-making process.

The below list of strategies is not definitive—it outlines some common approaches.

Strategy # 1—Use Your Computer's Internal Hard Disk

This is by far the simplest approach if you have a small library of images. As your library grows, however, you will likely find yourself running out of disk space. Also, if you have a system disk crash, your library crashes as well. As long as you have good backups and enough time to rebuild your system, this isn't a major problem.

Strategy # 2—Replace Your Computer's Hard Disk with a Larger One

Since most computers do not ship with the largest hard disk available, replacing your existing disk with a larger one can be a viable, cost-effective option. Since this procedure requires transferring all data to the replacement disk in a manner that allows that disk to be bootable (the disk must have the visible and hidden data needed to start your computer), you will need the disk cloning software necessary to transfer the data and the expertise needed to perform the disk swap. Hard disk vendors often sup-

ply this software with new, retail-packaged hard disks. If you are not comfortable with this task, most computer service organizations can do it for you.

Some disadvantages to this approach are that the replacement process requires at least several hours of downtime, and some of the space on the new disk will still be required for the operating system, programs, and support files.

Strategy # 3—Add a Second Internal Hard Disk

Most desktop and some laptop computers will accommodate one or more additional internal disks. This is a better option than replacing your existing disk because all of the new disk's space is available for data. It's also less complicated than disk replacement, since you will only be moving data to the new drive, which can be done with your computer's file copy utilities. You may have to format the drive, which is done using the computer's disk preparation utilities. Formatting prepares the disk to be used by your operating system. Some disk vendors provide their own installation software.

Using a second internal disk provides other benefits, as well. First, if there is a problem with your system disk, your data is likely still safe. Second, if you want to create a disk image for system recovery, you don't have to include your data, so your image can be smaller and recovery can be quicker. Third, if you upgrade to a new system, you can simply move your data disk. If your system allows you to add an additional hard disk, and your image library will fit on a single disk (with room for expansion, of course), this is a very cost-effective approach.

Strategy # 4—Create an Internal RAID Array

This strategy is possible if your computer's BIOS supports RAID (or you add a dedicated RAID controller), your computer's case has space for multiple hard disks, and your computer's power supply provides enough power for multiple disks. This modification will add disk redundancy and increase capacity. However, there are plenty of downsides. First, software- or firmware-based RAID will impact performance. Adding a dedicated RAID controller will help, but be careful—many low-cost add-in RAID controllers employ firmware-based RAID, and provide no performance benefit.

Second, building an internal RAID array is complex, and if problems occur, you are probably on your own.

Third, if you need to move your disks to another system, don't assume the replacement system's firmware-based RAID is compatible with your original system. You will likely have to perform a complete RAID array rebuild, losing your data in the process. In my opinion, an external disk array is a better option.

Strategy # 5—Add an External Hard Disk

Adding an external hard disk has the same advantages as adding a second internal hard disk. It also has the advantage of being easily removed and transported. If you use two computers at different times, such as a desktop and a laptop, storing your images (and catalog, if you use cataloging software like Lightroom) on the external disk makes switching systems easy. The downside is that it's easy to accidentally disconnect the disk at the wrong time, causing data corruption. Still, this is an easy and cost-effective way to add storage. For performance reasons, avoid USB 2.0 and FireWire 400.

Strategy # 6—Add an External Disk Array

An external disk array can provide disk redundancy and capacity beyond a single disk. If you are accessing the array from a single computer, a SAN device can potentially provide better performance than a NAS device. This sometimes requires adding driver and/or iSCSI initiator software to your computer, and installing an Ethernet expansion card. A NAS device, on the other hand, connects to your network switch and uses your computer's native network communication protocols. Software for management and configuration of the NAS device will likely have to be installed to one computer on your network. SAN and NAS devices for the home and small office markets typically support Windows, Macintosh, and Linux clients, but it is a good idea to verify the connectivity options before you buy.

Not all NAS and SAN devices are equal. Every vendor has its own set of features. Some provide automatic backup facilities, but these are limited. At least three vendors, Drobo, LenovoEMC, and Netgear, provide a software developer's kit (SDK) for people who want to develop applications to run on their NAS devices. Some products allow you to expand capacity by adding disks to existing arrays or replacing lower-capacity disks with larger-capacity disks. Some array vendors provide a service to make it easy for you to set up the array in a remote location and use it as a *private cloud*. Another difference is the granularity of access control and security. Some systems provide very basic username-only access control, while others provide support for users and groups, as well as management via common network directories such as Microsoft's Active Directory or Apple Open Directory.

Most, if not all, SAN and NAS devices sold for use in the SOHO market are based on the Linux operating system. Most use a variant of the RAID software that ships with Linux. However, just because they use the same operating system and software doesn't mean that there is any degree of standardization, even between models from the same vendor. For practical purposes it is best to treat all of these systems as proprietary. Some vendors do have a degree of compatibility between models, allowing you to migrate from, for example, a 4-bay device to a 6-bay device. This is not the case with all models, and definitely not the case with systems from different vendors.

When a disk array is configured for no disk redundancy (RAID 0), the failure of any disk means the loss of all data, and requires the array to be rebuilt and data restored

from backup after the failed drive is replaced. This means that the array will not be available until data is restored. When the array is configured for redundancy (RAID 1, 5, or 6, for example), it will still have to be rebuilt after the failed disk is replaced. The rebuild process can take hours or even days, and with most systems, performance will be severely degraded during this process.

Even with the potential problems, for those who want redundancy or need greater capacity, an external array is a good solution. Just be prepared for potential failures. Never assume that a disk array with redundancy is completely protecting your data. It's still a computer with a CPU, operating system, RAM, ROM, motherboard, and power supply. As with any other computer, components can die and data can get corrupted.

Support

Different vendors provide different levels of in-warranty and out-of-warranty support for external arrays. U.S. warranties can vary from one to five years. Some vendors include phone support for part or all of the warranty period. Some provide advance shipment of replacements as part of the standard warranty, while some require you to purchase a service plan for this amenity. Some vendors provide data recovery services (in most cases, at an extra charge), but some do not. There are also qualified third-party data recovery services, but it is easier if the vendor provides this since their staff is familiar with each of the vendor's models.

Here are some questions to ask about support before you buy a storage device:

- What is the warranty period?
- What does the warranty cover? What doesn't the warranty cover?
- Are extended or premium service plans available? What do they cost and what do they cover?
- What are the hours for phone support (or chat support)? Is phone support available during the entire warranty period?
- Is extended phone support, such as 24-hour support, available as part of an enhanced service plan?
- Are parts available, both in and out of warranty?
- Does the vendor provide advance shipment of replacements?
- Are data recovery services available? How much do they cost? How long will the service take?

Disk arrays do fail and data does get lost, so make sure you maintain good backups.

> **Note:** When setting up a storage array, read the documentation first. Make sure you understand the disk installation procedures and use supported disks, especially if you're installing disks that have been formatted for another system.

Strategy # 7—Use a Network File Server

For most photographers, a file server is overkill. If a small office needs shared data, a NAS device is a more cost-effective solution. If you need shared databases or applications, a dedicated network server can make economic sense. Even though shared databases can run on a desktop computer, access by other users on the network can affect that workstation's performance. Also, desktop machines can lock up, crash, or shut down at inopportune moments; those events prevent access, if only temporarily, by other users and can impact database integrity. If you have multiple computers that need to be backed up, a network server is a great location to host a backup system.

Another advantage of a network server versus a NAS or SAN device is that you have access to and control over the operating system. Most SAN and NAS device vendors only allow limited access, if any, at a system level, and you only have one choice for the operating system. This means that when the vendor decides to EOL (*end-of-life*) the device, you will likely no longer have access to patches and upgrades unless you like hacking systems (and you have the expertise to do so). In that case, there is often a do-it-yourself way around this kind of problem.

The major disadvantages to using a server are cost and complexity. Maintaining and managing a server, even if it runs a version of your desktop operating system, requires a certain skill set. If you take this approach and don't feel completely comfortable in setting up and managing the server, find a good support organization that understands the ins and outs of server setup, management, and troubleshooting. There are also cost issues. The hardware for a low-end server may be about the same as some SAN and NAS devices, but you will also need an operating system and, in some cases, a client license for each computer accessing resources on that server.

Support

As with disk arrays, support for servers is a critical issue. Most or all of the support issues for disk arrays apply to servers as well. With a server in warranty, you may or may not have on-site service from the manufacturer. Most vendors provide extended warranties with on-site service at a reasonable cost. However, be aware that the warranty typically doesn't cover saving or restoring data, so good backups are essential. Also, defective hard disks have to be returned to the server supplier. Major server vendors usually offer the option for you to keep failed disks; this is primarily for security reasons, but it affords you the opportunity to ship the disk to a recovery service in case you need to salvage data that wasn't backed up.

Three External SAN and NAS Devices

I have chosen the following SAN and NAS devices not to specifically endorse any particular brand or model, but because they all have very different attributes, and therefore provide a reasonably good overview of what's available. When selecting a SAN or NAS, make sure you buy something that meets your specific needs.

All three of the units profiled, like most small NAS and SAN devices, use a Linux-based operating system loaded into non-volatile flash memory. All three vendors provide *software development kits* (SDKs) to allow third parties to create or port applications to run on their systems. The products differ in a number of ways, including their approaches to disk redundancy (RAID), features, and support and warranty policies. In the following profiles I have not attempted to discuss all of the features of each system—only those that I felt were most important.

LenovoEMC px4-300d: with front cover in place (left) and with front cover open (right).

LenovoEMC px4-300d

LenovoEMC (lenovoemc.com) is the new name for the higher-end storage products from Iomega. The lower-end products are now labeled LenovoIomega. The entire product line, which used to be owned by storage giant EMC, is now a joint venture between EMC and the Chinese company, Lenovo. The 300d desktop product line (there are rack-mounted units, as well) includes the two-bay px2-300d, the four-bay px4-300d, and the six-bay px6-300d. Other than size and disk capacity, the units are almost identical. At the time of this writing, the average price for a diskless px4-300d was $400-450.

The 300d uses the Intel Atom Dual Core D525 CPU at 1.8 GHz and comes with 2 GB RAM. Like other LenovoEMC/LenovoIomega storage arrays, it uses EMC's Linux-based LifeLine OS. It supports RAID 0, 1, 5, 10, 5-1 (hot spare), and JBOD. In RAID 5 mode, disks can be added to an existing array without completely rebuilding it or losing data. You can also migrate from a single disk to RAID 1 with two disks, and from RAID 1 with two disks to RAID 5 with three disks. Disks should be the same capacity, speed, and manufacturer. It is configured as a NAS device by default, but you can create one or more iSCSI SAN virtual drives, as well. Using 4 TB hard disks, the px4-300d has a maximum raw capacity of 16 TB. Useable capacity will depend on the RAID level employed.

> *Originally a derisive term, JBOD means* just a bunch of disks. *In other words, each disk in the system can function as a stand-alone disk.*

The px4-300d comes with two gigabit Ethernet ports, two USB 2.0 ports, and one USB 3.0 port. It also includes a PCIe 4x expansion slot. It supports external storage UPS monitoring through the USB port, and functions as a print server for USB-connected printers.

Client support includes Linux, Mac OS, and Windows. It supports Windows workgroup networking and Active Directory domains. Access control is by both user and group. Apple Time Machine users can set up a network share as a Time Machine target. As with a Windows server, network access is based on shares. One limitation of

the 300d is that you cannot create shares for existing folders, and all shares are created at the root of the volume. The system includes video surveillance and media server software. The media server scans for content in shares that have media sharing enabled. Any media content contained in those shares is accessible to any user on your network with a media player. The system also includes a photo-transfer utility. Once configured, pictures are transferred from a USB-attached camera or card reader to a defined folder on the system. You can also create point-in-time snapshots of volumes, allowing you to recover deleted files or previous versions of existing files. The snapshots are created in the volume itself, and cannot be moved, copied, or backed up.

One important feature of the system is *Personal Cloud*. Personal Cloud allows you, or anyone you designate, to access the system from anywhere across the Internet. This allows you to access your data remotely or set up the system in a remote location as your own cloud backup server. Personal Cloud registers itself to a LenovoEMC server, which acts as an authentication service. To connect to your device, you authenticate through this server. You can connect to Personal Cloud in multiple ways: from a computer on your network, through a web browser, and from a smart phone. There is no charge for the Personal Cloud authentication service.

The px4-300d is a solid NAS/SAN disk array, and the Personal Cloud feature alone makes this system very attractive. One caveat—if you have a diskless unit, follow the setup instructions in the quick start guide and use supported disks.

Warranty and Support

The px4-300d comes with a three-year warranty. Standard support includes business hours email and phone, free firmware updates, knowledgebase, and advance hardware replacement, which means the replacement component is shipped before the defective part is returned. Additional service contracts are available, and out-of-warranty support is available on a charge-per-incident basis.

NETGEAR ReadyNAS 314

The NETGEAR (netgear.com) ReadyNAS 300 series includes 2-bay (312), 4-bay (314), and 6-bay (316) storage arrays. A three-bay expansion chassis is available that connects via an eSATA port. In addition to size and the number of drive bays, the two models differ slightly in the USB and eSATA port counts. Models are available with or without disks. With 4 TB hard disks, the 314 has a maximum raw capacity of 16 TB. Useable capacity, as with all such devices, will depend on the RAID level employed. At the time of this writing, the price for a diskless ReadyNAS 314 is $550-$652.

The 314 uses an Intel Atom dual-core 2.1GHz CPU and has 2 GB of RAM. It includes two gigabit Ethernet ports, two USB 3.0 ports, one eSATA port, one eSATA/USB 2.0 combo port, and an HDMI port.

The ReadyNAS 314 supports two different RAID technologies: Flex-RAID and X-RAID2. Flex-RAID provides standard RAID levels 0, 1, 5, 6, and 10. Flex-RAID allows

you to add a second disk to a single disk system to create a RAID 1 array, and add an additional disk to a three-disk RAID 5 array. Flex-RAID supports the use of differently-sized disks.

Netgear ReadyNAS 314: with front cover in place (left) and with front cover open (right).

X-RAID2 is a proprietary single-volume RAID technology that provides automatic array configuration. It allows you to expand storage by adding additional disks or replacing lower-capacity disks with higher-capacity disks. A single-disk array provides no protection. Adding a second disk provides redundancy, with data protection (parity) information spread across both disks. Each additional disk adds to array capacity, and the parity information spreads across all disks. You can convert from X-RAID2 to Flex-RAID and, depending on the RAID level, you can convert from Flex-RAID to X-RAID2 if you have a single volume.

The ReadyNAS 300 series uses the BTRFS (B-tree file system, sometimes pronounced "butter-fuss") journaling file system. Among other features, BTRFS provides for manual or automatic snapshots. As with the LenovoEMC 300d series, the snapshots are written to the same volume and cannot be copied, moved, or backed up. Unlike the 300d series, however, ReadyNAS can take snapshots of individual folders and files, not just the entire volume.

Client support includes Linux, Mac OS, and Windows. It supports Windows workgroup networking and Active Directory domains. Access control is by both user and group. For Apple Time Machine support, you must set up a virtual volume. Although you specify a fixed size during setup, the size can be changed at any time. The ReadyNAS 300 series provides Time Machine support to a remote array. As with a Windows server, network access is based on shares. Like the LenovoEMC 300d series, you cannot create shares for existing folders, and all shares are created at the root of the volume.

NETGEAR has a private cloud function called *ReadyCLOUD*. ReadyCLOUD is an online service that provides discovery of and authentication to ReadyNAS storage systems in local and remote locations, including from iOS and Android devices. You can access a remote device with a web browser or an FTP client. With the ReadyNAS Remote client installed on Windows or a Mac, you can drag and drop files, mount a share as a remote file system (Mac), or set a UNC path or mapped drive to a share (Windows). With ReadyNAS Remote you can also synchronize folders between a computer and a ReadyNAS device.

The ReadyNAS 300 series provides support for UPS management and monitoring, but with a little extra. Not only can it monitor a UPS connected via a USB cable, it can also monitor a network-attached UPS using *simple network management protocol* (SNMP) or a UPS connected to a computer on the network by using *Network UPS Tools*

(NUT). For more information about NUT, see *Orderly Shutdown of Multiple Systems* in chapter 8.

If you have a diskless system, read the setup instructions in the *ReadyNAS OS 6 Desktop Storage Systems Hardware Manual*. Using disks removed from other systems can be problematic if you do not follow the setup instructions.

One of the biggest advantages of the 314 is its RAID expandability. Not only can you add disks to an existing array or replace lower-capacity disks with higher-capacity disks, you can also add an expansion chassis, although this would likely impact performance. The snapshot features of the BTRFS file system and the ReadyCLOUD remote access features also make this unit attractive.

Warranty and Support

The unit carries a five-year chassis warranty, valid for the original purchaser, covering hardware and fans. The external power supply is not covered. Free chat (English only) and phone support is available for ninety days after purchase. Additional support contracts are available.

Drobo 5D or 5N (Photo courtesy of Drobo, Inc.)

Drobo 5N and 5D

Unlike LenovoEMC and NETGEAR, which can be configured as both NAS and SAN, Drobo (drobo.com) devices are sold as either NAS devices or direct-attached storage devices. The Drobo 5N is a NAS device, while the Drobo 5D is a direct-attached storage device. Although the 5N and 5D are functionally different, they share most of the same hardware and software. At the time of this writing, online pricing for the 5D is $775-850 and the 5N is $500-600, without disks.

Common features:

- five-bay hot-swap desktop enclosure
- supports 3.5" SATA hard disk, desktop, and Enterprise
- 1 m SATA SSD bay
- battery backup
- Linux-based operating system with BeyondRAID array technology
- Mac OS and Windows support
- data-aware storage tiering
- drive spin-down
- higher performance than previous models

5D-specific features:

- two thunderbolt ports (second port for daisy-chaining)
- one USB 3.0 port
- Mac HFS+ or Windows NTFS file system

5N-specific features:
- gigabit Ethernet interface
- Common Internet File System (CIFS) / Server Message Block (SMB) and Apple Filing Protocol (AFP) support.
- Apple Time Machine support
- Drobo apps support

All Drobo devices, including the 5D and 5N, use Drobo's proprietary BeyondRAID technology. BeyondRAID provides either single-drive or dual-drive protection, so depending on configuration, either one or two drives can fail concurrently without data loss. Dual-drive protection can be switched to single-drive protection, and given enough free disk space, single-drive protection can be switched to dual-drive protection.

BeyondRAID allows the use of drives of different sizes, and efficiently uses the capacity of all drives in the array. Drives can be added, and given enough free disk space, removed as necessary, allowing the capacity to grow or shrink while the array is in service. Unlike traditional volumes, which require pre-defined disk space, Drobo's "Smart Volumes" are thin provisioned, which means disk capacity can be increased as required without having to redefine volumes. Volumes pull storage capacity from a common pool as needed, so that multiple volumes that exceed actual available disk capacity can be defined. Since volumes are virtual, if a volume is deleted or if data is deleted from a volume, the space used is returned to the common pool.

Drobo 5D and 5N support nearly all SATA disk drives, although for performance reasons "green" disks, such as WD Caviar Green and Seagate Barracuda Green, are not recommended. The units include an mSATA expansion slot specifically for an mSATA SSD card. SSDs can also be installed in a drive bay, but since most SATA SSDs have a 2.5" form factor, a 3.5" carrier is required. With SSDs, Drobo uses *data-aware-tiering*, which means that Drobo stores recently used data on SSD, and automatically moves data to and from SSD as appropriate. Both models include battery backup that, in the event of a power loss, keeps the unit powered on long enough to write any data in cache memory to non-volatile storage, preventing data loss. Both systems also have a drive spin-down feature to reduce noise and save power when the system is not in use. This is configurable between 15 minutes and one day, or never. Of course, drive spin-up after spin-down will briefly affect performance.

The Drobo 5D and 5N support disk pack migration from earlier models. The 5D supports migration from Gen2 4-bay Drobo with FireWire, Gen1, and Gen2 Drobo S, and the 5N supports migration from Drobo FS. Drobo claims significant performance improvements over previous models due to a higher-performance processor. The 5D's high-speed Thunderbolt interface should also provide dramatic performance gains.

The 5N supports Drobo Apps, a set of third-party applications that can be installed on the 5N. There are a limited number of apps currently available, but more are being developed. Currently available apps include Copy, a cloud storage and file sharing app,

and Plex, an app that makes video, music, and photos available on all media devices connected to your network. You can find out more about Drobo apps here: drobo.com/solutions/drobo-apps/index.php.

Drobo's biggest selling point is simplicity. You can use almost any SATA disk and Drobo automatically configures the array for you. Management is via Drobo Dashboard, a GUI application that gives you a visual picture of the device's configuration and health. However, it is somewhat more expensive than competing products and it doesn't include remote access or private cloud features.

Warranty and Support

The two-year warranty includes optional advance replacement and 90 days of telephone support. Optional DroboCare extends warranty to three years with anytime telephone support for the warranty period.

A Small Server for a Small Office

HP's new ProLiant MicroServer Gen8, which is designed as a server for a small business or remote office, has the same build quality as HP's larger x86-based servers. It's small (9.15" x 9.05" x 9.65"), available in a desktop form factor, fairly quiet (after its initial startup), and reasonably attractive. HP even supplies custom front bezels in red, blue, and black.

The ProLiant MicroServer Gen8 can be used as a *headless* server: with Integrated Lights Out (iLo), it can be completely managed from any computer with a browser or smart phone; it doesn't need a keyboard, mouse, or monitor (although you can attach them if you like). The system can be powered on and off, and BIOS settings can be changed—even the BIOS firmware can be upgraded from another computer. Using virtual CDs, DVDs, or USB flash drives, software can be installed without physically touching the server. This is advantageous, especially for a small office without an IT staff, because it's easy for a remote IT department or managed service provider to maintain the server remotely.

The server is available with two CPU options: an Intel Pentium G2020T (dual-core, 2.5 GHz, 3 MB cache) or an Intel Celeron G1610T (dual-core, 2.3 GHz, 2 MB cache). These are both low-power (35W) processors. Two gigabytes of memory is standard, expandable to 16 GB. There are two GbE ports for connectivity to the network, five USB 2.0 ports (one is internal), and two USB 3.0 ports. A 9.5mm DVD drive is optional. The unit has four non-hot-swappable drive bays, and firmware-based SATA RAID is standard. The standard controller supports RAID 0, 1, and 10. HP supplies an optional SAS hardware RAID controller that can be accommodated by the unit's PCIe 16x expansion slot.

HP also supplies an optional matching web-managed 8-port gigabit Ethernet switch that sits above or below the server. The switch provides automatic discovery of ProLiant Gen8 servers on the network, and the switch's management webpage provides a link

to each server's iLO management page. The switch sup-
ports *link aggregation*, or the binding of two Ethernet
ports for improved server throughput and redundancy.

HP supports Microsoft Windows Server, Red Hat
Enterprise Server (RHEL), SUSE Linux Enterprise Server
(SLES), and Canonical LTS Ubuntu (Linux). The HP firm-
ware RAID controller is not supported with Ubuntu, so
it must be installed in Advanced Host Controller Inter-
face (AHCI) mode instead of RAID mode. Linux soft-
ware-based RAID can be used in this case and the per-
formance should be similar. Other Linux distributions,
although not officially supported and certified, will work

HP ProLiant MicroServer Gen8 with PS1810-8G 1 Gbit Ethernet Switch: with front cover in place (left) and with front cover open (right).

as well. I installed OpenSUSE version 12.3 in AHCI mode with software-based RAID
with no problems.

Installing Samba, a Windows server emulator, on a Linux server provides support
for Windows clients either through Windows workgroup networking or Active Direc-
tory. Apple networking support, including Time Machine support, is provided by
Netatalk. Both are free and open source. Samba (samba.org) is included with most
Linux distributions. Netatalk can be downloaded from netatalk.sourceforge.net. This
approach is used by small NAS devices, which almost universally use Linux for their
operating systems. Using Samba on a Linux server gives you more flexibility in how
you set up shares and user accounts than most NAS devices targeted toward the
SOHO market.

The ProLiant MicroServer Gen8 provides decent performance for the small business
or remote office at a reasonable price. In my limited testing, disk write performance
with software RAID 1 and 7200 RPM SATA disks was about 55 MB over GbE. This was a
very informal test. I copied about 300 GB of images, ranging in size from 1.5 MB to 25
MB, from a Windows PC, also with a 7200-RPM SATA disk. A test with the same data
set between two 7200-RPM SATA disks in the same computer yielded a result of about
45 MBps, and a test with a 4-disk NAS device yielded about 49 MBps.

Because of its excellent remote management, the MicroServer Gen8 is a good fit for a
small company that relies on a third-party service provider for system management and
maintenance. The base server, without disks, sells for $449 or $529, depending on CPU.

Warranty and Support

The warranty is one year, parts only. All components are considered customer self-
replaceable (meaning that a reasonably tech-savvy end-user without specialized
knowledge should be able to replace any component). Telephone support for hard-
ware is included, and replacement components are sent within 24 hours after prob-
lem determination. Additional service plans are also available, as well as service from
local independent organizations.

BACKUP AND ARCHIVING

Backup and *archiving* both refer to storing copies of data. The difference between the two is their purpose. Backup refers to copying and storing data for use in case of emergency. Archiving is data stored for long-term retention.

When you make a backup, you must consider all of the factors that can affect the use of your data, including accidental file deletion, system failures, and natural disasters. You must not only consider the data, but everything that must be done to get you up and running again. There are four primary purposes for backing up files:

- **Restoring deleted, overwritten, or damaged files:** This is by far the most common reason for restoring from backup. In many cases, however, the most recent backup is missing the same deleted file or has the same damaged file. Because of this, the ability to maintain multiple versions of files is important. This can be done by either using a backup media rotation scheme that maintains multiple backups or by using software that can maintain multiple file versions. The traditional method, used for years with tape backup systems, is to maintain multiple sets of backup media. A newer approach, which started with disk-based backup systems, is software-base versioning, in which older file versions are maintained even though newer versions are added to the backup.

- **Restoring after a system failure:** In this case, it is desirable to be able to do a disk image restore, or use a clone disk to replace the original system disk, giving you the ability to start the system without having to do time-consuming data restoration. These approaches (discussed later in this chapter) allow you to restart a system in the exact state it was in at the time of its last backup. This works well in the case of a hard disk failure. This does not always work as well when you are replacing or upgrading a system, since a new system usually has different hardware or a different operating system version from the old system. Fortunately, many (but not all) of the current backup software programs that do imaging can restore to different hardware. Also, many of the software programs that do imaging or cloning allow you to restore specific files and folders.

- **Restoring after a disaster:** In this case, not only is the original system that was backed up likely not available, the building in which it was located might be gone or so severely damaged that it is not available. For these situations you will usually have to rely on backups stored off-site.

- **Archiving:** Requirements for archiving vary from industry to industry, but in nearly all organizations there is a need to archive at least some data. Archiving is often done separately from backup since not everything on a particular computer or disk system may need to be archived, and there may be specific legal requirements for long-term storage of certain kinds of data. Professional photographers may have large libraries of images that are no longer active. Keeping and managing those images on primary storage systems and backing them up regularly is time-consuming and expensive. It is often much better to move inactive files to a separate archive on an off-line disk, optical media, or magnetic tape.

In the case of both backup and archiving, you should maintain multiple copies of data. When you are making decisions about the policies, procedures, and technologies that you will use, keep the purposes for copying and storing that data in mind. Of course, all of this must be done in a suitable time frame. If you make your living as a photographer, you might be able to survive a few days of downtime, but more than that could be disastrous.

What to Back Up

Your data, including your images and business data (customer files, accounting data, contact lists, critical email files, etc.), should be first and foremost in your mind. This is the data you can't replace. Custom software configuration files, templates, and other data that customizes software should also be backed up. This includes items such as Photoshop and Lightroom templates, and browser bookmarks. This takes some care, because programs and operating systems all bury this data in different locations. Lastly, even though you can reinstall programs and operating systems from original media (assuming you still have such media), how much time will it take? Ideally, you should have the ability to either restore this data quickly and easily, or be able to run from a clone disk if your primary hard disk has crashed. Accomplishing all of the above may require more than one backup approach and more than one type of software. In addition, you have a large variety of backup technologies from which to choose.

Creating a Data Protection Plan

Instead of concentrating on backup alone, I suggest creating a comprehensive data protection plan. A data protection plan is an outline of your data protection goals. It can be formal or informal, but should include the following:

- **Minimization of downtime:** You need to consider the consequences of short-term and long-term downtime. Some downtime is inevitable. If nothing else, most systems must be shut down for occasional maintenance. You need to determine the maximum unplanned downtime you can afford, and then weigh

that against the costs of implementing the systems and services necessary to achieve your desired level of uptime.

- **Access to data in an emergency:** Data is backed up so that it is available in an emergency. This could be a disk failure, data corruption, accidental data deletion, or a number of other causes. The backup data should be available and you should have the means to restore or access it.
- **Long-term storage of archived data:** Make sure that your data protection plan provides for archival storage of data that must be kept for legal, financial, or business reasons. Plan to migrate archived data to new media every five to seven years.
- **Verification and testing of backups and archives:** Most file and folder backup programs provide an optional verification process, usually requiring a second pass, to confirm that the data written to the backup medium is the same as the data on disk. LTO tape drives do an immediate verification after write, checking and correcting for possible tape errors. Even with verification, it is still a good idea to manually check backup media to make sure your data is readable.
- **Moving unused data from spinning media to static media for archiving:** This practice frees up space being used to store inactive data.

An effective data protection plan should include a method to quickly restore a system in case of emergency, and a method to restore individual files and folders, including previous versions. It should include local and off-site storage of backup and archived data.

In an ideal system, you can restore data to any previous point in time or file version. You can perform a *bare-metal restore*, which quickly and easily restores a complete system directly from backup, including system files and data, to the same or different computer hardware. Also, you can restore this data locally or in a remote location. This is what backup system vendors often promise; unfortunately, reality sometimes fails to live up to this ideal. Good policies, procedures, and appropriate backup hardware and software can get close, but always be prepared for a few hiccups.

The 3-2-1 Approach

3-2-1 is a simple backup strategy: **Maintain at least three copies of data on at least two different types of media in multiple locations, with at least one copy maintained off-site for recovery in case of a disaster.**

I recommend this simple strategy, but it's just a general outline; you still need to fill in the details yourself. When it comes to data protection, one size does not fit all.

The Origins of 3-2-1: *The name "3-2-1" was originally a marketing slogan created by Patrick Dowling and Steve Tongish while they were working at Plasmon. (Plasmon has since declared bankruptcy and Allied Storage Technologies acquired its assets.) The slogan was developed with market intelligence provided by analyst Carolyn Dicenzo, Research Vice President for Gartner, Inc., who supported Plasmon in its 2007 efforts to popularize the concept. "An archive strategy to meet today's demanding compliance standards is a business imperative. IT executives should strive to separate fixed content data from production data and move static data to an active archive," said DiCenzo. "A best practice for securing long-term data archives is to maintain three copies of data on at least two different types of media in multiple locations, mitigating the risk of media failure. At least one copy of the media should be removable and be maintained off-site for disaster recovery purposes."*

After Plasmon went into receivership, Tongish moved to QStar Technologies, where he and Dowling reused the concept of 3-2-1. QStar then produced marketing collateral based on 3-2-1, and other companies adopted it, as well. It has since become firmly established as a basic principle of data backup and archiving.

Original Plasmon ad promoting their product with the 3-2-1 system

Plasmon

Make Data Archiving as Easy as 3-2-1

IT organizations are looking for a better way to protect and retain long-term data. Many now recognize that traditional backup and replication does not provide an effective data protection strategy. Storing long-term data on spinning disk and backing it up repeatedly simply adds needless complexity, costs and risk.

Plasmon has eliminated the complexity and risk associated with retaining long term data while enhancing the data protection service levels of online backup, lowering operational costs, and accelerating data recall. Plasmon's archive solutions have been specifically architected to adhere to the accepted industry **3-2-1 Archiving and Data Protection Best Practice***. And you'll find that with Plasmon, creating a secure archive environment that meets all long-term data retention requirements is just as easy as 3-2-1...

Plasmon's 3-2-1 Archiving and Data Protection Best Practice implementation calls for a minimum of 3 copies of archived data, stored on 2 different types of media, 1 of which is removable, permanent and energy efficient. To access the Plasmon archive, users and applications interact with the system as a standard NAS file system. Automated rules ingest data written through the NAS directly into the archive's virtualized environment. Data can be single-instanced, compressed and encrypted in this process to guarantee storage efficiency and data security. The next steps are precisely 3-2-1:

3 The archive must make at least 3 copies of the data. These should include a "rapid access" copy accessible online to meet the retrieval performance required by business critical applications, a "copy of record" archived to guarantee the absolute security and authenticity of the data over its life-span, and a disaster recovery copy that can be pre-staged for remote failover when disaster strikes.

2 The archive must store the data copies on at least 2 different types of media. The most appropriate options are magnetic disk and secure ultra density optical disk (UDO), an ISO standard. This allows you to match the business needs of the 3 copies to the strength of the media while creating a resilient storage infrastructure that protects data from a single mode of failure.

1 At least 1 of the data copies must be stored off-site on removable media. True WORM UDO disk media addresses this requirement, providing absolute data authenticity and unmatched permanence with a media life of greater than 100 years. UDO also consumes zero power when inactive, making it the greenest possible archive solution. UDO is an obvious choice for the copy of record and provides the most cost-effective option for the disaster recovery copy.

The 3-2-1 Archiving and Data Protection Best Practices provide the security, resilience, permanence and cost-effectiveness essential for a professional archive environment, and only Plasmon delivers the full-range of 3-2-1 capabilities you need to deploy a simple and effective archive solution.

* Gartner Group - Carolyn DiCenzo, Digital Archives: Long-Term Planning Assumptions

Global Sales

Americas & Asia Pacific Sales HQ
370 Interlocken Blvd., Suite 600
Broomfield, CO 80021
800.451.6845
Sales@plasmon.com

EMEA Sales HQ
Whiting Way,
Melbourn
Hertfordshire, SG8 6EN
+44 (0) 1763 262963
emea.sales@plasmon.com

www.plasmon.com Archive Without Compromise™

Backup Hardware Technologies

You have a choice of hardware technologies to use for backup, and they all have their pros and cons. If you follow the 3-2-1 approach, you will use at least two technologies.

External or Removable Disk

External and removable disks have the advantage of reasonably low cost per GB combined with relative ease-of-use.

External Disks

Plugging in an external disk using USB 3.0, eSATA, or Firewire 800 is simple. These disks are sold in stores like Costco, so the prices are often lower than equivalent internal disks. The disk is in an enclosure, so it has some protection from shock. 2.5" external disks usually take power from the computer through the data connection, but 3.5" disks require an external power supply. There's no standardization, so swapping disks may also mean swapping power supplies and power cords.

Removable Hard Disks

Removable hard disks have similar advantages and disadvantages as external disks. Removable disks are usually bare (internal) hard disks that are inserted into an external docking station or a carrier installed in a 5¼" device bay in a computer. The disk carriers use standard SATA data and power connections, and the external docking stations use eSATA or USB 2.0 or 3.0. Some carriers and docking stations only accept 3.5" disks, but some accept both 2.5" and 3.5" disks. If you are using a disk carrier connected to an internal SATA port, it is a good idea to set the SATA port for *Hot Plug* in your computer's BIOS setup. This allows you to safely install and remove disks while the system is running. If you are using bare disks, it is a good idea to use a case or protective device when transporting and storing them.

Issues with External and Removable Disks

The advantage of external and removable disks is that they can stay connected and powered on or they can be disconnected and stored elsewhere. If they remain connected, they are subject to many of the same potential problems that can affect your primary storage, such as power-related issues, accidental file deletion or corruption, viruses and malware, and normal disk failures. Disks that are disconnected and stored can degrade over time. Disk manufacturers do not quote a shelf life for disconnected hard disks, and most have an average life of five years for disks in normal use.

In addition, the life of your disk-based backups is limited by the availability of the technology needed to connect them to a computer. For example, the ST-506/412 inter-

face created by Seagate in 1980 was the major disk interface standard into the 1990s. Today, if you had a working ST-506/412 drive, you would be hard-pressed to find a way to connect it to a modern computer. This is one reason to periodically refresh your long-term archives to newer media. Another issue is not with the technology itself, but how people use it. Many people back up or copy data to a single disk and think they are protected. Even worse, they continually copy new data over older data. Remember 3-2-1!

Disk Cartridges

There are several disk cartridge systems on the market, but the only one with multiple vendor support is the RDX cartridge system that was developed by ProStor Systems Inc. in 2004. Numerous companies have licensed the technology, and the product is available under many brand names, including Tandberg Data, HP, Imation, and Quantum. The cartridge incorporates a 2.5" hard disk in a hermetically sealed plastic cartridge. Internal carriers and external docking stations are available for RDX. The major issue with RDX and other cartridge systems is cost: disk cartridges typically cost two-to-three times that of bare or external disks.

RDX vendors claim the cartridges have an archival lifetime of thirty years, and can sustain a 1-meter drop on a concrete floor. This claim is apparently based on a single accelerated-aging test that used high heat and humidity (conditions to which disks are not usually subjected) to test the cartridges. The test did not determine magnetic signal fade over time, something that affects all magnetic media to one degree or another. You can see the study here:

dataarchivecorp.com/pdf/prostor/RDX%20Removable%20Disk%20Archivability%20Study.pdf

Optical Disc

For backup purposes, CDs are no longer viable for most photographers, due to their limited capacity. DVDs are also less viable than they were a couple of years ago, because the size of digital images has grown dramatically. Less than two years ago, for example, my RAW images were about 10 MB in size; now they're about 25 MB. A single-layer DVD can hold fewer than 200 images, while a double-layer DVD would hold fewer than 350.

Even though the cost of Blu-ray discs has dropped substantially, in terms of capacity, they make less sense for backup than they once did. I currently use 32 GB and 64 GB memory cards. A single-layer BD holds 25 GB and a double-layer holds 50 GB, so backing up a single 64 GB card would require at least two discs. I could use BDXL, but at $40 and higher per disc, I can't justify the cost.

There is also the issue of life span (see chapter 2). CD-Info (cd-info.com) claims a shelf life of 50-200 years for recorded CD-Rs, 30-100 years for recorded DVD-Rs, and

30-200 years for recorded BD-R and BD-E. On the other hand, a document posted on the U.S. National Archives website (http://www.archives.gov/records-mgmt/initiatives/temp-opmedia-faq.html) says, "CD/DVD experiential life expectancy is 2 to 5 years even though published life expectancies are often cited as 10 years, 25 years, or longer. However, a variety of factors...may result in a much shorter life span for CDs/DVDs." The difference between pre-recorded music and video CDs and DVDs that you buy in the store and writable CDs and DVDs is that the pre-recorded discs are pressed, while the writable discs are burned.

If you still plan to use optical media for backup, I would suggest reading the National Archives document referenced above. Also, make sure optical media is not your only backup media.

NAS or SAN Disk Array

The big advantage of NAS and SAN devices is capacity. In addition, some arrays allow you to expand capacity by adding disks or replacing low-capacity disks with larger-capacity disks. These devices can give you enough capacity to store backups of your data, and images of your boot disk or partition for quick recovery in an emergency. If your budget allows, this is a good option for the primary backup system in your 3-2-1 strategy.

If you have more than one computer on your network, a NAS probably makes more sense than a SAN, since it allows you to back up all your computers to the same device. Many of today's devices function as a NAS or a SAN, and some allow both functions concurrently, although the two functions cannot access the same data. Bear in mind, however, that NAS and SAN devices are computers, and subject to the same issues as other computers. Any component in the device can fail, including multiple hard disks. The devices typically remain powered-on all or most of the time, so they consume a significant amount of power. If you use a NAS or SAN device for backup, you should also consider using some form of off-line storage, such as removable disks or magnetic tape, as a second form of backup.

Magnetic Tape

Although disk-based backup has become popular in recent years, the use of magnetic tape continues to grow as well. There are several reasons for this:

- **Tape is reliable.** Current tape technology, such as LTO Ultrium, has proven to be very reliable. When properly handled and stored, LTO storage life is estimated to be about thirty years. Based on bit error rates for tape and sector error rates for desktop SATA disks, LTO is about 100 times as reliable as disk.

It is prudent to migrate data from tape or any other backup or archive media every five to eight years.

- **Tape is portable.** Magnetic tape is easy to transport or ship. Current tape technologies are very resistant to shock.
- **Backing up to tape is faster than backing up to disk in most circumstances.** In the past, backing up to tape was slow because it had to be fed at constant speed. Modern LTO drives use variable speed and buffering to alleviate this problem.
- **Tape is cost-effective.** Although the per-terabyte cost of hard disks continues to drop, so does the cost of tape. For example, at the time of this writing, the street cost of an LTO-5 tape cartridge with a native (uncompressed) capacity of 1.5 TB is $33-40. The cost of a 1 TB, 3.5" desktop-grade hard disk is $50-80. There is, of course, an initial investment in the tape drive and SAS host adapter.
- **Tape is safer.** Because tape is taken offline, it is not susceptible to the same system and software glitches that can affect disk-based backup systems. Also, since tape doesn't use the same file systems as disks, it is less susceptible to the malware that can corrupt disk systems.

All major video production studios use tape because of its cost-effectiveness, reliability, and suitability for long-term storage. Even online storage services use tape. On February 28, 2013, a software update effectively deleted all on-line copies of about 0.02% of Google Gmail data. Fortunately, Google backed up that data to tape. Google's blog entry about the incident is here: gmailblog.blogspot.com/2011/02/gmail-back-soon-for-every-one.html. A third-party blog post is here: blog.bandl.com/2011/03/07/why-the-google-incident-proves-relevance-of-tape-storage.

Tape does have some disadvantages:

- **Tape is a linear medium.** It does not lend itself to deleting or changing individual files. This is the case even with LTO's Linear Tape File System (LTFS). When you "delete" a file from LTFS, the space used is marked as deleted, but it is not released for reuse. Even though tape records on multiple parallel tracks (LTO-5, for example, writes to 1280 parallel tracks, writing to 16 tracks each pass), restoring a single file is slower then restoring from disk because the initial seek time is longer. Seek time for LTO tape is in the tens of seconds, while seek time for a disk is in milliseconds. Restoring a large block of contingent data from tape should not be slower than restoring from disk (other than the initial seek time) since restore time is limited by the write performance of the target disk. In other words, the limiting factor is usually how fast the disk being written to can ingest the data, regardless of whether it comes from tape or another disk.
- **Tape storage is static.** Disk backups can be dynamic, with constant, continuous updates. All updates and changes to data on tape must be added to the end of the existing data. This makes tape unusable by some backup programs that maintain multiple file versions. Of course, the backups created by those programs can also be backed up or archived to tape for an additional level of safety.

- **Current LTO tape drives require a SAS connection.** For a desktop system, this means adding a PCIe SAS adapter or, for Macs, a Thunderbolt-to-SAS adapter. Newer Mac laptops have Thunderbolt, but Thunderbolt-to-SAS adapters are expensive. Most other laptops have no provision for adding a SAS adapter.
- **There is an initial cost.** You must buy a tape drive and SAS adapter.
- **Tape life is usage-sensitive.** Tapes wear with usage. For example, an LTO-5 tape is estimated to be good for about 16,000 end-to-end passes.
- **Tape is "different."** Dealing with tape is different from dealing with disk. Unless you are using LTFS, tape can only be accessed through your backup software.

If you have more than 1 TB of data, and sometimes even if you have less, I recommend considering LTO-5 or LTO-6 tape as a part of your backup and archive system. LTO drives will write to and read from the previous generation (i.e., LTO-6 will write to LTO-5). Even if LTO-5 meets your current needs, consider future-proofing by buying an LTO-6 drive and using LTO-5 tapes. As your library size grows, you can always move to the larger-capacity LTO-6 tapes.

Online (Cloud) Backup

Online backup can give you additional protection against deletion or corruption of critical data files, but it should never be your only backup. Use an online backup service that allows you to retain multiple versions of backed up files and set the number of file versions to retain, as well as the file retention period. On-line backup should be used for critical data files that cannot be easily recreated. Usually software and system files do not need to be included in online backup (assuming you have those included on other backups), but you may want to include configuration files and templates that are often intermixed with application software.

Security is a major concern when using online backup. You have no way of knowing who has access to your data, regardless of service provider promises. Encryption makes sense for online backup, but be aware that encryption can be a double-edged sword—if you lose the security keys, your data can remain locked up forever.

Be aware that events outside your control can affect your access to data. Cloud services do have outages and lose data. Cloud services even shut down (or are shut down by government agencies) with little or no notice, taking your data with them. Protect yourself. Never make cloud backup your only backup.

Private Cloud

Another approach to cloud storage is creating your own *private cloud*, which is private storage accessed from the Internet. Many NAS device vendors include this capability, although they typically have their own name for it. LenovoEMC (formerly Iomega) calls theirs *Personal Cloud*, while Netgear calls theirs *ReadyCloud*. Although there are

differences in the services from each vendor, the basics of access are the same: you register the unit with the vendor's online service, then log-in to the service, authenticate, and the service gives you a direct connection to your remote NAS device. There is a software component to install on your computer, which allows you to set a path or map a drive letter to the device. You can typically access your system from a mobile device or web browser as well.

This approach has a couple of advantages over a cloud service. First, you are in control: you know where your data is physically stored. You are not subject to the whims of a cloud service provider, such as abrupt changes in service plans and costs. You know exactly what your costs are, because you paid them when you bought your NAS device.

There are some disadvantages, as well. Depending on the system, you may have to make firewall and router modifications to allow communication to and from your remote device. You also need a place to put the device. It could be anywhere with a good Internet connection and good power, but remember that once it's in a remote location, you do not have immediate hands-on access and control, so you must trust whoever is at that remote site. You also have fixed costs—you have to pay for the hardware, and typically, more storage than you immediately need. With cloud storage, you pay as you go.

Your remote location should be far enough away to protect your data from a site disaster but close enough to physically access if you need to. If you are concerned about natural disasters, find a storage site that is less likely to be damaged in such events.

Backup Methods

Not too many years ago, you had two options for backup—file and folder backup, and image backup. Today there are many backup options, but not all of them work effectively (or cost-effectively) in small offices, or for all operating systems. This book will concentrate on backup systems that can be effective in small offices. There is a whole class of backup software and systems targeted toward the enterprise (large organization) market, but that is beyond the scope of this book.

File and Folder Backup

This method backs up files and folders and their related metadata, such as security and access control information. Even if you back up the files required by your operating system, this approach, by itself, will not let you build a working system after a crash. You will first need to reinstall the computer's operating system and, most likely, all of your programs. In other words, this form of backup is great for restoring your data, but not so great for restoring a complete system.

File Synchronization

File synchronization refers to the periodic or continuous copying of files and directories from a source location to one or more destination locations in order to maintain duplicate file sets. This technique is often used to make sure the most recent versions of files are available elsewhere if a primary system fails. When implemented with a versioning system, this approach can maintain multiple revisions of files. File synchronization is often used between systems within an organization to make sure data is quickly available in case of a site-related disaster. File synchronization is often used in addition to traditional backup systems since it can provide immediate access to data. Most approaches to file synchronization are unidirectional, meaning they synchronize in one direction only.

Bidirectional or multi-directional approaches also exist, but they are much more complex to implement, and often require manual intervention to avoid version conflicts. When updating files that have previously been replicated, some programs re-replicate entire files, while some use a technique called *delta encoding* to only replicate file changes. Delta encoding can significantly reduce disk space usage, network traffic, and replication time.

Image Backup

This method creates an image of a disk or disk partition that can be used to restore the system to the state it was in at the time the image was created. With an image backup you will typically boot your system with an optical disc (CD or DVD) or a USB flash drive, and install the image on the disk. This process will overwrite anything that is on the disk; if your disk has multiple partitions, and you have a partition image, it will overwrite anything in that partition. The image file will usually be smaller than the disk or partition. This is because the file only contains data, and does not include the unused space on the disk or partition. In addition, many imaging programs use compression to further reduce the image file size. Depending on the software used to create the image, individual files and folders can usually be extracted from the image and restored.

The biggest advantage of image backup is that it allows you to quickly restore your system. However, you must back up the entire partition or disk, and you cannot selectively back up files and folders. Doing this on a daily basis and keeping multiple versions can take up a lot of disk space. Some imaging software, however, will create incremental or differential backups which only save changes. Compared to storing multiple full images from backup, this saves disk space. These files must be used with the full backup to restore a system to the most current version. Another problem with image backup is that depending on the imaging software, you may or may not be able to restore your image to different hardware.

Cloning

Cloning a disk means making a bootable copy. If your primary disk fails, you can immediately boot the system from the clone. The big advantage to cloning is that you can be up and running immediately after a disk failure. Also, since the clone is a copy of a disk, if it is mounted as an additional disk (not the boot disk) all files are accessible with programs and standard file management utilities. The big disadvantage is that the clone disk, in most cases, should have at least as much capacity as the cloned disk, which means maintaining multiple versions will require multiple disks. Unlike an image, which is a file and can be stored on disks holding other data, each clone is its own disk. As with imaging software, a clone may only work with the original or an identical computer.

Snapshots

A snapshot captures the state of a system, volume, or directory at a specific point in time. Disk images and clones are actually forms of snapshots, but there are other forms as well. Snapshotting can be a function of a file system or backup software. Snapshots created by the file system are usually stored on the same volume as the files and directories being snapshotted. Snapshots created by backup software, however, are typically stored on separate backup media. For example, the BTRFS file system used on some Linux systems and NETGEAR ReadyNAS devices can create snapshots of directories and then store those snapshots on the same volume. Apple's Time Machine stores snapshots on an external hard disk.

Snapshotting techniques vary greatly in how they capture and store data. For example, when creating an initial snapshot, BTRFS does not actually copy any data, it just sets pointers to the original data. Subsequent snapshots then only record the changes and store those parts (deltas) of files that have changed. Time Machine, on the other hand, copies all the data being tracked to the Time Machine backup drive. On subsequent snapshots, it saves entire changed files to the backup drive. In both cases, entire data sets or specific files and folders can be restored to a particular point in time.

Pointers are additional references to existing objects or files in the file system. For example, if BTRFS creates an initial snapshot of a particular directory, it doesn't make a copy; it just references the original so the initial snapshot does not take additional disk space. Only subsequent changes take disk space.

This type of snapshot makes it easy to recover data in a previous state. Even if you delete the original directory, the data that is tracked by the snapshot remains, allowing you to restore the saved version of the entire directory. Of course, if you lose the whole volume, you lose the snapshots as well, since they must be created on the same volume. However, it's a quick and effective way to recover deleted or overwritten data.

Full and Incremental Backup

A full backup will back up everything, while an incremental backup will only back up data that has changed since the last full backup. The full/incremental approach has long been used for file and folder backup, and more recently is being used with images and clones as well. The specific mechanisms vary between different backup programs, but the approach allows data to be restored to a specific point in time, or allows specific file versions to be restored.

Continuous, Near-continuous Backup

When data is written to disk, a continuous data protection system saves that new or updated data to a backup system. A near-continuous data protection system will capture changed data every few seconds, or at pre-defined intervals instead of immediately upon disk write. For most purposes, the two approaches are the same—data can be restored from nearly any point in time. Both approaches can have some effect on system performance, and both generally consume more backup media space than more traditional approaches. In many cases, continuous and near-continuous backups function like full and incremental backups, allowing the restoration of specific files or restoration to a specific point in time. The difference is that full/incremental is typically done on a manual or scheduled basis, while continuous and near-continuous backup monitors the system for changes and performs the backup as needed.

Versioning

Many modern backup systems give you the ability to restore previous versions of data, but some, including many cloud-based backup systems, do not. Considering that recovering deleted or overwritten files is one of the most common reasons for restoring data from backup, your backup software should have this important feature.

Open File Backup

In most circumstances, backing up open files (files currently in use) is risky, at best. The backup may fail, or the files may not be in a useable state when they are restored. This is especially true of database files, where multiple data files and index files need to be kept in synchronization. Many database systems provide utilities or *application programming interfaces* (APIs) to put the files in a safe state for backup. Utilities are loaded before the backup, while APIs are used directly by the backup software. These utilities and APIs lock the database to prevent updating during backup. Any writes to a protected file during backup are written to a buffer, or temporary data location. Read requests can access the buffer, so you'll be able to get to any data written during backup, even while the database is locked. The database is updated from the buffer after backup.

On Windows systems, many databases use Microsoft's *Volume Shadow Copy Service* (VSS) for this purpose. VSS is a set of services that are designed to provide consistent copies of Windows systems and Windows applications, such as Microsoft SQL Server and Exchange. The VSS API is available for other applications to use as well.

The most common database used on Macs is Filemaker Pro. The server version provides facilities through the admin console to back up open databases, but the desktop version does not; the program should always be closed before backing up. If you want to include Filemaker Pro Server in your regular backups, only include the backup files created through the admin console, not the live, running database.

Many databases running on Linux provide scripts or utilities that allow the safe backup of open files, usually as part of a regular backup routine. As with other operating systems, backing up open files without these mechanisms will either fail or potentially produce corrupted backups.

Compression and Deduplication

Compression and deduplication are two techniques for reducing media space requirements. Compression is commonly used on primary storage as well as backup and archiving media. Deduplication is primarily used on backup and archiving media. Compression operates on the bit level and removes redundant bits of data. It replaces them with codes that can be used to restore those bits when the data is read. Deduplication is similar to compression in that it reduces the amount of space a given data set requires on disk.

A deduplication program analyzes data and looks for files or blocks of data (depending on the particular deduplication method employed) that are the same. When two or more files or blocks match, the system sets a pointer to a single file or block and does not store multiple copies of that data. Deduplication provides the greatest benefit where there is a significant amount of redundant data. On primary media, compression can be implemented on a volume basis or by individual file and folder. With backups, compression is typically applied to the entire backup job. This can be done through backup software or, in the case of magnetic tape drives, implemented in firmware. Deduplication is often included as a feature of enterprise-level backup systems as well as some systems designed for smaller organizations. Deduplication can also be used on primary storage systems, and can be implemented at the file system level. The SDFS file system for Linux from OpenDedup (opendedup.org) has some deduplication capability built in. Deduplication is also planned for a future release of the BTRFS file system.

Both compression and deduplication can save disk space, but without hardware dedicated to their processing, they will almost always negatively impact performance. They are of limited advantage for most photographers because much of our image data does not benefit from either space reduction technique.

Encryption

Encryption is employed to prevent unauthorized entities from viewing and copying your data. Encryption uses a *key*, which is a piece of information that is used to translate your data into unreadable gibberish and back again. In simplest terms, the length and complexity of the key determines the difficulty of breaking the encryption. Longer keys also have greater impact on performance. 56-bit keys used to be common, but 128 bits is the new usual minimum for data encryption, with 256-bit (and larger) keys becoming more common. Keys are generated with a random key generator.

No encryption scheme is completely unbreakable, but the time and cost of breaking modern encryption algorithms, especially 256-bit keys or higher, are enough to deter all but the largest organizations with deep pockets (think governments) from even attempting decryption.

There are three primary methods for encrypting backups:

- **Software-based encryption:** Many backup software packages include encryption capability. Employing software-based encryption will usually affect backup and restore performance.

- **Encryption appliances:** Encryption appliances are typically expensive and used with enterprise-class backup systems. Because the appliance has its own processor, encryption and decryption usually have no negative impact on backup and restore performance.

- **Tape drive encryption:** LTO-4 and later generation LTO tape drives include hardware-based encryption. Tape drive encryption does not impact performance. Encryption and the encryption key are controlled through the tape drive's interface and managed by the backup software. If the drive is part of a tape library, encryption is managed by the library's management system.

Who Maintains the Keys?

Sometimes the user maintains the keys, and sometimes the application handles it all internally. In this last case, the user typically supplies a login name and password. Remember: if you lose the key or password, you lose access to your data. This is the danger of using backup encryption.

Requirements for an Effective Backup and Archiving System

There is no one best approach to backing up and archiving data because everyone has different requirements. You may need more than one type of backup software or system to meet all your backup and archiving goals. Here are some things to look for in your backup system:

- **The ability to create clone or image backups for fast system recovery.** Depending on your operating system and the backup software you are using, there are numer-

ous ways to accomplish this. There are several programs for Macs that will maintain a bootable clone on a continuous or near-continuous basis. For Windows and Linux computers, there is software that can be used to periodically create image backups, including incremental image backups and clones. Your imaging or clone software should allow you to back up a single partition and multiple partitions.

- **The ability to select by volume, file, or directory.** Your file backup software should allow you to select what to back up by the criteria most important to you.
- **The ability to create multiple backup jobs and back up to multiple destinations.** You might want to back up some data to a local destination and other data to the cloud, or you might want the same backup written to two different locations.

- **The ability to span multiple backup targets.** This is particularly important if you are using removable media, such as tape or removable disks, for backup. If one backup target gets full, you should be able to continue the backup by replacing that target with new media.
- **Simple and straightforward restoration.** Backup is done calmly and restoration is done in a panic. Complex restoration procedures do not help.
- **The ability to maintain backups of deleted files and multiple versions of changed files.** One of the most common reasons for restoring data is that a file has been deleted or overwritten by a newer version.
- **For backup software that maintains multiple versions, the use of delta encoding to only record file changes instead of making multiple copies of entire files is a plus.** This not only saves space on backup media, it also improves backup performance.

Backup Tips

- **Create a recovery disk.** Depending on your operating system and backup software, this could be a CD, DVD, or USB flash drive.
- **If you are imaging your system disk, consider creating a separate data partition, or store your data on a different disk.** Use a smaller partition (or partitions) for the operating system and application programs, and a separate partition (or disk) for data. This allows you to image the system partitions and back up the data partition separately. This makes backup and restoration of the system from an image file faster and easier. It also makes it less likely that restoring the image will overwrite newer data.

- **Temporary files and browser cache files should be excluded from your backup.** See Common Browser Default Cache File Locations. On Windows, you should exclude **C:\Users\<username>\AppData\Local\Temp**. You can exclude Lightroom previews since they are easily recreated. If your backup program maintains multiple file versions, you may want to consider excluding Lightroom catalog backups, as well.

> *Lightroom catalog backups refer to the backups created by Lightroom, not by your backup software. Lightroom backs up my catalogs, but I exclude those files from my regular file and folder backups, since my backup software maintains multiple versions of the catalog anyway.*

- **Label all removable media.** Backup media should be labeled in a manner that is understandable to anyone who might be involved in backing up or restoring data. The label information should include basic information about what has been backed up, the type of backup (full, continuous, incremental, etc.), and the date of the last backup (perhaps written in pencil). If you use a media rotation scheme, the media's position in the rotation should be included, as well.
- **Make sure you include program templates, profiles, and configuration files with your file backups.** See Common Default Template and Configuration File Locations.

Common Default Browser Cache File Locations

Safari (Mac)
Cache files: ~/Library/Caches/com.apple.safari

Internet Explorer 8, 9, and 10 (Windows 7 and 8)
C:\Users\<username>\AppData\Local\Microsoft\Windows\Temporary Internet Files

Firefox (Mac)
~/Library/Caches/Firefox/Profiles/<profile>/Cache

Firefox (Windows 7 and 8)
C:\Users\<username>\AppData\Local\Mozilla\Firefox\Profiles\<profile>\Cache
C:\Users\<username>\AppData\Local\Mozilla\Firefox\Profiles\<profile>\OfflineCache

Firefox (Linux)
~/.mozilla/firefox/<profile>/Cache

Chrome (Mac)
/Users/<username>/Caches/Google/Chrome/Default/Cache/

Chrome (Windows 7 and 8)
C:\Users\<username>\AppData\Local\Google\Chrome\User Data\Default\Cache

Chrome (Linux)
/home/<username>/.config/google-chrome/Default/Application Cache/Cache

Common Template, Profile, and Configuration File Locations

Please note that some of this data may be in hidden folders or files. See your operating system documentation for information on how to access hidden files and folders.

Aperture

~/Library/Application Support/Aperture

Lightroom 4 and 5 (Mac)

Preferences: //Users/<user name>/Library/Preferences

Presets and Templates: //Users/[user name]/Library/Application Support/Adobe/Lightroom

Registration Data:

 4.0: //Library/Application Support/Adobe/Lightroom/Lightroom 4.0 Registration

 5.0: //Library/Application Support/Adobe/Lightroom/Lightroom 5.0 Registration

Lightroom 4 and 5 (Windows 7 and 8)

Preferences: C:\Users\[user name]\AppData\Roaming\Adobe\Lightroom\Preferences

Presets and Templates: C:\Users\[user name]\AppData\Roaming\Adobe\Lightroom

Registration Data:

 4.0: C:\ProgramData\Adobe\Lightroom\Lightroom 4.0 Registration.lrreg

 5.0: C:\ProgramData\Adobe\Lightroom\Lightroom 5.0 Registration.lrreg

Photoshop CS5 and CS6 (Mac)

Files may be in subfolders.

General settings, actions, Camera Raw preferences, third-party plug-in settings, editing and painting tools, paths, save for web, filters and effects, lens profiles, workspaces: Users/<username>/Library/Preferences/

Custom color and proof settings, saved presets: Users/<username>/Library/Application Support/Adobe

Photoshop CS5 and CS6 (Windows 7 and 8)

Windows registry settings may be in sub-keys.

General settings, actions, custom proof setups, custom color settings, editing and painting tools, save for web, filters and effects, lens profiles workspaces, saved presets: Users/<username>/AppData/Roaming/Adobe

Camera Raw registry settings: HKEY_CURRENT_USER/Software/Adobe/CameraRaw/6.0
 Users/[user name]/AppData/Adobe/CameraRaw/Settings

Paths registry settings, Third-party plug-in registry settings: HKEY_CURRENT_USER/Software/Adobe/Photoshop

Corel AfterShot Pro (Mac)

Settings: ~/Library/Application Support/AfterShot Pro

Catalog: ~/Pictures/AfterShot Pro Catalog

Corel AfterShot Pro (Windows)

Settings: C:\Users\<username>\AppData\Local\Corel\AfterShot Pro
 C:\Users\<username>\My Pictures\AfterShot Pro Catalogs

Corel AfterShot Pro (Linux)

Settings: ~/.AfterShot Pro

Catalog: ~/Pictures/AfterShot Pro Catalogs

Internet Explorer

Favorites: C:\Users\<username>\Favorites

Firefox (Mac)
~/Library/Mozilla/Firefox/Profiles/<profile folder> ;
~/Library/Application Support/Firefox/Profiles/<profile folder>

Firefox (Windows 7 and 8)
C:\Users\<username>\AppData\Roaming\Mozilla\Firefox\Profiles\<profile folder>

Firefox (Linux)
~/.mozilla/firefox/<profile folder>

Chrome (Mac)
/Users/<username>/Library/Application Support/Google/Chrome/Default/Preferences

Chrome (Windows 7 and 8)
C:\Users\<username>\AppData\Local\Google\Chrome\User Data\Default\Preferences

Chrome (Linux)
~/.config/google-chrome/Default/Preferences

Backing Up NAS and SAN Configurations

Most NAS and SAN devices allow you to back up your array configuration settings to a file so you can restore them in an emergency. It's a good idea to back up your settings both before and after any configuration changes. When you save the file, include the date and time in the file name, and save it to a location on a device other than the SAN or NAS. Make sure those files are included in your normal backup routine.

Backing Up Your Website

If you have a website hosted by an Internet service provider (ISP), you should be backing it up. Don't rely on the ISP to do this for you. Always make sure you keep local copies of anything you post on the web, and back up those copies as part of your regular backup routine. Even though you have this data backed up, you still want to back up your complete website so that you can quickly recover it in an emergency or, if necessary, move to a different hosting company.

There are two types of hosting you may be using. The first type is a generic site, where you (or your web designer) select the web-building tools (WordPress, Joomla, etc.) and build the site. The second type is a "we-do-it-all-for-you" type of site. Most photo hosting sites fall into this category. The hosting company either builds your site with their site-building tools, or they provide a limited range of layout options, and you add your images and data.

If you have a generic-type site, you can usually back it up using *file transfer protocol* (FTP). A command-line version of FTP ships with pretty much every operating system. There are also GUI FTP clients, such as WinSCP for Windows (winscp.net) or Cyberduck for Mac OS and Windows (cyberduck.ch), and there are browser plugins like FireFTP for Firefox (fireftp.net). Your web hosting service may supply tools to help you back up your web files. If you are not a seasoned web developer, you may need technical assistance to help figure out exactly what to back up.

One advantage of the command-line FTP versions is that they are usually easy to script and schedule for automatic backup. Typically you will back up to your local computer and include those files in your normal system backups.

If you use a "we-do-it-all-for-you" web-hosting service or a photo-hosting service, ask (preferably before you sign up) how to back up your web data. Also find out what would be involved in moving to another service, which can be an issue with this type of web service. If the web development tools are proprietary, you may be locked in. This applies to photo sites as well. You may be able to retrieve your photos, articles, blog posts, etc. (you should already have local copies of all this anyway), but you may not be able to back up or retrieve the organizational metadata that defines your site layout. If you want to move to a different service, you may end up rebuilding everything from scratch. Find out this information before you invest a lot of time and money into your website.

Archiving Data

Archiving is the process of moving data that is no longer used to a separate storage device for long-term retention. Of course, there is no reason that you cannot archive copies of currently used data as well. When archiving data you need to consider what to archive, the retention period, and maintaining archive integrity.

What to Archive

Not all your data needs archiving. For example, software, system image files, and system configuration information is typically of short-term value. It needs to be backed up, but not archived. Images, financial records, and other business records usually do need to be archived. In many industries, certain data, such as email, needs to be archived due to regulatory requirements. Even without regulatory requirements,

archiving email may be valuable (or possibly detrimental) in the event of litigation. You (and your business advisers, if you have them) need to make the determination as to what needs to be archived.

Retention Period

For most photographers, the retention period for their photographic images is open-ended. Images may end up having artistic or historical value, and with current U.S. copyright laws, they may have monetary value to the photographer's heirs.

Some data, such as tax records, might be archived for a specific period of time. When archiving such data, you should have a mechanism for destroying it at the end of the archive period. This means separate archive media for data with different destruction dates. Also, any media with a destruction date should be labeled with that date.

Maintaining Archive Integrity

The first thing to consider is the expected life of the archive media. First, quoted lifespan figures for various types of media are, at best, statistical averages based on previous experience, accelerated age testing, and other factors. At worst, they are little more than marketing spin. In any case, there is always the chance that any specific unit of storage media can fail prematurely. You should also consider how long the hardware and software required to read that media will be available. For example, even if I still had a hard disk from a thirty-year-old IBM PC-XT, I would have a hard time finding an ST-506 disk interface to connect it to, much less a working PC-XT.

Another concern is the future readability of file formats. This should be a major concern for proprietary RAW images and old word processing formats, for example. Archived media should be checked every few years for readability. Do a full restore to disk (not to the original location), if possible, and at least spot-check the files. Archives should be moved to new media at least every five to eight years. You should also make sure software is available to read your archived file formats.

Selecting Media for Archiving

Keep in mind that the purpose of archiving is long-term storage, while the purpose of backup is restoring lost data. NAS and SAN devices, as well as running hard disks, may be appropriate for first-line backup, but they do not usually make the most sense for long-term archiving because they are subject to power-related problems, viruses and malware, and accidental file deletion or modification. However, they do have the benefit of allowing you immediate access to your archived data.

Online storage has similar issues. The difference is that someone else is in charge of the day-to-day maintenance of the systems that store your data, but the data is

still stored on spinning hard disks, and you are effectively paying to keep those disks spinning. You may not be in charge of the day-to-day maintenance, but you are still responsible for the data. If you read the service level agreement with your online service provider, you will likely find no guarantees—just a promise to use their best efforts to keep your data safe. Even the biggest cloud service providers have lost user data. Others have ceased operation, either voluntarily or otherwise, taking user data with them. The best option for archiving data is some type of removable media, which includes optical discs (CD, DVD, Blu-ray), hard disks (external or removable), flash media, or digital magnetic tape.

Optical Disc

Experience has shown that data on writable CDs and DVDs can become unreadable in as little as two or three years. Because of the relative newness of Blu-ray, the jury is still out on its long-term ability to retain data. Capacity and write speed are also issues, as is media cost per GB, especially with Blu-ray. Readers for optical media are common, and many computers ship with drives that can read all three formats, so access to data is quick and easy. However, few readers currently shipping with consumer-grade computers can read 100 GB BDXL disks.

External and Removable Hard Disks

Hard disk manufacturers do not specify a shelf life for data stored on non-operating hard disks, but the expected life of a continuously running hard disk averages around five years. There is some evidence that data on non-running disks can degrade in two or three years. One good thing about hard disks for archiving is that you don't need special hardware, such as a tape drive, to retrieve your data.

Flash Media

Flash media, including SSDs and USB flash drives, appears to be very stable. When stored properly, it should be able to retain data for ten years or more. The biggest issue with flash media is the cost.

Digital Magnetic Tape

Magnetic tape, in particular LTO tape, has demonstrated its ability to store data for extended periods of time. The biggest downside is the cost of the tape drive needed to write the data, and the fact that if you need to recover data years from now, you'll need a compatible tape drive to read that tape. Fortunately, LTO tape drives read three generations of tapes, so an LTO-6 drive reads LTO-4, LTO-5, and LTO-6 tapes. LTO-3 tape drives, which are still currently available, will read LTO-1 tapes from over twelve years ago. One more advantage of tape—it is immune to malware and viruses. The data stored on tape may be infected, but unlike hard disks, the tape itself cannot become infected.

Archive File Formats

Because you are archiving for long-term storage, archived data should be stored in a manner that does not require proprietary software to read it, since such software might not be available when you need to extract the data. It's best to store archived data in its native format. If you are archiving to LTO tape, use the LTFS file system, which will allow the data to be read by any compatible drive with LTFS support.

What about compression? Compression does not significantly reduce the size of photographic image files. If you have software or tape drives that compress by default, I suggest you turn compression off. If you choose to encrypt your archives, make sure that the passwords or encryption keys will be available years down the road. Otherwise you're putting an unbreakable lock on something that may have artistic, historical, or personal value.

Storing Archive Media

All digital media should be stored in a clean environment with moderate, stable temperature and humidity. All media should be kept in protective cases. Tapes and removable disk cartridges usually come with plastic cases, and cases for bare hard disks are available online and in electronics stores. Maintaining consistent, moderate humidity is the most important factor for preserving the life of hard disks and tapes. Optical media should be protected from scratching and light. Dye is used to differentiate between logical ones and zeros (the laser actually burns the dye layer), and light will fade the dye over time.

Protective disk storage boxes are available from local electronics stores and online sources

At least two copies of archived media should be maintained in at least two physical locations, preferably far enough apart that a natural disaster would be unlikely to affect both sites.

Backup Software

There are hundreds of backup software packages available, and this is not a comprehensive review of all of them. I am profiling software I've had personal experience with, or that has been highly recommended to me by people I trust. I've profiled products that I believe are suitable for the single user or small office, although some may be suitable for larger organizations, as well. These products are all reasonably priced—typically between $25-80 per desktop.

The one open source product profiled, Mondo Rescue, is available at no cost, and Apple Time Machine and the Microsoft-supplied backup software are bundled with the operating systems.

Macintosh

Apple Time Machine

Time Machine, which is included with current versions of Mac OS X, creates incremental backups of all locally attached disks by default. Specific disks, volumes, folders, or files can be excluded. Current versions of Time Machine can back up data to multiple types of targets, including external disks and NAS devices that include Time Machine support. Time Machine automatically makes hourly backups that it saves for 24 hours. It saves daily backups for a month, and weekly backups older than a month until the backup target runs out of space. Time machine can restore files, folders, and entire systems. Time Machine allows you to browse backups to restore previous versions. Time Machine does not record delta changes—it backs up complete changed files. Time Machine doesn't directly support off-site backups, but at least one third-party NAS device provides off-site capability for Time Machine. Other than file, folder, and volume exclusions, Time Machine is not very configurable. For example, the scheduling is pretty much fixed, and the number of backups saved cannot be changed. Time machine is not suited for creating long-term archives.

Apple Disk Utility

Disk Utility is Mac's general-purpose disk-management utility. It can be used to repair permissions, erase disks, and set up RAID if you have multiple disks. It can also copy the contents of a hard disk to another location (this function is called *Restore*) and create disk images. The Restore function can be used to clone hard disks, including bootable system disks, while resizing partitions in the process, allowing for migration to a larger disk.

Support

Apple provides 90 days of software telephone support. Additional no-cost support may be available depending on the specific warranty coverage for your product.

SuperDuper

SuperDuper (shirt-pocket.com) is primarily a disk-cloning program. It allows you to create a bootable clone of your system. There is a free version, with limited capabilities, and a paid version, profiled here. SuperDuper is an online cloning program, which means you don't have to shut your system down to create the clone. Its *Smart Update* feature allows for updating existing backups manually or on a scheduled basis. Smart Update only makes the changes, additions, and deletions necessary to make the backup match the source. SuperDuper will also let you create image files, which they call Sparse Images, side-by-side with other data on external or network drives. Sparse Images are not bootable, but can be restored to a drive in bootable condition. SuperDuper lets you create scripts to exclude files from backup. This allows the exclu-

sion, for example, of temporary files that do not need to be part of a system restore. SuperDuper does not maintain previous file versions or deleted files.

Support

SuperDuper provides unlimited email support.

Carbon Copy Cloner

Carbon Copy Cloner (CCC) (bombich.com) creates bootable clones of Macintosh disks and will also back up files and folders to external disks and other Macs on your network. CCC has a function that allows you to update your backups on a scheduled basis. CCC incremental backup offers the option of maintaining deleted files or previous versions of changed files in a separate archive folder on the backup target. It also allows you to control the size of the archive by *pruning*, or deleting older files based on available disk space, the size of the archive, or the age of the files. The CCC archive function maintains complete files, not delta changes. The CCC archive should be considered temporary storage only if automatic pruning is used. The user manual specifically recommends maintaining a copy of your archive folder elsewhere.

Support

CCC provides online help desk support.

ChronoSync

ChronoSync (econtechnologies.com) is a cloning and synchronization program. It can create bootable clones of disks and keep them synchronized; it can synchronize sets of folders and files; and it can perform bidirectional synchronization, keeping two active sets of files in synchronization. After an initial synchronization, ChronoSync monitors file changes on the source system and replicates only those changes to the target system on a scheduled basis. ChronoSync also provides versioning (which their documentation calls *archiving*), which allows you to maintain deleted files and older versions of changed files. The user can specify a minimum and maximum number of versions to keep, as well as a maximum version age. The ChronoSync software lets you browse, open, or restore versions. ChronoSync's versioning keeps complete files, not delta changes, so it can require a considerable amount of disk space over time.

Support

ChronoSync includes unlimited email support and free upgrades.

CrashPlan

CrashPlan (crashplan.com) is an online backup service. It provides free backup software that can be used with or without online backup. CrashPlan's software lets you created multiple backup jobs and back up data to multiple locations, including local disks, network shares, remote computers and Crashplan's online backup site, CrashPlan Central.

CrashPlan includes versioning, compression, and deduplication by default, all of which are configurable. It will back up Macs, Windows, and Linux. If you have a CrashPlan online account, you can access data that is backed up to CrashPlan Central from a mobile device. Backup is based on schedules, and scheduling is completely configurable. You can also set bandwidth limits for local and Internet traffic. CrashPlan has multiple plans for home and business, and allows customers (U.S. only) to seed the cloud account by sending data on a hard disk. Crashplan's software always encrypts backed up data, even when you back up to a local device. One caveat with CrashPlan— if you remove a backup data source, the data previously backed up from that source will be removed as well.

Support

CrashPlan provides web, chat, email, and phone support to paid users.

Retrospect

Retrospect was once the leading backup software for Macs, but due to multiple corporate acquisitions (Dantz, the company that produced Retrospect, was first acquired by EMC, then sold to Roxio, which was acquired by Rovi), the product languished and fell behind its competitors. In 2011 a group of the original developers bought the product from Rovi and formed Retrospect, Inc. (retrospect.com) to continue developing the product.

Retrospect is a very powerful program. It is sold in a desktop edition and multiple server editions. Regardless of the edition, the program has two parts—the engine and the client. Retrospect can back up multiple clients to the system hosting the engine. Retrospect for Mac (as well as for Windows) can back up Mac, Windows, and Linux clients. The desktop version includes five client licenses (the computer hosting the backup engine and four additional clients). Retrospect will perform traditional file and folder backups, and can create images and bootable clones. In file and folder mode, Retrospect provides file versioning with extensive control, although it currently does not record delta changes—it keeps multiple versions of complete files. Retrospect for Mac supports tape drives in native mode, but does not currently support LTFS. It lets you create and schedule multiple backup jobs and provides extensive support and documentation for disaster recovery. Its Duplicate mode is great for archiving data, because it copies data in native format with a wide range of selection criteria. However, its terminology and wide range of file selection options make the user interface a bit complex, so it takes some getting used to.

Support

Retrospect provides free phone and email support during a 45-day trial period, and 30-day phone and email support after purchase. Online forums, knowledgebases, and tutorials are always available for free. Annual support contracts are also available.

Windows

Windows 7 Backup and Restore

Windows 7 Backup and Restore allows you to create a recovery disk (CD, DVD, USB flash drive, etc.), create system images, and perform file backups. Also, you can restore files from the system image backup. It supports a single backup schedule for both file and image backups. If you want to change the list of files to be backed up or the backup times, you have to overwrite the existing schedule. New backups overwrite existing backups (unless you change the backup media), so versioning is not supported. You can designate the disk or network share for the backup, but you cannot designate a particular folder. Microsoft does not support restoring images created by Windows 7 Backup to other computers.

Support

Windows support policies apply.

Windows 8 File History (with Windows 7 File Recovery)

File History is a scheduled backup program that backs up files stored in Libraries, Desktop, Favorites, and Contacts folders. The only way to back up other folders is to create a new library or add the folders to an existing library. You can also exclude folders. The default schedule is every hour, but that can be changed. File History maintains multiple versions of files, and the retention period can be changed. The default is *forever*, but other options include one, three, six, and nine months, one or two years, or until space is needed. You cannot set the number of versions to retain. File History can use external drives or network shares as targets, but will not write to CDs, DVDs, or Blu-ray discs. Windows 8 also includes the same functions as Windows 7 Backup and Restore, but it has been renamed Windows 7 File Recovery and is accessible from a link at the bottom of the File History page.

Support

Windows support policies apply.

Windows 8.1 File History (with System Image Backup)

File History in Windows 8.1 differs from the 8.0 version in that it will no longer create a System Repair CD, only a System Recovery USB drive. Windows 7 File Recovery is also gone; the link has been replaced with a link to System Image Backup. Unfortunately, System Image Backup has no scheduling facility, but a web search for "how to schedule a Windows 8.1 System Image backup" will return several results that show how to use the Windows Task Scheduler.

Support

Windows support policies apply.

Altaro Oops! Backup

Altaro Oops! Backup (altaro.com) is an easy-to-use file and folder backup program that provides automatic versioning. It detects file changes and then backs up the changed files on a schedule set by the user. Oops! Backup uses what Altaro calls *ReverseDelta Technology*, meaning it only backs up actual changes to files. The latest backed up version of a file is stored as the complete file, while deltas are stored for previous versions. This allows you to retrieve the latest version quickly, and since it is not stored in a proprietary format, you can retrieve it using standard copy utilities, if necessary. Oops! Backup lets you keep a full copy of each file after a specified number of versions are saved. You can also set a time limit after which old versions will be purged. Oops! Backup will back up to and from external disks, NAS devices, and network shares. For laptops (or desktops) Oops! will automatically back up when the backup drive is connected. You can also set up a second backup drive or location that will synchronize daily with your primary backup, at a time the user specifies. Oops! Backup is easy to set up and use. Because of its ReverseDelta design, it cannot back up to tape, but a backup disk can be copied to tape for archiving purposes. A limitation of Oops! Backup is that it can only back up a single backup job on a single schedule.

Support

Altaro offers email support, live chat, user forum, and a knowledgebase.

Altaro BackupFS

Altaro BackupFS (altaro.com) is similar to Oops! Backup, but has a number of additional features. First, it backs up Windows servers, while Oops! only runs on Windows workstations. Altaro runs as a Windows service so it can run without a user logged into it. It provides greater scheduling flexibility and it sends email notification on backup success or failure.

Support

Altaro offers email support, live chat, user forum, and a knowledgebase.

CrashPlan

See CrashPlan, under Macintosh.

Macrium Reflect

Macrium Reflect (macrium.com) is a versatile backup program that provides disk imaging, cloning, and file and folder backup. Image files are compressed and can be mounted as drive letters. Full, incremental, and differential images can be created. A system recovery disk based on WindowsPE, Windows Automated Installation Kit, or Linux can be created to recover a system disk image. Reflect's file and folder backup creates a compressed virtual drive (in .zip format) that can be mounted as a drive let-

ter. Additional full, incremental, and differential backups each create and store their data in new .zip files. A system recovery disk based on WindowsPE, Windows Automated Installation Kit, or Linux can be created to recover a system disk image. The Professional and Server editions allow image redeployment to new computer hardware. A free edition that does imaging and cloning, with scheduling, is also available. Unfortunately, Reflect's compression will not significantly reduce the disk space required by most photographic image files. If you want to store backups on LTO tape, the backup should first be written to disk, then copied to tape.

Support

Support is via email, user forums, and a knowledgebase. The free version is not supported.

Retrospect

See Retrospect, under Macintosh. The Mac and Windows versions are very similar, but in addition to supporting native tape mode, the Windows version can duplicate (copy) to LTFS tapes, although LTFS doesn't support extended attributes of the Windows NTFS file system. This is a good option for archiving data to tape in native mode.

Linux

Most backup programs for Linux are free and open source, but they require knowledge of the Linux command line. The programs profiled here have a menu or GUI interface for most common operations.

Mondo Rescue

Mondo Rescue (mondorescue.org) is an online imaging program for Linux. It will back up to local disk, external disk, NAS and SAN devices, network locations, and tape. It creates a bootable recovery disk and allows complete bare-metal restoration. It also allows the restoration of individual volumes, partitions, files, and directories. Mondo is free and open source software and is used in small offices, government agencies, and large corporations. Mondo is primarily a command-line program, but it also has a basic menu interface.

Support

Support is available from the Mondo website, wiki, and mailing list archives. Paid commercial support is available as well. Information about support options is available here: mondorescue.org/support.shtml.

Areca Backup

Areca Backup (areca-backup.org) is a Java-based backup program for Linux and Windows. It is a free and open source program that performs full, incremental, differential, and delta backups. It is relatively easy to install and use once you understand the terminology and interface. (I highly recommend following the tutorial at areca-backup.org/tutorial.php to get started.) Files are stored in original file-and-folder format or in a standard .zip file. Scheduling requires using the Areca command-line interface to create backup scripts that can be scheduled using the cron scheduling utility.

Support

Support is limited to the forums on the Areca website.

Rsync and rsync-based Backup Applications

Rsync (rsync.samba.org) isn't technically a backup program—it's a file synchronization program. On its own, it's a command-line utility that can be scripted to replicate files from one computer system to another. When it updates existing files it only records delta changes, minimizing synchronization time and network traffic. Rsync is available for all commonly used operating systems, so it's not just a Linux tool. Rsync is also the basis of a number of open source backup and synchronization tools; there are GUI front-end programs, such as Grsync (opbyte.it/grsync/) for Linux, Mac, and Windows. Using rSync, even with a GUI front end, can be a complex process. It's not for those who are unfamiliar with command-line programs.

A number of backup applications are either based on rsync or they use rsync functions. These include Back In Time (backintime.le-web.org), TimeVault (launchpad.net/timevault), and FlyBack (flyback-project.org). Although these are all GUI-based utilities, they all have their own quirks and may, at some point, require command-line-based Linux utilities. All are free and open source (although the authors may ask for donations) and all are a little rough around the edges.

Support

Rsync support is pretty much a do-it-yourself affair. The web page will point you to documentation and the rSync mailing lists. Support for rsync-based backup programs is similar. See their websites for details.

Retrospect

The Retrospect backup engine only runs on Mac and Windows computers, but it does include client software for Linux that allows the Linux system to be backed up across the network. Retrospect Desktop Edition includes licenses for backing up five computers. If you also use Mac OS or Windows computers, Retrospect makes it easy to add your Linux system to your backup routine. Unlike most other Linux backup programs, using Retrospect doesn't require knowledge of the Linux command line.

A Basic Mac Backup Routine

For a single Mac, here is a basic routine:

- Use Time Machine to back up data to an external drive.
- Use cloning software (ChronoSync, SuperDuper, Carbon Copy Cloner, etc.) to maintain a bootable clone.
- Back up critical data to a remote or cloud location, preferably with file versioning. This can be done a number of ways, including:
 - cloud services and software like CrashPlan (Crashplan actually lets you back up to a friend's computer at a remote location)
 - private cloud, as provided by NAS vendors like LenovoEMC and NETGEAR
 - Rsysnc-based solutions (this is trickier, because it typically requires knowledge of routers and firewalls); Rsync ships as part of Mac OS, although newer versions are usually available from rsync.samba.org

A Basic Windows Backup Routine

For a single Windows PC, here is a basic routine:

- Use third-party software to back up data, preferably with versioning, on a continuous, near-continuous, or scheduled basis.
- Use the imaging function of the included Windows backup software or third-party software to periodically create a restorable image of your system. It's a good idea to create a separate disk partition for data or store your data on a separate disk. That way you can exclude the data partition from the image backup, creating a much smaller file.
- Back up critical data to a remote or cloud location, preferably with file versioning (see *A Basic Mac Backup Routine*).

A Basic Linux Backup Routine

For a single Linux system, here is a basic routine:

- Use a Linux file-based backup program such as Areca to back up data on a scheduled basis.
- Use Mondo Rescue to periodically image the partitions that are required for booting the system.
- Back up critical data to a remote or cloud location, preferably with file versioning. This can be done a number of ways, including:
 - cloud services and software like CrashPlan (Crashplan actually lets you back up to a friend's computer at a remote location)
 - private cloud, as provided by NAS vendor LenovoEMC (NETGEAR does not provide a Linux version of ReadyNAS Remote)
 - Rsysnc-based solutions (this is trickier, because it typically requires knowledge of routers and firewalls)

My Backup Routine

My office is in my home, and both my wife and I work there. My backup routine may seem like overkill, and it probably is. However, I have not found a single backup system that does everything I want. Our complement of systems consists of:

- my desktop Windows PC with external hard disk for photographic images;
- my Windows laptop;
- my wife's desktop Windows PC;
- a Linux server with attached SAN;
- a remote NAS for off-site backup (private cloud); and
- an LTO-6 tape drive.

I use five backup programs:

- Windows Backup
- Mondo Rescue, free and open source imaging software for Linux
- Altaro Oops! Backup
- CrashPlan
- Retrospect

As much as possible, my backups are automated. The bundled Windows backup software is used to image the Windows PCs, and Mondo Rescue is used to image the Linux server.

I use Crashplan to back up data from all systems on an automated basis. Except for photographic images, all data is backed up to the CrashPlan cloud service. All data, including photos, is backed up to the server-attached SAN.

Altaro Oops! Backup backs up critical data and photos from my PC, my wife's PC, and the Linux server, and saves the data to an external hard disk attached to my PC. Oops! then synchronizes the backup to a remote NAS using the private cloud function provided by the NAS vendor.

Retrospect and the LTO-6 tape drive are the newest additions to my backup routine. Retrospect and the tape drive are installed on my PC, and agent software is installed on the Linux server and my wife's PC. After an initial full backup of data on all three systems, nightly incremental backups are run for a month or until the tape is full. At that point the tape is replaced with a blank tape and the process repeats. I use Retrospect's *Duplicate* function, which copies data in native format, to archive data to an LTFS-formatted tape on a yearly basis.

As I said, this is probably overkill. Remember: 3-2-1 is a minimum, not a maximum.

RECOVERY

If you experience an event that causes data loss—accidentally deleted files, a fried hard disk, a fire, or a flood—don't panic!

Panicking is the worst thing you can do in a data emergency because it may lead to rash decisions. Even experienced, professional systems administrators commit errors if they panic. I have personally witnessed all of the following common errors:

- Old data is restored over current data.
- After a disk array failure, the wrong hard disk is removed, making the array unrecoverable without sending it to a professional recovery service.
- A hard disk is reformatted, or it's replaced and the original disk is returned to the vendor for warranty, before backups are verified. In the former case, the likelihood of recovering data is greatly diminished. In the latter case, it is eliminated completely. Data can usually be recovered by professionals from a failed disk, but not if the disk is no longer available.

Whenever you are in a data loss or recovery situation, stop, take a deep breath, and assess the situation. *Primum non nocere*, which means *first, do no harm*.

General Rules of Data Recovery

- Stop using the device (computer, external drive array, memory card, etc.) until the issue is resolved! I know you have a deadline and you don't time for this. You don't have time to deal with appendicitis or a heart attack, either, but somehow you find a way. Which is more important—your next deadline or saving all your data?
- Don't assume everything is backed up. It's easy to forget to update backup routines. When did you last back up? Are you sure that backup includes your most current data? Verify this even if you think you have backups.
- Don't do anything potentially destructive to the system or device from which you are attempting to recover data until that data is actually recovered. This is

a good reason to have separate system and data partitions or disks—you can recover a system partition or disk without writing over newer data.

- If you have accidentally deleted files or formatted the disk, try a data recovery tool. There are many available for a relatively low cost (some are even free) on the web. Nearly all of these programs have a demo mode that will show you what they can recover. If one doesn't work, try another.
- If you can't verify your backups and you can't recover the data using normal means, consider a qualified data recovery service. The cost of such a service can be hundreds of dollars or more, but if that is the only way to get your data back, it may be worth it.

If the issue is beyond your level of expertise, find a good independent service agency. This can be tricky, so get references from people whose judgment you trust. Be careful about working with the underpaid (and typically under-trained) technicians at chain stores—they have incentives to resolve the problem (i.e., make it go away) as quickly and as profitably as possible. Saving your data is not always their primary concern and they are often not qualified to even attempt it.

For those of you with a technical bent: when trying to restore data from working disks in malfunctioning computers, it's often helpful to have another computer available. An external disk docking station that accepts 2.5" and 3.5" SATA disks and a USB 3.0 interface lets you access hard disks that have been removed from the malfunctioning systems. This type of dock is available for less than $40.

Restoring Data from Backup

Unfortunately there are no standards for backup software. There are differences in the user interfaces, terminology, format for storing backed up data, and more. There can even be differences within the same software package between the procedures for restoring files and folders and restoring disks or partitions. Before you have an event that requires you to restore data, familiarize yourself with your backup software's data

An external disk docking station that accepts 2.5" and 3.5" disks can be very useful when trying to recover data. This unit has USB 2.0 and eSATA intefaces, and is available for less than $30. USB 3.0 units are available for under $40.

restoration procedures. You really don't want to be learning how to restore data while you're working under pressure. You will want to learn:

- how to restore individual file and folders;
- how to restore previous versions of files and folders;
- how to restore files and folders to alternate locations;
- how to restore complete partitions and disks;
- how to restore individual files from images and clones.

Restoring Files and Folders

Most data loss that doesn't involve hardware or system failure is caused by human error. For example, it's very easy to accidentally delete a file or move a directory. It is also very common, when working with documents such as word processing files, to accidentally save a new version of a file, only to realize later that you still need the older version. Sometimes data appears to be gone, but it has only been moved. Modern GUIs make this easy to do, both intentionally and accidentally. Before you attempt to restore missing data from backup, especially if it has seemingly disappeared for no reason, use the Mac Finder, Windows Explorer, or similar utility to search for the missing file or folder. Do a search from a higher point in the directory tree; this may save you from having to restore from backup, and from having two versions of the same files and folders on your system. Before attempting to restore a deleted file from backup, see if you can recover it from the Recycle Bin (Windows) or Trash Bin (Linux and Mac).

For Windows users, if you have accidentally modified a file stored on a local hard disk, you may be able to restore a previous version by right-clicking on the file and selecting "restore previous versions" from the menu.

When you restore files and folders, first verify what you want to restore. It's easy to select an entire folder or folder hierarchy and accidentally overwrite newer files. If you are unsure, restore to an alternate location, compare the restored files with the originals (if there are any), and then copy the files that need to be replaced from the alternate location to the original location.

Restoring Previous Versions

When restoring previous versions of files, be as selective as possible. If you are restoring over existing file versions, move or copy the existing files to a new location before you restore from backup. After verifying that the restored files are the correct ones, you can delete the moved files. When restoring, use the option to restore with a different file name if the file already exists on disk. This will protect you in case you missed moving or copying one or more of the files you are restoring.

Alternatively, restore to an alternate location to make sure you don't overwrite needed data.

To restore an older version, right-click the file, then select "Restore previous versions."

Restoring Disks and Partitions

Typically you will only restore an entire disk or partition after major system corruption or a disk failure. How you restore will depend on the software and backup mode (clone or image) that you used.

If you created a disk image, you will need a bootable recovery disc or USB flash drive to boot the system and install the image. If you cloned a disk, you should be able

to swap the clone for the original disk. If you restore an image file or clone, you will lose any data or system changes made since the image or clone was created.

If you don't have a recent image or clone, try to create a file and folder backup of the disk or partition (if it is still readable) so that you can reinstall any files that were created or updated since the image or clone was created.

Restoring a System Image to a New or Dissimilar System

Restored system partition images will usually only boot on the original computer or a computer with substantially similar hardware, but some imaging software includes the ability to create images that can be installed on dissimilar hardware.

In larger organizations, the IT department will make a *base image*, or a basic installation, with the operating system, standard settings used in that organization, and sometimes other common applications. This base image is applied to all computers and provides system consistency that makes support of multiple systems easier. Being able to apply the same base image to newer computer models is a real advantage in this environment.

When dealing with one or only a few computers, restoring to dissimilar hardware has some short-term advantages, but it has disadvantages as well. The main advantage is that it gets a replacement system up and running quickly. The big disadvantage is that in the process of applying the old image to a new computer, you bring along all the old baggage, such as configuration settings, obsolete drivers and, with Windows, unneeded registry settings. There is something to be said for starting with a clean installation on a new system.

Windows System Restore

If your Windows system becomes unstable, try Windows System Restore before you restore your system partition from backup or reinstall Windows. System Restore allows you to roll back the system to a previous state without affecting user data. When you install software or make system changes or updates, Windows tracks the changes and creates a Restore Point. System Restore can restore the system to a state before a particular restore point. In most cases, System Restore can be run from an active system. In more extreme cases, it must be run from the Windows recovery partition or recovery disc.

Handling a Failed Hard Disk

Before you assume a disk has failed, verify it. The problem could be anything from a power supply issue to a problem with the motherboard. Hard disk testing is beyond the scope of this book, but an online search for "hard disk failure Mac," "hard disk failure Windows," or "hard disk failure Linux" will return information on the subject.

Before you do anything potentially destructive, make sure you have a current backup. If you aren't sure, attempt to back up the data. This may mean removing the disk and mounting it on another computer with the same operating system, using an

Handling SSD Data Recovery

external disk docking station or other means. It may also mean, if the disk is actually spinning, booting with a recovery disk and trying to access your data with data recovery software. If that fails, and you absolutely need to get the data back, your last option is a data recovery service.

Working with External Disks

If you're dealing with an external hard disk, there are other issues to consider. An external hard disk includes the disk itself, the case, the internal electronics (SATA to USB adapter), and for desktop disks, a power supply. There is also a cable between the disk and the computer. I suggest the following troubleshooting steps:

- Swap the cable with one that you are certain works.
- For desktop disks: if you don't hear the disk spinning, check the power supply. First make sure you have the correct power supply; most external disks have an external power supply with a 12V DC output. You can check the voltage output with a multimeter. Usually the center connector is positive (+) and the barrel is negative (-). If the voltage and current are correct, the polarity (+/-) could be wrong. If the polarity is correct and the barrel size is correct, the connector's center pin and socket could be different sizes.

You can buy a basic digital multimeter for $10-$25 at electronics, hardware, and home improvement stores.

- If none of the above works, and the disk is not under warranty, you could consider major surgery as a last resort. You could either send the disk to a recovery service or you could open the case, remove the disk itself, and try to read it using an external disk docking station. Be aware that this last suggestion would most likely void any warranty and might even damage the disk in the process.

Handling SSD Data Recovery

SSDs are high-capacity flash memory cards. The same data recovery procedures and software that are used for flash memory cards apply to SSDs as well. The difference is that SSDs use a SATA, SAS, or mSATA interface. One issue with SSDs is the TRIM command. TRIM is an ATA command (built into a SATA SSD's command set) that can be triggered through the operating system. When data is deleted from most media, only the link to the data, not the data itself, is actually deleted. With an SSD and an operating system that both support TRIM, both the link and the data are deleted. This makes recovering data from SSDs less likely than recovering data from hard disks or flash memory cards. TRIM only operates on SATA SSDs, not SSDs that use the mSATA interface.

| 131 |

SSD hardware components can fail, which can prevent access to data or cause data loss. In the case of hardware failure, your only recourse is to use a data recovery service. Few data recovery software packages mention SSD recovery. Two that do are Yodot Hard Drive Recovery (yodot.com/hard-drive-recovery) and EaseUS Data Recovery Wizard (easeus.com/data-recovery/other-recovery-software/SSD-drive-recovery.htm). Recovery services include hard disk recovery services (described later in this chapter) and flash memory recovery services (see chapter 1).

Because of the way data is written to and deleted from flash memory, the actual data is not always deleted when a TRIM command is issued. In flash memory, data can only be erased when an entire block of data (typically 512 KB) has been flagged for deletion.

Recovering a Disk Array

Complex systems create complex problems. Statistically, the more disks you have, the greater the chance is that you will experience a disk failure. The idea behind fault-tolerant RAID configurations is that even though you have a greater chance of a single disk failure, you have a reduced chance of data loss. There is some evidence that the possibility of multiple disk failures in RAID arrays is significantly higher than a normal statistical distribution would suggest. One possible reason for this is that an external event that affects one disk in an array can affect others as well. Also, certain types of disk errors are not discovered or do not affect the array until a rebuild happens. In any case, disk array problems should always be handled with the utmost care.

External Disk Array (NAS or SAN) Issues

An external disk array is a computer, and can suffer from the same problems that affect other computers, including defective power supplies, defective motherboards, fan and cooling issues that cause intermittent shutdowns, and more. Don't ignore these possibilities when troubleshooting.

Handling a Disk Failure

Before replacing a failed disk, perform a backup of both the data and the array configuration. A full backup is preferable, but sometimes the diminished performance on an array with a failed disk makes that difficult. If you have a recent full backup, you might want to perform an incremental backup instead.

Before you do anything, verify which disk has failed. Depending on the array, the indicator for a failed disk might be an LED, a message on the array's LCD display, an email message to the administrator, information on the array management console, or a combination of the above. If there is any question, call the manufacturer's support line.

Before you replace the disk, make sure your replacement disk is the correct capacity and is on the manufacturer's supported disk list. Also, make sure you know what procedures must be followed to start the rebuild process.

Catastrophic Array Failure
The most common causes of catastrophic array failure are:
- an error on a disk (other than the one replaced) preventing a rebuild;
- the person replacing the disk accidentally removes the wrong one;
- the correct drive was removed, but replaced with a drive that is slightly smaller or, for some reason, is not recognized by the array;
- the array configuration gets corrupted; or
- a hardware problem with the array controller or other NAS or SAN electronics.

If you have a hardware problem, you will need to address that before you do anything else. That may require consulting a local service provider or the NAS or SAN manufacturer. If you do not have a hardware problem, you will need to recover the data. You have the option of trying recovery software or shipping the array to a data recovery service.

An Internet search for "RAID recovery software" will return numerous links to companies that provide recovery software for RAID arrays. Expect to pay several hundred dollars for the software. Be aware that when you recover data from a RAID array, you'll need another storage device with enough capacity to hold the data. If the recovery software approach is not successful, you will either need to rebuild the array from scratch or ship it to the manufacturer or a data recovery service. This service can run hundreds, even thousands, of dollars.

WARNING! Before you attempt to recover data from a failed raid array, be aware that by attempting this process yourself, you may make it difficult or impossible for a data recovery service to recover data, if necessary.

Data Recovery Software
If you accidentally deleted data and can't recover it by normal means, or you formatted a disk that holds critical data that hasn't been backed up, the first step is to try data recovery software. Most data recovery packages have a demo mode that will show you what can be recovered. Since not all products produce the same results, you may need to try more than one. If a particular product works for you, you can usually pay for a license or unlock code to restore your images.

A web search for "data recovery software" will return more results than you can possibly sift through. I suggest narrowing your search by adding your operating system (Mac OS, Windows, etc.) to the search criteria. You can narrow it further by adding "reviews," although many online reviews are sponsored and not necessarily impartial.

Look for software that has a portable edition that does not need to be installed on your hard disk (installing could potentially overwrite the very data you are trying to recover) or software that runs from a bootable CD, DVD, or flash drive. Also, make sure you have a different disk, such as an external hard disk, available for saving recovered data.

A Note About Downloading Data Recovery Software

There are a couple of issues to remember when downloading data recovery software from the Internet. First, some free software is actually demoware that will only demonstrate what it can recover. You have to pay for the service before you can recover your images. Second, some download sites force you to install their own downloader, which opens you up for security breaches in the form of spyware and adware. If the site requires you to install their downloader, use another site or go directly to the developer's website to download the product. Third, some products that are free may install additional software, such as browser tool bars.

Major Surgery—Data Recovery Services

When all else fails and you absolutely need to recover data from your disk or disk array, you will need a qualified data recovery service. The key word here is *qualified*. A qualified data recovery service will have the following:

- knowledgeable, experienced, trained technicians
- a secure environment to keep your data out of the wrong hands
- the equipment needed to recover data from a variety of devices
- a database of information from many sources about recovering data from different devices and systems
- proper facilities for safely dismantling hard disks and tapes

If you do an online search, you will find ads similar to the following (from ebay):
"Data Recovery Service only $2/GB for Any size/kind PC hard drives &/or USB'S"
"DATA RECOVERY SERVICE Lost all your pictures, music, data? We CAN help $99.99 or Best Offer!"

These two are from the same seller:
"Data Recovery Service only $3.00 per gb Any size/kind PC hard drive"
"Data Recovery Service only $1.00 per gb Any size/kind PC hard drive"

My personal favorite:
"Computer Data Recovery Service Start Up Sample Business Plan! $19.95"

Would you select a surgeon this way? There is no shortage of low-price data recovery services. Saving money is a good thing, but when it comes with the possibility of destroying your data in the process of trying to recover it, you might want to use additional criteria when selecting a data recovery service.

Selecting a Data Recovery Service

When selecting a recovery service, research their reputation. Kroll Ontrack (krollontrack.com), CBL Data Recovery (cbldatarecovery.com), Drive Savers (drivesaversdatarecovery.com), and ESS Data Recovery (datarecovery.com) are companies that have reputations for quality service and results. They do not have reputations for low prices, however. Visit their websites as well as the websites of other data recovery companies you are considering before making a decision. Most reputable companies will give you a rough estimate before you ship the disk, and then give you an actual cost before proceeding. Kroll Ontrack will even send a report giving you a detailed list of files that can be recovered. Reputable companies also implement solid security procedures to keep your data out of the hands of others.

> *Kroll Ontrack even recovered data from a burned, partially melted hard disk that was found on the desert floor months after falling from the explosion of the Columbia space shuttle. Read about it here: Data-recovery specialist tells Columbia story, by Brian Bergstein. From nbcnews.com, May 9th, 2008, nbcnews.com/id/24542368/ns/technology_and_science-space/t/data-recovery-specialist-tells-columbia-story/#.UjHoZj9nSGM*

For the most part, companies advertising low-cost services do not have the expertise and facilities needed for delving deeply into data recovery problems. They usually use off-the-shelf software (something you can do yourself) and have no *clean room* facilities (environments with a controlled level of environmental pollutants). Sometimes they will salvage only the easy-to-recover data. Local computer service organizations, particularly the chain services, rarely have the facilities or expertise to do more than run data recovery software.

A qualified data recovery service will charge hundreds, even thousands, of dollars for their services. Recovering data from RAID arrays costs much more than recovering data from stand-alone disks. The bottom line is: your best option is to implement effective backup procedures so that a recovery service is not necessary.

POWER

One of the most misunderstood aspects of data protection is the effect of electrical power on computer and storage systems. Most people seem to think that if you plug your system into a surge protector, especially one that guarantees to pay for your equipment if it is damaged, everything will be fine. Unfortunately, things aren't that simple. If something happens that affects your equipment, you'll find out exactly how much (or how little) that equipment guarantee is worth.

Power problems are complex, and the industry tends to give us simplistic solutions. In addition, very little independent information is available on the topic. Most research in this area is conducted or commissioned by vendors of power protection products, and each study seems to show how that vendor's products or approaches to power protection are superior to those of the competition. Those few non-vendor-sponsored studies are primarily related to large data centers, not individual computers in a home or small office.

Causes of Power Defects

Power defects (or disturbances, interference, or transients) can have many causes. Lightning is an obvious source. It does not have to hit power, telephone, or data lines directly to affect electronic equipment. The electromagnetic field generated by a near miss can induce transients on these lines. As current from the lightning spreads into the ground, it can create voltage inconsistencies at grounding points, which can induce surges through the electrical system. Lightning is probably the most damaging source of electrical disturbance, and also the most difficult to protect against.

> *Mark Waller wrote an excellent book on the topic of power in 1988, titled* PC Power Protection *(Howard W. Sams & Company, ISBN 0-672-22637-5). Unfortunately, the book is out of print (and somewhat obsolete), and Mark has left the power consulting business to become a family counselor. Despite this,* PC Power Protection *is still probably the best book on the topic, and there might be a few new and used copies at Amazon (amazon. com) and Powell's Books (powells.com), so you still might be able to find one.*

The power company switching from one source of power to another can also cause defects to occur, as will power circuits overloading during heavy usage periods. Other sources of disturbance outside the building include downed power lines, power out-

Power cords hang over the city streets in India

ages, and lightning-induced flashover between power lines that causes momentary sags. In addition, heavy equipment outside your building can create power disturbances that can be transmitted into your building.

Many power defects are generated within the building. Copiers, electric motors, elevators, refrigerators, space heaters, medical equipment, arc welders, and other electronics are potential sources of power disturbances.

There are several kinds of power defects that can affect your computers and storage devices, as well as several avenues through which those defects can be induced. Power defects can enter a system via power lines, telephone lines, wide area network connections, or even the LAN cabling. Power defects that can cause problems include:

- **Power Outages and Blackouts:** This means that the power goes out entirely. This will cause loss of any data in a computer's memory that is not written to disk. Some applications are particularly sensitive to this, and require the extensive rebuilding of data files. Corrupted database index files are also common. Power outages are commonly caused by downed power lines, overloaded circuits, power transmission equipment failure, power cords accidentally being unplugged, or equipment accidentally being switched off.

- **Brownouts:** In a brownout, the power will dip below normal for an extended period of time. Persistent brownouts can cause data corruption and loss. Computer power supplies can overheat and burn out. Brownouts are usually caused by the demand for power exceeding the power company's ability to supply it, but they can also be caused by poor wiring within a building or the chronic overloading of a building's electrical system.

- **Sags and Dropouts:** A sag is a momentary drop in voltage, and a dropout is a total loss of power, usually under one second. Sags and dropouts are often caused by utility switching. Sags are also caused by momentary heavy loads in a building, such as the startup of a motor that temporarily overloads a circuit. Dropouts and sags can cause computers to reboot.

- **Swells and Over-Voltage:** These are sustained increases in voltage. These problems are rare, and are caused by power generation and distribution problems. Over-voltage conditions can damage equipment.

- **Surges:** A surge is defined by ANSI and the IEEE as "a transient wave of current, potential, or power in an electrical circuit." This definition is somewhat broad—in practice, a surge is considered to be a momentary increase in voltage that lasts between a few microseconds to a few seconds. These can be from a few volts to over 5,000 volts, with current up to thousands of amps. Surges of 50 volts or more are common, sometimes occurring several times per hour, while surges of over 1,000 volts are infrequent.

- **Spikes:** Also called an impulse, a spike is a sudden, high-frequency (usually 10-20 kHz and above) increase in voltage. Spikes can be generated by lightning, or faulty or poorly designed electrical or electronic equipment. Spikes can cause sporadic errors and can damage equipment.

- **Noise:** Noise is unwanted, high-frequency (10-20 kHz and above) signals generated by lightning, copy machines, air conditioners, elevators, refrigerators, and switching power supplies. Noise can cause sporadic disturbances, such as data loss, and RAM and CPU errors.

- **Static Electricity:** High-voltage, high-frequency electrical discharges between objects can cause mysterious, unexplained glitches, data loss, loss of network communication, and chip damage. The failures caused by static are difficult to distinguish from those caused by other electrical transients.

- **Lightning:** Electrical surges caused by lightning can enter a computer via any electrical or electronic connection. Lightning can generate currents up to 270,000 amperes (amps); lightning voltages have been measured as high as 5,000,000 volts! At these voltages and currents, lightning can cause problems with power and communications systems without a direct hit. If lightning hits the ground near a telephone or power pole, for example, it can induce a surge on the lines. Lightning-induced surges can enter a system through power lines, phone lines, and high-speed Internet connections. A friend of mine even had lightning strike a computer through an open window! A computer or other component does not have to be on for lightning-induced damage to occur, it just needs to be connected to the affected source.

Protecting Against Power Problems

Major potential power problems can be summed up as over-voltage (swells, surges, spikes, static electricity), under-voltage (brownouts and sags), power outages (blackouts, sags) and noise. The solutions here apply if you work in a home or office with a properly designed and implemented electric system. If you work in an industrial area with nearby heavy electrical equipment that affects your power or you have electric-system problems, you may need to consult a qualified electrician.

Handling Surges, Spikes and Noise

First, the good news: modern computer power supplies are designed to handle most surges, spikes, and electrical noise. This has been true for the last twenty years or more. You might then ask, "Do I need a surge protector?" This is a good question, since buying surge protectors is so ingrained in us that we seem to do it automatically. In fact, in the 1980s I worked in a ComputerLand retail computer store, where the first add-on to the low-margin computer sale was a high-margin surge protector.

What Does a Surge Protector Do?

Surge protectors divert over-voltage energy from the hot side of the power circuit to the neutral side and, with most surge protectors, to the safety ground. Since the neutral side of the circuit is bonded to the ground at the service panel, if your electrical system has a proper earth ground, this energy should be diverted there. But electricity takes the path of least resistance; it could end up being diverted to something else, like the closest electronic device. In other words, an effective surge protector needs proper electrical wiring with a good ground. The closer the surge protector is to that ground, the better it will divert energy away from the protected equipment. For surge suppression to be effective, energy has to be effectively dissipated or diverted to a good earth ground. North American power systems use three-wire, split 220-240VAC circuits to provide 110-120 VAC to the power outlet. The two outer wires are hot, and the center wire, which is grounded, is neutral.

There are two major types of surge protectors—Mode 1 and Mode 2. Mode 1 diverts excess energy to the neutral side of the circuit, while Mode 2 diverts to the neutral side and the ground. Arguments rage about which is the more effective approach, as well as which has the least (or most) potential for damaging equipment. Most surge protectors sold in the U.S. are Mode 2 devices.

Circuit board from an under $10 surge protector

The least expensive surge protectors use one or two inexpensive components, the primary one being a *metal oxide varistor*, or MOV. A quick search on eBay found 5,000 MOVs for $250, or about $0.05 each. MOVs are sacrificial devices—a few good hits and they no longer function. MOVs can cease to function, and even short-circuit, after absorbing surges much smaller than your computer's power supply can handle. Some devices will indicate a failure with an LED and some will not. MOV failure at a low threshold has

the unfortunate side effect of convincing people that the unit did its job and protected their equipment, when their power supply would have handled the surge effectively without the surge protector.

More expensive surge protectors may or may not use MOVs; they may use other, more expensive devices for surge diversion. Some have additional components to filter electronic noise, something your computer power supply does already. Some Mode 1 surge protectors, such as those from Zero Surge (zerosurge.com), absorb the surge and dissipate it over time, lessening its impact.

Circuit board from a surge protector that sells for about $25

Some surge protectors have LEDs to indicate that they're connected to a power outlet with a proper ground. If that surge protector also protects a coaxial cable connection, the LED may show proper grounding, even if the outlet is improperly wired, because the shield of the coax cable is likely to be grounded as well. You can buy a simple three-prong circuit tester at any hardware or home improvement store that will tell you if your outlet is correctly wired.

This basic circuit tester won't tell you about power quality, but it will tell you if your circuit is correctly wired

Some surge protectors have connections for network, modem, and/or coaxial cables. There is some disagreement over whether or not these connections actually provide additional protection, or if they merely provide an additional path for surges to be diverted back into the equipment.

Surge Protector Equipment Warranties

Certain surge protectors include a warranty covering damage to connected equipment. How good are these warranties? Before you buy based on the connected equipment warranty, find out what it actually covers and what you have to do to collect on it. Many warranties of this sort require you to provide proof-of-purchase, so make sure you know where your receipt is. Most require you to get, at your expense, a repair estimate for the damaged equipment, and return the surge protector to them at your cost. Most manufacturers pay depreciated value, not replacement cost, for destroyed equipment. Finally, if there is no damage to the device itself, they will likely deny your claim. It's probably easier to go through your business or home insurance.

Do You Need Surge Protectors?

Unfortunately, I have not found any independent studies showing the effectiveness of the type of surge protectors that plug in to a wall outlet. However, in February 1992, IBM published the *Personal System/2 Installation Planning Manual*, which said the following:

> *"External surge suppressors are not required on IBM PC and PS/2 systems. These systems have been designed to meet the IBM corporate requirements that include levels considered adequate for product protection.*
> *External surge suppression equipment has been known to be the source of difficult to diagnose system problems."*

Computer power supplies have improved considerably since then, especially their ability to withstand common power disturbances.

One more thing to consider: can the surge protector itself be a problem? When an MOV fails, it will typically fail "short," meaning it creates a short circuit across hot-to-neutral or hot-to-ground. At this point it can heat up, starting a process called thermal runaway. When the heat is high enough, the leads can split in half or melt. In a worst-case situation it can actually cause a small explosion or fire in the surge protector (I have had this happen). Usually this is contained inside the surge protector, but in rare instances it can ignite a larger fire.

Personally, I don't use plug-in surge protectors. I use UPSs that include surge protection, but only because it is nearly impossible to buy a UPS without it. The choice is up to you. Be aware that using a plug-in surge protector connected to the input or output of most UPSs voids the UPS warranty, and using them (or any outlet strip or extension cord, for that matter) in series violates U.S. Occupational Safety and Health Administration (OSHA) regulations and the National Electrical Code. Make sure your electrical system is in good condition with proper grounding and proper neutral-to-ground bonding at the service panel.

Whole House/Building Surge Suppression

Under most circumstances, surges large enough to damage equipment typically come from outside the building. Utility switching, transformer problems, and lightning are the most common causes. Because surge protectors divert energy instead of suppressing it, the best location for them (to protect against this type of problem) is the place where the wires enter the building. Diverting energy at its point-of-entry makes it less likely to affect sensitive equipment inside the building.

Whole-house surge and lightning protectors that install at the electrical service panel are typically rated for 40,000-80,000 Amp surge currents, or about 2-4 times the current of most lightning strikes. They sell for $50-150. Electrical-meter-based

units are also available, but they cost a little more and require installation by the power company. Broadband and phone line point-of-entry surge protectors are $20-70. Electrical protectors should be installed by a qualified electrician and, because of grounding requirements, telephone and broadband surge protectors should also be installed by an electrician.

Maintaining Consistent AC Line Voltage

All computer equipment built since the early 1980s uses a type of power supply known as a switching power supply. Without going into technical details, a switching power supply provides better voltage regulation than most voltage-regulating devices. In fact, the Intel design guide for PC power supplies[1] specifies an input voltage range of 90-135 VAC for 120-120 VAC electrical systems, and 180-265 VAC for 220-240 VAC systems. This means that voltage stabilization is only needed if power fluctuates outside of this range. A UPS can effectively handle occasional fluctuations. If voltage fluctuation outside this range is a common problem, you should contact your power company. If they cannot resolve the issue, you may need to locate the services of a good power-quality engineer.

Handling Power Outages, Brownouts, Sags, and Over-voltage

UPSs can be a solution to brownouts, sags, and over-voltage conditions, if you purchase the right one. Technically, most devices sold as UPSs are standby power supplies (SPSs). A true UPS continuously charges a battery or batteries, which supply DC voltage to a power inverter, which powers your equipment. In an SPS, current is supplied to your equipment by the power line, and the inverter only kicks in when the power goes off or drops below a specified voltage level. To avoid confusion, we will adhere to industry practice and refer to this whole class of power backup devices (UPSs and SPSs) as UPSs.

What a UPS Does

A UPS provides power for a short period of time in the event of a power outage. Depending on the type of UPS, it can also regulate voltage and provide an orderly system shutdown during a sustained power outage. Most small UPSs are not designed to provide extended runtime during a power outage; they are designed for outages of only a few minutes. There are three primary technologies for UPSs:

- **Standby:** Your equipment is powered directly by the incoming power line, which also continuously charges the UPS batteries. Battery charging requires a rectifier circuit to convert the incoming AC to DC, and to lower the voltage to the level

1 Power Supply Design Guide for Desktop Platform Form Factors, Revision 1.31. Intel, April 2013, http://cache-www.intel.com/cd/00/00/52/37/523796_523796.pdf

that is required by the batteries. In the event of a power loss or drop in voltage below a specified threshold, the internal power inverter turns on and switches the equipment power from the power line to the inverter-supplied power. One problem with this technology is that that the switchover time may be too slow for some equipment. Some degree of surge protection is usually provided as well. This is the least complex and least expensive type of UPS.

- **Line-interactive:** A line-interactive system is a standby system with additional circuitry that can adjust for high and low voltage conditions. In low voltage conditions, the unit will use more current than normal to compensate for the boost in voltage it must provide. A line-interactive UPS provides voltage regulation within a range of 90-140 VAC on 110-120 VAC systems, and 180-280 VAC on 220-240 VAC systems. This means that the UPS is less likely to switch to battery in a low-voltage condition.

- **Online/double-conversion:** Online UPSs, also called double-conversion UPSs, are like a standby or line-interactive system in that they use a rectifier to charge the battery and an inverter to power the protected equipment. The difference is that the rectifier circuit in an online UPS continuously charges the batteries and also powers the inverter with no switchover. In a power outage, the rectifier circuit simply drops out. Because an online UPS requires a much more substantial rectifier circuit, the cost is considerably higher than a standby or line-interactive unit. Operating costs are usually lower since this approach tends to extend battery life. Online UPSs, due to their initial cost, are rarely used for small computer systems.

UPS Output Wave Form

Alternating current from the power lines is delivered as a sine wave, which is the most desirable waveform to deliver to computer equipment. Delivering a pure sine wave from a UPS can be costly, so another waveform is often used.

A few years ago, many low-cost UPSs delivered square waves, which were problematic for computer systems. Another waveform, called a quasi-sine wave, simulated sine wave, stepped square wave, and modified square wave, among other names, evolved. These approximated sine waves include multiple waveforms with different appearances, but electrically they all simulate a sine wave. UPSs that produce this waveform are almost as inexpensive as square wave UPSs, and they have the advantage of working with most computers and other electronic equipment. This type of UPS has become the most common type used for computer systems, and until recently, they have done a good job. The march of technology, however, has made this design less desirable for many newer computer systems, primarily because of something called *power factor correction* (PFC).

True sine waves (image courtesy of
CyberPower Systems)

Simulated sine wave (Image courtesy of
CyberPower Systems)

Power Factor and Power Factor Correction (PFC)

The simplest explanation of the PFC problem is that a switching power supply, such as is used in most electronic equipment these days, distorts the wave shape of power drawn from the power lines. This increases the amount of current drawn from the power company and puts an extra load on the entire power distribution system. The degree of this distortion is called the *power factor*. To compensate for and help alleviate the problem, PFC circuitry has been incorporated into many newer computer power supplies. Two types of PFC are used—active and passive. Passive is less expensive, but active is more effective and, in most cases, greener. Better power supplies use active PFC.

Pure sine wave UPS sized for a computer, monitor, external disk array, and LTO tape drive

Unfortunately this has created a side effect—many power supplies with active PFC don't play well with UPSs that produce simulated sine wave output and require a true sine wave. With a simulated sine wave, these power supplies have difficulty with the UPS's switchover from line power to battery, and they shut down.

Do You Need a UPS?

If you use any computer or data storage system other than a laptop, you should consider a UPS. Even with a laptop, if you use an external storage device that does not draw its power from that laptop, you should consider a UPS. For small computer applications, a standby or line-interactive UPS is a good, cost-effective solution. Look for these basic features:

- proper sizing for your connected equipment, including your computer, monitor, and external storage and backup

devices. Undersized UPSs may fail or not provide sufficient runtime for effective shutdown. Most UPS manufacturers have sizing and runtime information on their websites.

- USB connectivity. Modern operating systems include UPS monitoring functions to provide for an orderly system shutdown in case of an extended power outage. Most vendors also provide software with additional shut down features, as well as features to allow you to manage and monitor your UPS. Unfortunately for Mac and Linux users, this software is often Windows-only.
- sufficient outlets and spacing—the UPS should accommodate power blocks without obstructing other outlets (also, additional outlets without UPS protection are a plus)
- audible alarm that sounds when the unit is on battery power
- easily replaceable batteries—UPS batteries should be replaced every 3-5 years. Most units use batteries with standard sizes and specifications, and are often available from local sources.
- effective status indicators on the UPS
- Energy Star compliance
- sine wave or simulated sine wave output (see UPS Waveform and PFC)—avoid UPSs that provide a square wave output
- voltage regulation

The outlets on the left have UPS protection, while the outlets on the right do not

UPS vendors may sell a "green" product line, a "performance" line, an "economy" line, etc. Look beyond these labels to the actual product specifications.

UPS Waveform and PFC

Newer computer power supplies use *active power factor correction* (active PFC), and some of these power supplies do not function well with simulated sine wave UPSs. If you are buying a UPS for the long term, consider one with true sine wave output, even if you don't need it now. A UPS can easily last ten years or more (assuming a battery replacement or two), and it is likely you may need true sine wave output at some point. Of course, this is a gamble, because it is also possible that power supply manufacturers will modify their products to handle the problem.

Orderly Shutdown of Multiple Systems

Most UPSs designed for small offices can provide orderly shutdown for one computer, usually through a USB connection; but, if you have two computers or a computer and (for example) an external NAS device, that class of UPS can't directly control two systems. One approach is to purchase a UPS with a network management port. These usually come with software to shut down multiple systems. This type of UPS is quite large and expensive. The second approach is less expensive, but difficult and complex to implement. Network UPS Tools (NUT) (networkupstools.org) is a set of utilities for UPS management. Although it is available for Mac OS and Windows (beta version), this is definitely a Linux utility.

All the documentation is for Linux and the utilities are command-line. Installation on Windows is complex (I suspect it is for Mac, as well) and the drivers will probably kill your UPS-vendor-supplied software. Still, if you absolutely need this capability and you have the time and patience to implement it, NUT may be for you. One word of caution—in my attempt to configure NUT, I accidentally over-wrote my Windows 8 mouse driver. The only way I could recover it was by booting with a recovery CD and rolling back to a previous restore point. In other words, be careful and make sure you can roll back if things go awry.

Additional Power Issues

Electrical power is complex, and not all power-related problems have simple solutions. In this chapter I have tried to provide information about the most common electrical problems and their possible solutions. If you are experiencing issues that go beyond this, you may want to talk to your power company or an electrician. Office building issues can be extremely complex, because electrical circuits are shared by multiple offices. If you are in rented space in an office building, talk to your building management or building engineer. Most of the available books on the topic of power quality are written for electrical engineers and are not all that helpful for the layperson trying to solve their own power problems.

ODDS AND ENDS

Migrating Data to New Storage

As your library grows, or even as your equipment ages, you will eventually need to migrate your data to new storage. Prior to migration, you will need to make sure your applications and your backup software will link to the new storage location. If possible, use the same volume names and drive letters (Windows) or mount points (Mac, Linux). Also, do a full backup of the disk being migrated.

Migration Tools

If you are migrating an entire disk or partition to a larger disk, cloning software is usually the easiest approach. Most cloning software will allow you to migrate to a large disk and adjust partition sizes as necessary. Not all cloning programs do actual file verification. Carbon Copy Cloner, Chronosync, and Macrium Reflect (including the free edition) optionally perform file verification.

If you are migrating to a NAS or SAN device, software that does file verification is the best approach. Some backup software provides a copy mode (separate from its standard backup mode) with verification. Retrospect's *Duplicate* mode (*copy* mode in the Mac version) has options to compare files on the source and destination, to perform a byte-by-byte file comparison, and to duplicate file and folder security information.

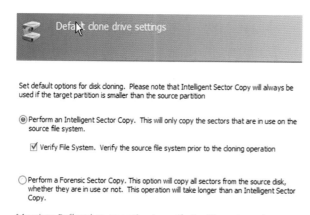

Macrium Reflect has an option to verify the file system when cloning drives and partitions

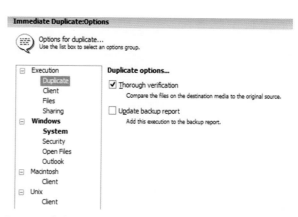

Retrospect's duplicate option (copy in the Mac version) provides file verification

If your backup software doesn't have a verified copy mode, there are a number of copy utilites available that have verification.

- **Teracopy** (codesector.com/teracopy) is a copy utility for Windows that is free for non-commercial use. Commercial use requires a license.
- **Ultracopier** (ultracopier.firstworld.info/download-all.html) is a copy utility for Windows, Mac, and Linux. Ultracopy is free and open source under the GPL 3 license.
- **FastCopy** (ipmsg.org/tools/fastcopy.html.en) is a copy utility for Windows. FastCopy is free and open source under the BSD license.
- **SafeFileManager** (mindbytez.com/sfm) is a java-based copy utility for Windows. Download the .exe file for Windows or the .jar file for other Mac OS and Linux.

Migrating File Formats

The major reason for migrating graphics from one format to another is that the software (and sometimes hardware) needed for reading a particular format is at risk of disappearing. Three formats that appear to fall into this category are Kodak PhotoCD, Kodak RAW, and PICT. There is current software that can read all three formats, but because the use of those formats for generating new images has effectively ceased, software vendors, either commercial or open source, may not continue to provide support for much longer. Other older RAW formats fall into the same category. To prevent losing access to graphics with older file formats, you may want to consider migrating them to newer formats.

Photoshop will batch-convert many file formats, but Kodak PhotoCD and some Kodak RAW formats may require plug-ins from Kodak. The open source GIMP will also convert numerous file formats. The freeware program XnConvert (xnview.com/en/xnconvert) works with over 500 formats, including the aforementioned Kodak PhotoCD and Kodak RAW.

For other RAW formats that are in danger of becoming obsolete, your best bet is to convert them to DNG. Adobe provides a free DNG converter at their download site.

Kodak plug-ins are currently available here: kodak.com/global/en/professional/support/DCS/dcsRegister/downloadIndex.jhtml?dcsFwSelector=fileFormat

kodak.com/global/en/service/software/pcdPlugInUpdates.shtml

Migrating Backups to a New or Different Computer

One great thing about software that does continuous or near-continuous backup is that you can recover multiple versions of the same file. What happens, however, when you move your data to a different computer? Do you lose all that history? It depends on your software and how you handle the move. These links show how two backup programs handle this situation:

CrashPlan
support.crashplan.com/doku.php/faq/general#what_happens_when_i_adopt_a_computer

Oops! Backup
support.zoho.com/portal/altaro/HomePage.do
Then select: "How to install Oops!Backup on a new PC (different PC / formatted PC) and restore from an existing Backup Drive"

Protecting Passwords

How many passwords do you have? How do you remember them all? How often do you use the same password for multiple sites? We all need to access multiple services that require passwords and pin numbers, and most of us employ one or more of these three strategies for handling them all:

- creating easy to remember passwords (relatively short words that are names of something or someone near-and-dear to us, using zeros for "O"s or adding numbers to the end);
- reusing the same password on multiple sites; and
- writing them down where they are easy to find (or easy to hack).

All of the above practices are dangerous, but how do you create unique, difficult-to-crack passwords for multiple sites that you can remember? The easiest way is to use a secure password database. There are two password databases that I use—KeePass and LastPass.

KeePass (keepass.info) is a free and open source (GPL 2.0 or later) secure password database for Windows, Mac OS, Linux, and other operating systems. KeePass stores your passwords in a highly encrypted database that consists of a single data file that can easily be backed up and copied. To use KeePass, you only need to remember a single password. It includes a random password generator that allows you to set the level of complexity of the passwords that are generated. KeePass also allows you to organize the database into folders. LastPass (lastpass.com) is a web-based, encrypted password database that can be accessed from almost anywhere using a web browser. Like KeePass, LastPass stores your passwords in an encrypted database and allows you to organize passwords into folders. Unlike KeePass, copies of that database are installed on a LastPass server and any computer on which you install LastPass. Even though the database is installed on a LastPass server, only you (or anyone to whom you give the login name and password) can access the data. If you lose your password to LastPass, the company can send you a key to unlock your local copy and create a new password. LastPass can be accessed using a web browser on any computer. LastPass is free, but if you would like to be able to access it from your mobile device, you need LastPass premium ($12 per year). Premium also removes ads and gives you priority email and phone support. If you prefer to remember your passwords, here is another option:

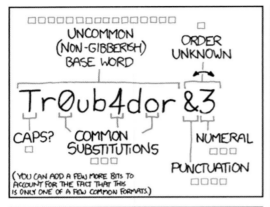
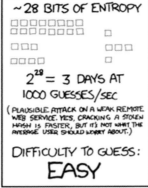
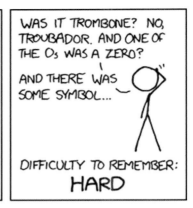
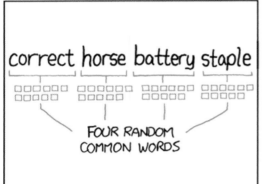

THROUGH 20 YEARS OF EFFORT, WE'VE SUCCESSFULLY TRAINED EVERYONE TO USE PASSWORDS THAT ARE HARD FOR HUMANS TO REMEMBER, BUT EASY FOR COMPUTERS TO GUESS.

Password strength by xkcd (xkcd.com)

Software Licenses

Most software can be downloaded if you lose it, but the licenses are more difficult to recover. I use two methods to maintain license codes:

- I save the license documents, if any, in a directory that is always backed up.
- I save the license codes in KeePass.

Retiring Media

When you no longer need hard disks, optical media, flash drives, and backup tapes, what do you do with them? If you are concerned about data falling into the wrong hands, you need to take steps to make sure your data is no longer readable. Many years ago I bought used computers from a major bank. Whoever prepared them for sale didn't really do their job; I found sensitive HR information, including employee termination letters, on the hard disks. This should never have happened and you should make sure it doesn't happen to you.

Hard Disks

There are three ways to securely removed data from hard disks—*degaussing, massive destruction*, and *secure disk-wiping*. Deguassing is the process of exposing the disk to a strong magnetic field. Deguassing usually makes modern hard disks unusable, since it not only removes stored data, it also removes the data that controls the read-write head's servo control motor. Massive destruction is exactly what it says—the disk is destroyed in such a manner that no remnant of magnetic media is readable. Secure disk-wiping uses software to securely overwrite the data on the disk. The disk is still useable after wiping. Of the three methods, disk-wiping is the least secure, but also the least difficult and expensive, method of removing hard disk data. It will prevent all but the most determined (think NSA) from accessing any of your data.

There are two approaches to disk-wiping—block erase tools and Secure Erase. Block erase tools work on nearly any hard disk, while Secure Erase is a command built in to the firmware of SATA hard disks and some earlier ATA hard disks (made in 2001 or later). Without getting into the details, Secure Erase is more effective on supported disks than the block erase method. If you have SAS hard disks, or pre-2001 IDE or ATA disks, you will need to use the block erase method. Many of the programs that wipe hard disks are designed to boot from CD, USB flash drive, or floppy disk(!), so you can use them with any disk regardless of the operating system.

> *These two blog posts do a pretty good job of explaining the two approaches to disk-wiping:*
>
> *ultraparanoid.wordpress.com/2007/06/20/can-god-create-a-rock-so-heavy-even-he-cant-lift-it*
>
> *ultraparanoid.wordpress.com/2007/09/12/securely-erase-hard-drives*

Block erase programs include:
- Darik's Boot and Nuke (DBAN), freeware: dban.org
- Disk Wipe, freeware: diskwipe.org
- WipeDisk, freeware: gaijin.at/en/dlwipedisk.php

Programs that call the Secure Erase command include:
- HDDErase, freeware: cmrr.ucsd.edu/people/Hughes/Secure-Erase.html
- MHDD, freeware: hddguru.com/software/2005.10.02-MHDD

Optical Media

The best way to wipe optical media (CD, DVD, Blu-ray) is a heavy-duty paper shredder. Unless you are dealing with incredibly sensitive data, cutting the disc into four or five pieces should be sufficient to deter all but the most determined persons from attempting to recover your data. Recovery from multiple pieces of optical media requires sophisticated equipment and a lot of expertise.

Flash Memory Cards

Data recovery programs for flash memory cards typically include a Secure Erase function, as does the SD Format program supplied by the SD Association. For more detailed information, see chapter 1.

SSDs

Firmware for SATA SSDs includes the Secure Erase command mentioned above. The same software that calls Secure Erase for hard disks works for SATA SSDs as well.

Magnetic Tape

Many vendors of tape drives provide software that will perform a Secure Erase, but the procedure usually takes several hours per tape. Degaussing, or exposing the tape to a strong magnetic field, is another option, but it will render any tape that has pre-recorded servo tracks completely unusable. Degaussing services are available in most metropolitan areas. The third approach is shredding. Companies that shred documents often provide tape-shredding services as well.

The Perils of Social Media

Always read the terms of service for any social media sites before posting images. For example, Facebook's (facebook.com) terms of service includes the following:

> *"For content that is covered by intellectual property rights, like photos and videos (IP content), you specifically give us the following permission, subject to your privacy and application settings: you grant us a non-exclusive, transferable, sub-licensable, royalty-free, worldwide license to use any IP content that you post on or in connection with Facebook (IP License). This IP License ends when you delete your IP content or your account unless your content has been shared with others, and they have not deleted it."*

Twitpic (twitpic.com), the photo-sharing arm of twitter, says this in their terms of service:

> *"You retain all ownership rights to Content uploaded to Twitpic. However, by submitting Content to Twitpic, you hereby grant Twitpic a worldwide, non-exclusive, royalty-free, sublicenseable and transferable license to use, reproduce, distribute, prepare derivative works of, display, and perform the Content in connection with the Service and Twitpic's (and its successors' and affiliates') business, including without limitation for promoting and redistributing part or all of the Service (and derivative works thereof) in any media formats and through any media channels."*

In both cases, the bottom line seems to be, "you own your images, but we can do whatever we want with them." Twitpic's terms have this to say about liability:

> *"You agree to indemnify and hold Twitpic, its officers and employees exempt from any claim or demand, including reasonable attorneys' fees, made by any third party due to or arising out of Content you submit, transmit, post or otherwise make available through Twitpic."*

If, for example, you post a picture of a person, such as a friend or relative, and you do not have a signed model release authorizing commercial use of that person's image, and Twitpic uses that picture to promote their service (i.e., commercial use), who is liable if the individual pictured decides to sue or ask for compensation? I'm not a lawyer, but my layman's interpretation is this: Twitpic can use your images pretty much any way they see fit. If there is a legal problem as a result, you are liable even though you no longer have control over usage.

> *You can find an actual lawyer's interpretation of this topic here: nyccounsel.com/business-blogs-websites/who-owns-photos-and-videos-posted-on-facebook-or-twitter.*

Be careful what and where you post online. Always read the terms and conditions of any site on which you post images.

Metadata, Watermarking, and Copyrights

Even when terms of service are not as onerous as those quoted above, I would suggest watermarking your online images with a copyright notice (disclaimer: I am not a lawyer, so these are my layman's suggestions). I also suggest making sure identifying metadata, including contact and copyright information, is included in the image. Some software used to upload photos strips metadata by default, so always check. Although copyright registration is not mandatory in the U.S., it can facilitate the process of making an infringement claim. For information on U.S. copyright registration procedures, see: copyright.gov/circs/circ40.pdf.

Deleting Images from Social Media

Each social media site is different, and some don't make it easy. For example: Facebook only allows you to delete photos one at a time, while Flickr (flickr.com) allows you to delete entire sets. Photobucket (photobucket.com) allows you to delete single images or entire albums.

EPILOGUE

The best-laid schemes o' mice an' men
Gang aft agley,
An' lea'e us nought but grief an' pain,
For promis'd joy!

(The best laid schemes of mice and men
Go often awry,
And leave us nothing but grief and pain,
For promised joy!)

"To a Mouse, on Turning Her Up in Her Nest
with the Plough," Robert Burns, 1785

The Event

Shortly after I finished the manuscript for this book, I switched to a new computer. When I plugged in and powered on the external hard disk drive that held my entire photographic library, instead of the usual sound of a hard disk starting up, I heard a slow tick...tick...tick...

That was it—my year-and-a-half-old hard disk had gone to disk drive heaven (or perhaps the other direction). Fortunately the data was backed up, and I was able to restore everything after buying a replacement drive.

However... Restoring data rarely goes as smoothly as we would like, and it always takes a bit more time than expected. On the positive side, it gives us the opportunity to review our backup procedures and data protection plan.

Here's what I found in my review:

How Many Copies?

I thought I had at least three backups of my data, but what I really had was two backups and a replication of one of those backups. Crashplan was backing up to a SAN attached to my Linux server, and Oops! Backup was backing up to an external disk, which was replicating every night to an off-site NAS device. The good news is that the backups and replications did their job. However, I discovered that certain additional files (which weren't necessarily critical, but would have been inconvenient to lose) were only being backed up by CrashPlan, and therefore only backed up to a single location.

I added an LTO-6 tape drive and Retrospect to my system when I made the move to the new computer. Now, Retrospect does a nightly incremental backup of all the data that is being backed up by CrashPlan and Oops! Backup. I plan to back up to a single LTO-5 (1.5TB) tape, which will be replaced monthly.

Restore Speed

In the past, I had restored files with both programs without problems. However, I had not attempted to restore several hundred gigabytes of data at a time. Restoring data with Oops! Backup went as expected, but restoring with CrashPlan did not.

The more data you need to restore, the more memory CrashPlan needs. By default, the CrashPlan backup/restore service is set to use a maximum of 512MB of memory.

Unfortunately, that isn't enough when restoring a lot of data, and CrashPlan will likely crash. Documents on the CrashPlan support site say this is a problem with more than 1GB of data, but I experienced this issue with only 130MB of data. The fix is a simple edit to a configuration file that will allow the CrashPlan service to use more memory.

However...

Even after increasing the memory parameter to 1024, restoring to my PC from the SAN device attached to my Linux server was extremely slow, about 50MB/min. Since my Linux server also runs CrashPlan, I was able to attach an external disk to the server and restore to that disk, then attach the disk to my PC and copy the restored files to their proper location. Not an elegant solution, but it got the job done.

An additional side effect of increasing the memory parameter is that the CrashPlan service decided it needed about 700MB of memory, even when idle. I have since reset the parameter to its default value, which is fine for backup.

By the time this book is published, new CrashPlan clients that will reportedly solve the memory problems should be available. I will continue using CrashPlan, but I will re-evaluate after I try the new clients.

Lessons Learned

Don't panic. (You already knew this.) Think through your restore process before you begin. Even if you have deadlines, make sure you take your time to do things right.

Expect the unexpected. You will find things you didn't think of or plan for; these lessons will help prepare you for the next time. Every incident can be a learning experience. If you run into trouble:

- Read the documentation.
- Search the knowledgebase on the backup software vendor's website.
- Do a web search for the specific problem you are experiencing.
- Locate your software's log files and scan for anything related to the problem you are experiencing. Do a search of the logs for the word "error."
- Contact vendor support if necessary, but don't expect a quick response from the support staff for low-cost backup software and services. For fast response, you will usually need to pay extra. For an online service, this could mean a premium service level. For software, it might mean paying for a support contract or per-incident support.
- Sometimes there is more than one way to solve a problem. (For instance, how I solved my CrashPlan restore problem, above.)

When it's all over, a final debriefing is helpful. What worked? What didn't? Do you need to change your procedures? Is your current software working for you or should you look for something different? How comfortable are you with your backup hardware? Your system for backing up and archiving your data should evolve based on your needs and experiences, so don't be afraid to make necessary changes.

ACKNOWLEDGMENTS

I would first like to thank my family for their patience during this project. I would also like to thank everyone at Rocky Nook, including my editor Maggie Yates; Joan Dixon, Managing Editor; Matthias Rossmanith, Project Manager; Gerhard Rossbach, Publisher; Sue Irwin, Proofreader; and Cora Banek, Layout Designer. I have worked with publishers that are only interested in filling existing niches; Rocky Nook is one of those rare publishing companies willing to create new ones.

I would also like to thank all the people and companies that provided information and review products for this book. I especially want to thank all the public relations and marketing communications people that helped me navigate their corporate jungles to get access to those people in their companies with real industry and product knowledge. Without their help I would not have been able to complete this project.

INDEX